Bodies of Modernity

Figure and Flesh
in Fin-de-Siècle France

INTERPLAY

THEORY ARTS HISTORY

Bodies of Modernity
Figure and Flesh
in Fin-de-Siècle France

Tamar Garb

With 173 illustrations, 12 in colour Thames and Hudson

For Gabriel Adam Jamie

© 1998 Thames and Hudson Ltd, London

British Library Cataloguing-in-Publication Data
A catalogue record for this book is available from the
British Library

ISBN 0-500-28049-5

Printed and bound in Slovenia by Mladinska Knjiga

Contents

Bodies of Modernity is the product of more than twenty years of speculation about late nineteenth-century French art. I was first captivated by the art of the French Impressionists as a teenager, growing up in the strained circumstances of apartheid South Africa. It was in the colonial classrooms of Cape Town that I used to scrutinize the mediocre reproductions of French paintings that my teachers offered me and it was there that I dreamed of Europe and what, for a young displaced South African child, seemed like a wonderland of visual pleasure. Fixated on Europe, I was unable to connect with the cultural contexts of Africa. It is only now, after living in England for two decades, that I realize how formative were those vague second-hand encounters with foreign cultures that I then experienced. To my first teachers, therefore, I owe an enormous and as yet unpaid debt. To Pat Lendrum who taught me to think about art socially and politically when I was just thirteen, to Julia Eppel who taught me to think in words, to the late Patricia Atkinson who taught me to love painting, to Evelyn Cohen who allowed me to imagine that I might one day be an art historian and to Neville Dubow who made me feel that Europe was accessible, reachable, even comprehensible, I offer deepest thanks.

In England, the home of my adult years, I have incurred many debts. My naive infatuation with French culture was tempered and tamed by the rigours of scholarship and the example of my peers as much as my teachers. I owe thanks to John Golding, Tag Gronberg, Tom Gretton, Charles Harrison, Andrew Hemingway, John House, Timothy Hyman, Margaret Iverson, Lynda Nead, Griselda Pollock, Alex Potts, Judith Ravenscroft, Katy Scott and Helen Weston, all of whom have helped me in a number of indispensable ways. Kathy Adler, Caroline Arscott, Adrian Rifkin, Briony Fer and David Solkin have shared large parts of this book with me, agonizing over theoretical points, staring for hours at paintings with me, putting up with some of my wilder speculations. Moira Benigson and Myra Stern have been the most supportive of friends, offering the help, encouragement and understanding that only deep familiarity can provide. With them I am always 'at home'.

My involvement with the women's movement has opened intellectual and professional doors across continents. It has facilitated some of my richest and most enduring friendships, especially with feminist scholars in the US, who have influenced my own work enormously. I would like here to pay tribute to the work of Holly Clayson, Carol Duncan, Carol Ockman, Molly Nesbitt, and Abigail Solomon-Godeau, and to acknowledge my debt to them. Special thanks are due to Linda Nochlin, without whom feminist art-historical scholarship would not have gained the legitimacy it has, and whose tireless energy, personal warmth and intellectual vigour have been a continual inspiration to me.

My work has been facilitated by the support of a number of institutions, most importantly my colleagues and students at University College London who have provided an unparalleled context for experimenting with ideas, trying out new material and countless informal chats which have influenced my thinking in more ways than I could mention. Jill Walters and Francesca Berry have helped me with many of the practical aspects of completing this project. I received financial support from the Deans Travel Fund at UCL, which facilitated a research trip to Paris, and I was also the recipient of a Leverhulme Research Fellowship which enabled me to take off one year from teaching to write a considerable proportion of the book. I gratefully acknowledge my debt to these institutions. All of the chapters in the book originated as lectures planned to coincide with exhibitions or conferences and all have been transformed in the current context. Chapter One began as a lecture at the Art Institute of Chicago to coincide with the Caillebotte retrospective of 1994–5.[1] Chapter Two originated as a lecture at the *Sculpture and Photography* conference held at UCL in 1995. Chapter Three started out as a lecture given at a symposium organized to coincide with the exhibition of Tissot prints held at the Art Gallery of Ontario in 1996. Chapter Four was delivered as a lecture at the National Gallery in London as part of a series accompanying the 'Seurat and the Bathers' exhibition in 1997. Chapter Five was first delivered in Williamstown, Massachusetts, at a conference organized around the exhibition 'A Passion for Renoir' held at the Sterling and Francine Clark Institute in 1996–7. Chapter Six is a version of a lecture delivered at the symposium held to coincide with the large Cézanne retrospective which took place at the Tate Gallery, London, in 1996, while Chapter Seven has gone through many permutations, beginning with an Open University/BBC film first broadcast in 1993 and then reformulated as a lecture which I hawked around three continents over three years.[2] The content of this book is determined, therefore, as much by institutional initiatives and

events of which I have had no control as by my own passions and concerns, but each of these occasions has provided me with an opportunity to think or rethink material with which I have long been fascinated.

Preparing this book for publication has involved the usual agonies and traumas but the task has been greatly eased by the support and advice of Nikos Stangos at Thames and Hudson. His friendship and belief in this project, even when it missed its first two deadlines, has sustained and nurtured me. And my family, now spread across three continents, have been enduringly present, from my first intellectual endeavours, filled with more enthusiasm than substance, to the sober reflections which I now offer them. To Anne and the late Jack Bloch and to Ivor, Cynthia, Allen and Carol Garb, I offer my thanks. To Rasaad Jamie, with whom I have shared this entire project, I give my gratitude. But it is to Gabriel Adam Jamie that I dedicate this book, with love and deep respect.

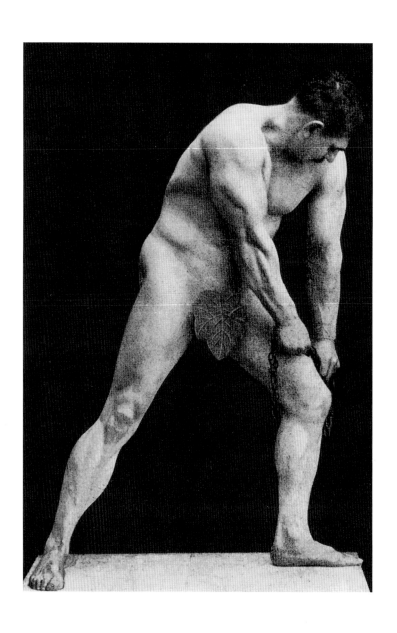

Modernity produced its own image of the body. According to the dictates of science and philosophy, modern men and women were expected to look dramatically different from one another. To the nineteenth-century European mind, a 'masculine woman' or 'feminine man' represented an unnatural aberration, a grotesque distortion of a preordained set of distinctions that were rooted in biology, decreed by nature and endorsed by the complex organization of sexual and social behaviour which characterized modern society.[1] If men and women were to occupy their prescribed roles, then they had to look their parts, inhabiting those social fictions as if they were either inevitable or acquired without effort. Appearances testified to the maintenance of a social order based on visible distinctions. If boundaries were transgressed, chaos could ensue.

The modern body is always, therefore, a 'gendered' body. Moulded, modelled, ornamented and adorned, the body bears the burden of displaying difference. For nineteenth-century witnesses, muscles that were rounded and swollen, and skin that was rough, textured and covered with hair (trimmed, waxed and shaved in the right places) reinforced notions of masculinity, while minute waistlines, bejewelled bodices, unblemished complexions and elaborate coiffures affirmed ideas about the feminine. These were not interchangeable characteristics. They were borne on the body as an expression of an inner essence, the confirmation of an identity which must be easily recognizable. Figure painting and photography constituted an important arena for the representation of the body as an expression of social norms. For the expectation of art was that its manipulation of figure and flesh would reflect and reinforce contemporary constructions of masculinity and femininity. Many images of the body in the period do exactly that. Society leaves its mark upon the body, fashioning men and women in its image. Naked or clothed, the body in representation is cloaked in convention, conforming to society's expectations in setting, pose, attributes and physical characteristics.

And yet there are instances when the body seems to rebel against the strictures of the social, straining against convention as if it is unable to

1 'A Modern Hercules', from La Culture Physique, January 1905

fulfil its role as guarantor of sexual difference. In such cases, the depicted body appears to disobey its designated role, exceeding expectations or falling short of them, and producing an identity which is not fixed and secure. This is the body's apparent 'failure', its refusal to function as a vehicle for a coherent subject obedient to the dictates of convention. Flesh spills out of its carefully framed contours, muscles swell too ostentatiously from finely modelled limbs, tightly laced bodies exceed their demarcated boundaries and perspiration blemishes the polished veneer of external appearances. The balance between an adequate expression of sexual difference and an excessive or deficient representation of it can be precarious. Candour can deteriorate into caricature, parody can pass for description, awkwardness of execution can read as a violation of accepted codes.

The physical nature of painting and the artifice of photography may provide, therefore, the means for the undermining of difference, and contribute to its subtle, sometimes inadvertent, subversion. In the smudged painterly contour surrounding a figure or the flamboyant imposition of a coloured patch or a shaft of light in the 'wrong' place, painting may disrupt culture's highly organized categories and so generate doubt, confusion and the possibility of dissent, if only in the realm of the image. Masculine men may be seen to betray 'feminine' features, while 'feminine' women take up the poses usually ascribed to men. Even the most consummate representatives of manliness and womanliness may appear over-zealous in the performance of their sexed identities, producing an exaggerated or excessive display of difference. The strain of maintaining perfectly policed boundaries betrays a fear of their loss. In the rigid conformity of the bourgeois gentleman, replete with his top hat, cane, cigarette and costume, or the painted perfection of the 'Parisienne', parasol, fan and gloves providing the obligatory accessories, images of masculinity and femininity are kept ineluctably apart, so that their very separation reveals an anxiety around the collapse of difference. Picturing difference provides the possibility of puncturing difference, and figure painting and photography sometimes reveal unexpected ways of doing both.

Bodies of Modernity traces the representation of men and women in a number of late nineteenth-century pictorial practices: mostly painting, but also photography, advertising and caricature. The book begins with a discussion of the Impressionist artist Gustave Caillebotte's male figures in the context of contemporary debates around masculinity, and then examines the uses of photography to defend a revivified 'classical' conception of the male body. From there it turns to an analysis of the

image of the feminine as encapsulated in James Tissot's *Femme à Paris*, his extraordinary series of paintings exhibited in 1885. A detailed study of Georges Seurat's *Young Woman Powdering Herself* in relation to contemporary portrayals of the 'woman at the toilette' by both male and female artists precedes a discussion of Renoir's eschewal of the modern in his adumbration of a world free from society's restraints and embodied in the rounded, full-bodied forms of young country women, epitomizing the kind of natural sexuality and earthiness which, he believed, the asphalted surfaces of the city served to repress. Here it is the rejection of modernity that fuels the image of a nostalgic fantasy premised on some imagined earlier perfection perceived to be threatened by the forces of modernization. Similarly nostalgic fantasies of masculinity are apparent in the photographs of male body builders analysed in Chapter Two, which promoted an image of a pre-modern virility as a corrective to the enervated physicality of modern men.

The final two chapters of the book are devoted to Cézanne. The first focuses on an early painting, *The Eternal Feminine*, in order to explore how its allegorical mode, while drawing on standard misogynist fantasies, calls into question the ability of art to represent the 'feminine'. Naturalist and traditional pictorial strategies are shown to be implicated in a number of psychic manoeuvres which betray a fear of female sexuality, making it impossible to represent it in any but a displaced or disguised form. Finally, the book turns to Cézanne's late bather paintings, both male and female, and by juxtaposing them with works by Renoir and Jean-Frédéric Bazille demonstrates the sexual indeterminacy of Cézanne's figures, their bizarre androgynous quality. Of all the figure paintings examined in this book, Cézanne's late bathers are shown to be the least secure in their sexual identity. Unlike Tissot's *Femmes à Paris*, in which women appear to perform their femininity with the passive obedience of mechanical dolls, or Caillebotte's muscular rowers, where men display the attributes of manliness with unvexed ease, the sexuality of these figures is indeterminate, collapsing corporeal differences and smudging bodily distinctions in a painterly world which seems far removed from the gendered strictures of *fin-de-siècle* France. But a careful tracking of Cézanne's compositional structures demonstrates that the bathers' androgyny occurs within a set of pictorial strategies that encode sexual difference not so much on the figures themselves as in the composition of the image. Denuded of references to modern life or traditional anecdotal content, and populated by figures drawn more from the world of painting than the context of contemporary France, these highly influential modernist works nevertheless testify to

the persistence of gender distinction as one of the quintessential ways of making meaning in the modern world.

In juxtaposing such unlikely bedfellows as Tissot and Cézanne, Caillebotte and Renoir, I hope that tired formulae about significant modernist masters and conservative *juste milieu* compromisers will seem irrelevant and that the fascination these pictures exert will be felt because of the *different* ways they have of fashioning aesthetic and historical materials. Sexual difference does not discriminate on grounds of style or quality: it permeates modern culture at all levels. But it is not an homogenous entity, and visual culture does not offer an easily recognizable mirror of social relations. Refracted, distorted, disguised and displaced, sexual difference forms the very stuff of representation, imbricated in its pictorial languages as much as in the bodies and beings depicted on its surfaces. And this is as true for the anonymous photograph of a male body builder as it is for a late bather painting by Cézanne. The realization of the body in paint or print, its physical manifestation on paper or canvas, can provide a space for the body's rebellion, its somatic seepage beyond the margins of carefully demarcated roles and strictly policed desires. It is the capacity of the imaged bodies of modernity to articulate dominant social relations while managing, sometimes, to expose or erode them that this book explores.

2 Details clockwise from top left: GUSTAVE CAILLEBOTTE Oarsmen, 1877 (figure 20); PIERRE-AUGUSTE RENOIR Bather with Griffon, 1870 (figure 121); Edmond Desbonnet, body-building pioneer, early 1900s (figure 31); E. FICHEL The Kiss in the Mirror, c. 1891 (figure 87); JAMES TISSOT The Sporting Ladies, 1883–5 (plate VI); PAUL CEZANNE Three Bathers, 1879–82 (figure 155)

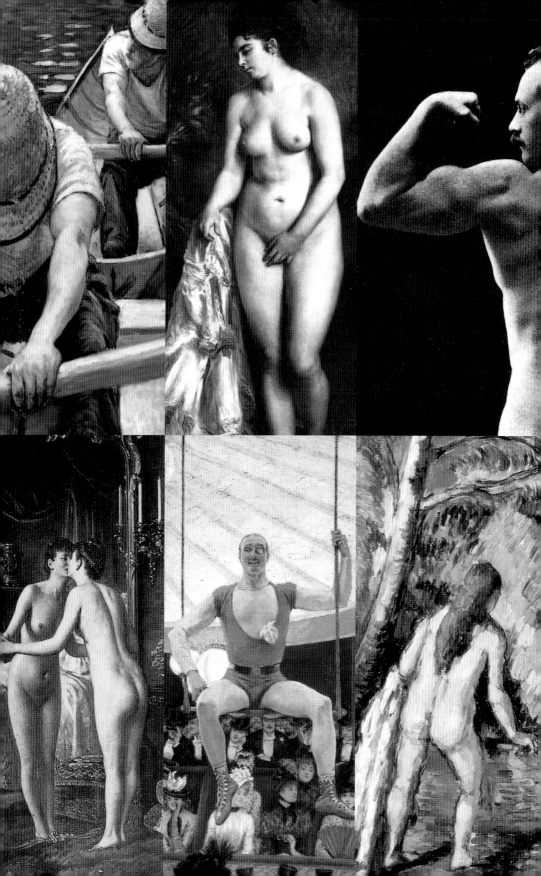

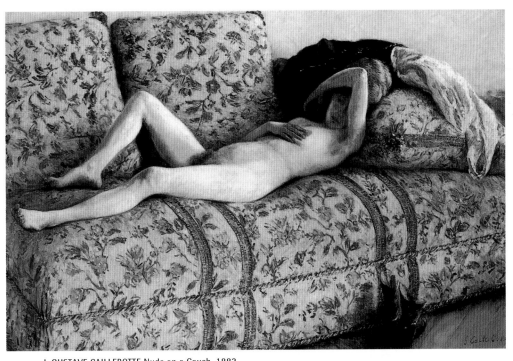

I GUSTAVE CAILLEBOTTE Nude on a Couch, 1882
II GUSTAVE CAILLEBOTTE The Floorscrapers, 1875

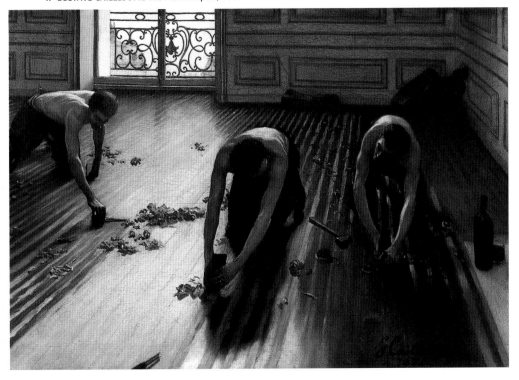

III JAMES TISSOT The Political Lady, 1883–5
IV JAMES TISSOT The Woman of Fashion, 1883–5

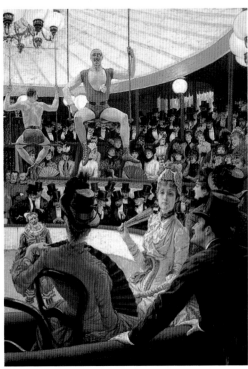

V JAMES TISSOT The Shop Girl, 1883–5
VI JAMES TISSOT The Sporting Ladies, 1883–5

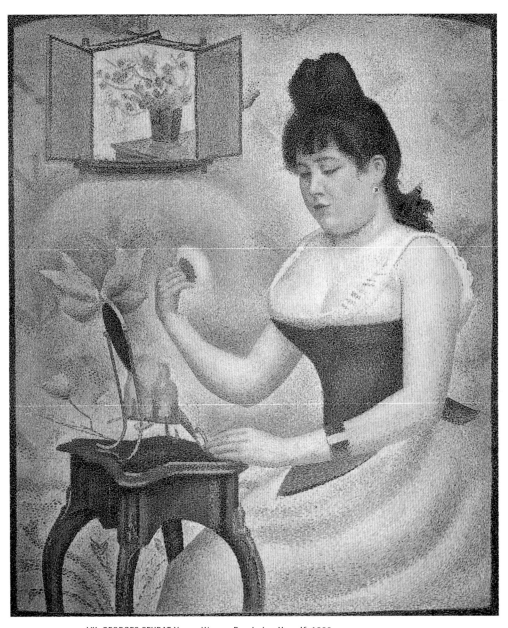

VII GEORGES SEURAT Young Woman Powdering Herself, 1890

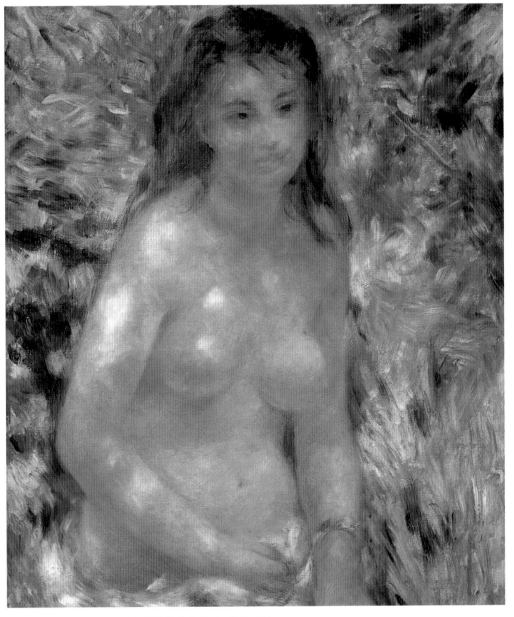

VIII PIERRE-AUGUSTE RENOIR Nude in the Sunlight, 1875–6

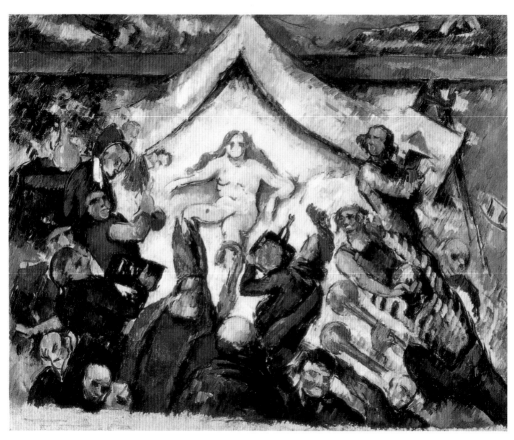

IX PAUL CEZANNE The Eternal Feminine, c.1877

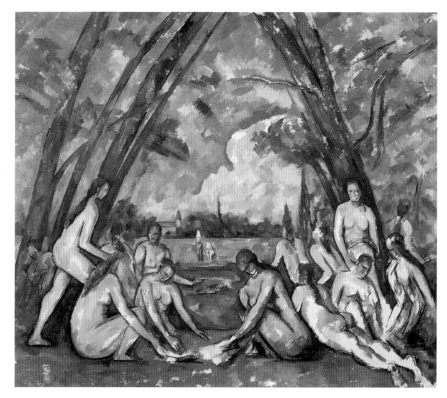

X PAUL CEZANNE The Large Bathers, 1906

XI PIERRE-AUGUSTE RENOIR The Large Bathers, 1887

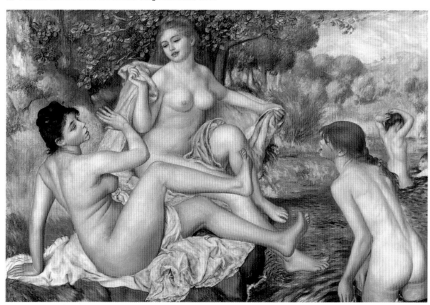

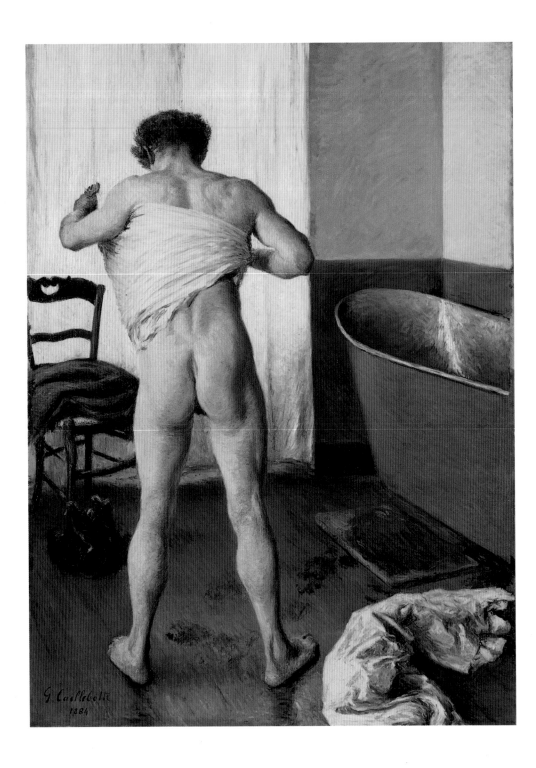

In 1882 and 1884 respectively, Gustave Caillebotte, Impressionist painter and collector, painted two of the most unconventional images of the human body produced in the nineteenth century. In each of these works he transgressed the accepted conventions for the decorous representation of the nude. In the case of his extraordinary female *Nude on a Couch* (pl. I), the earlier of the two paintings, the undressed model is slumped indecorously on a large sofa, her indolent body bearing the signs of the undergarments she has recently removed, her pubic hair flamboyantly covering her genitals, her hand lingering suggestively on a nipple. The physicality of this woman is palpable. The encounter of flesh and faded upholstery, of hair and inner thigh, of arm and face, are vivid tactile moments in a carnal world. Even the draped discarded garments and the glimpse of fiery red fabric in the dark crevice behind the model's shoulder seem to resonate with her physical presence. Her hands are rough and ruddy, the soles of her feet worn and tarnished, her toes cramped and squashed as if they have just been eased out of boots (placed conspicuously in the foreground) which are slightly too tight. This is no nymph or goddess, no ethereal other-worldly creature. Here the female figure is denuded of her conventional painterly costume: the smooth skin, flawless complexion, hairless body and idealized proportions of countless salon nudes. Realism has produced a nude for the bedroom, one which is of this world: mundane, matter of fact and uncompromisingly fleshly. While the reclining posture, raised arm and sleepy disposition recall Neoclassical renderings of the female nude (Cabanel's *Birth of Venus*, fig. 3, is a good, if obvious, example), the unidealized body, tactile paint surface and everyday setting create an image of a contemporary sexualized woman, scandalously available for scrutiny and suggestion.[1]

In the case of the analogous, and equally monumental, *Man at his Bath*, painted two years later, Caillebotte outrageously inserted an assertively naked *male* body into a prosaic domestic setting, stripping the figure of both its clothing and its traditional heroic attributes. Here, as in the female nude, the clothes are conspicuously discarded, the boots strategically placed, the body assertively naked. But whereas, in keeping

with nineteenth-century conventions, the female body reclines in a self-absorbed stupor, the male figure vigorously dries himself, body upright, feet firmly placed on the floor. As the author of these two images alone, Caillebotte would have to be considered as a major nineteenth-century figure painter, working within and transforming the genre of the nude. But where his image of Woman in the *Nude on a Couch*, however transgressive, forms part of the ongoing encounter, indeed obsession, with the female body that characterized modernist no less than academic painting, his extraordinary rendering of the male body represents something different, something so unlike the work of either his contemporaries or predecessors that it requires special attention.

The transformation of the genre of the idealized female bather (to which, as we will see in Chapter Five, Renoir was to return) into the context of the quotidian had been admirably achieved by Alfred Stevens in his suggestive placing of a contemporary woman into an ordinary tin tub, but no one, until Caillebotte, had thought to do the same for the male bather. When Gustave Courbet, for example, experimented with imaging modern masculinity, he had, at least, used the manly image of wrestling as his vehicle for displaying naked men in action.[2] These may not have connoted the heroes of ancient Rome but their gladiatorial spirit and beefy bodies partook of the same manly narrative of which epic tales were made. Caillebotte's bathing man, seen alone and self-absorbed, is doing no more than drying himself. Here, neither narrative nor circumstantial props to masculinity are evident. In contemporary academic images of the male nude, such as Jules-Elie Delaunay's *Triumphant David* (1874), the heroic narrative and idealized body construct a lofty image of adolescent manliness in which weaponry, action, pose and strategically placed body coverings contrive to create an assertively phallic image of masculinity, one in which the male body is both beautiful and complete. By contrast Caillebotte creates a setting for his model which is simple and sparse and renders the figure without any of the usual idealizing strategies to which contemporary audiences would have been accustomed. There is neither grandeur nor extravagant posturing here. Metal bathtub, wooden chair and discarded clothing seem mundanely matter-of-fact, assertively ordinary. Instead of the ideal, virile masculinity on display in the Delaunay, Caillebotte presents the actual, lived-in body of a well-built nineteenth-century man engaged in what had become, by this date, the private ritual of washing and drying himself.[3] As with the female reclining nude, the brute reality of a naked body in an ordinary room is all that confronts the viewer, and it is the paucity of conventional narrative indicators that forces attention dramatically onto the figures themselves.

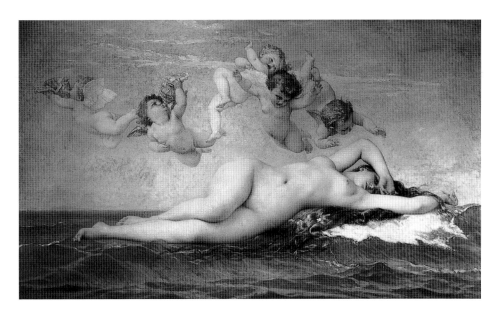

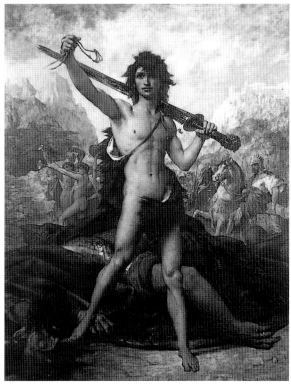

3 ALEXANDRE CABANEL
Birth of Venus, 1863

4 JULES–ELIE DELAUNAY
Triumphant David, 1874

By the time Caillebotte came to paint the *Man at his Bath* in 1884 and the contemporary *Man Drying his Leg*, a similarly non-heroic image of manliness, he had been exploring the image of modern masculinity for some fifteen years. In these two paintings he used what appears to be the same model and the same setting (even the chair and the towel are transferable from one image to another) and focused attention on the bodies that he rendered. Muscular and vigorous, the assertive masculinity of these figures belies their insertion into what had conventionally been perceived as a female environment, the juxtaposition of woman and water having a well-trampled trajectory from the traditional images of Suzannah and Diana at the bath of the past, to the nymphs and prostitutes of the present. Historically, men were more likely to have been placed in settings that enhanced their masculinity rather than threatened to undermine it.[4] The male nude had traditionally been used as a vehicle to signify abstract truths and lofty aspirations, not the mundane day-to-day functions of contemporary men. Naturalism posed a threat to heroic masculinity, depriving it of its conventional props and epic significance. In this context, it was the body itself which alone had to become the locus of men's manliness, the site for an elaboration of an invigorated modern masculinity.

It was that modern masculinity that formed the subject matter of the majority of Gustave Caillebotte's figure paintings, both in terms of the people he painted and the particular position from which he painted them. Chronicler of modern man, caught between the fabrication of his own mirror image and the object of his democratizing fantasies, he produced an image of modern man that is never exclusively either a

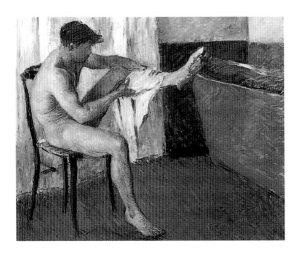

5 GUSTAVE CAILLEBOTTE Man Drying his Leg, c. 1884

6 Photographer unknown, Gustave Caillebotte boxing, c. 1880

7 Photographer unknown, Gustave and Martial Caillebotte, c. 1886

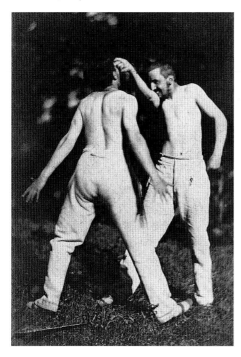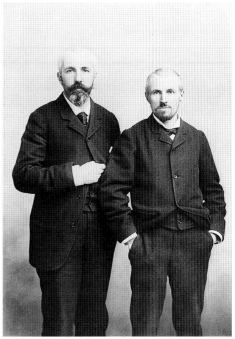

representation of the self or the other, never exclusively subject or object. Processes of identification and objectification, mirroring and distancing, co-exist in this practice. When the male artist confronts the male body in the assertively contemporary setting that naturalism demands, his own subjectivity – that is his own psychic and social position – is as visibly on display as that of the model.[5] For in this context, the encounter with the other is always simultaneously (and explicitly) an encounter with the self, in the recognizable arena of the present.

Two small anonymous photographs from the 1880s serve to demonstrate some of the possible splits and gaps in the subjectivity of a nineteenth-century man such as Gustave Caillebotte. Each represents Caillebotte with a male companion. In the earlier image he is shown semi-naked and engaged in an energetic boxing match with an opponent whose flexed muscles, moving hands and recoiling gesture suggest that he has either just received a blow or is engaged in exuberant, boyish play-acting. The men confront each other head on, their bodies are open to one another, their legs cross over one another, their faces are uncomposed, laughing, grimacing, expressive. The uninhibited physicality which this picture represents is in stark contrast to the static, clothed and respectable posture struck by Caillebotte and his brother in

the later photograph. Soberly attired in the uniform of bourgeois respectability, faces masked and composed, feet firmly set on the ground, the Caillebotte brothers look out at the viewer with an assertive and confident demeanour. In fact it is hard to tell from the photographs alone that the dignified, firm-lipped man in the double portrait is the same person as the wildly gesturing, smiling pugilist in the other image.

Promoted as an aristocratic sport in nineteenth-century France by a number of important literary figures, boxing nevertheless was still widely regarded as a plebeian pastime, associated with the popular entertainments of fairgrounds, public spectacles and brute force.[6] A bourgeois gentleman participating in this sport had to be exercising a certain amount of class irony, which paradoxically could claim impeccable credentials, having as its alibi the activities of the ancients as represented in sculptural groups such as the famous Wrestlers of Antiquity.[7] The alleged bravery and physical prowess of the ancients were used as a defence of contact sports in the second half of the nineteenth century, when they were promoted as a means of countering what was widely thought to have become the lamentable 'effeminacy' of modern man. The men of the Third Republic, announced protagonists of wrestling and boxing, 'despised their fathers who ... had allowed the French race to degenerate, by gradually abandoning all healthy and fortifying exercise which in antiquity had produced such robust men'.[8] Engaging in boxing for the *haut bourgeois* was never a simple form of self-expression. It involved a certain amount of 'playing rough', of acting out a rude and brutal form of behaviour associated with working-class culture. In the identification of his own body with that of the combatants of old or the fighters of the present, the respectable *homme du race* could imagine an alternative way of being, one which was not circumscribed by the trappings of bourgeois masculinity.

It was, however, in the context of bourgeois constructions of masculinity that Gustave Caillebotte had been formed and it was through the image of his own social group that he described a crucial aspect of his identity, whether represented in the solitary standing figure framed picture-like through the window of his family home, distracted, detached and yet witness to the spectacles of Paris, as in the *Young Man at his Window* of 1875, or in the subtle intimations of a self behind or beyond the picture space, as in the stiflingly formal *Luncheon* of 1876. Here the artist's brother and mother and the family butler are shown at dinner with the half-moon of the plate and knife in the forefront like a palette and palette knife, standing for the hidden presence of the artist, son, brother and witness, who is both part of and apart from

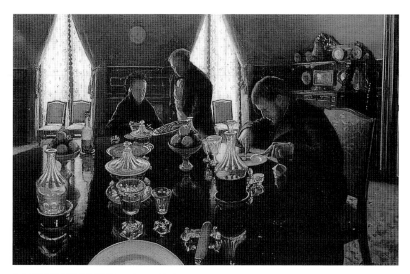

8 GUSTAVE CAILLEBOTTE Luncheon, 1876

the world that he pictures. In images like these the cold austerity of middle class social rituals and bodily comportment is vividly suggested. In the *Luncheon*, the interior seems to close in on its occupants, whose formal dress, hunched and uncomfortable physical presence, lack of visible communication and sparse meal speak of a culture in which the realm of desire and the satisfaction of physical needs has little place. The material accoutrements of bourgeois life and ritualized, well-mannered encounters evoke a silent world of sober respectability, carefully controlled passions and curtailed physical expression, broken only by the incessant ticking of the clock whose rhythmic pulse beats out the slow passing of a regulated life. The artist's plate is significantly empty, his participation in the event half-hearted, humourless and yet obsessively fascinated.

It was the silent and intent diner of the *Luncheon*, Caillebotte's younger brother René, who had been the model for the slightly earlier *Young Man at his Window*, now looking out from the same apartment on to the boulevard below. The rigid, erect stance of the standing figure at the window (the exact back view of the pose that Caillebotte had struck in the photograph with his brother) is static and controlled. Sealed from view both by the sobriety of his dress and the elevated vantage point from which he peruses the street, his gaze almost tangibly fixes on the passing figure of a woman in the virtually deserted street below. The shadowless, crisply outlined form of the man is disciplined

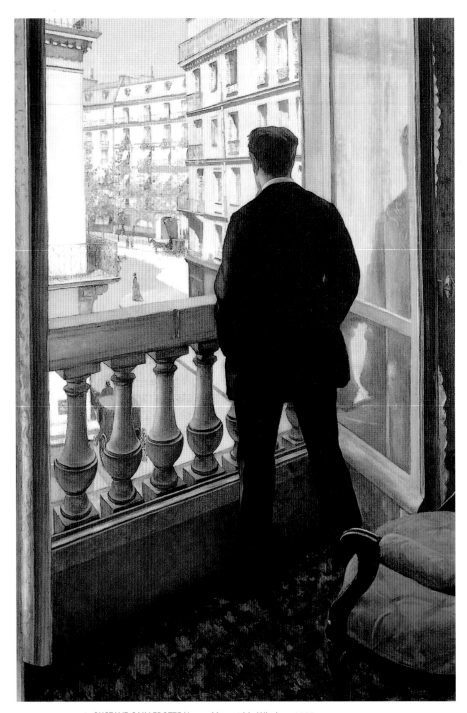

9 GUSTAVE CAILLEBOTTE Young Man at his Window, 1875

and contained. Only the reflection, fringed with the lace of the feminized interior, gives a sense of a self that seeps out of the boundaries of its phallic defensiveness, its strutting, spread-legged, solid foundations.

Robert Nye has most coherently analysed the subjectivity of the ruling-class males of the nineteenth century, that social, political and economic élite to which Caillebotte belonged. Nye has shown how the primordial qualities of manliness as exemplified in the noble gentleman were adopted and adapted by middle-class men.[9] The codes of honour and comportment of the aristocracy, he demonstrates, were taken over by the emergent upper-middle-class élite and expressed themselves in public life, the political arena, sports and even the duel, a way of settling differences between men that remained popular throughout the nineteenth century. One of the areas in which the nineteenth century differed from the *ancien régime* was in the emphasis placed on marriage and the greater control of reproduction and sex. Where heredity and lineage had conferred identity and power in earlier centuries, the bourgeois needed to assure himself of a successor who would preserve and augment a legacy that had been built with industry and skill. The self-made man knew that he could easily lose all that he had carefully built up if he did not take steps to safeguard it. The rules and precepts governing marriage, reproduction and family life were tightened and codified in the nineteenth century, therefore, and this ossification of the bourgeois family as the principal social unit was accompanied by a demand for an ultra-virile masculinity which would guarantee and preserve it. The honourable bourgeois man was assertively masculine both in his secondary sexual characteristics and in his capacity to reproduce. Indeed the degree to which his masculinity was demonstrated by his body served as a guarantor of his virility. An ample moustache, for example, could be seen as testifying to a 'manly temperament'.[10] The ideal virile man would be, in the words of an early nineteenth-century commentator, 'dark, hairy, dry, hot and impetuous', his perfect partner commensurately 'delicate, moist, smooth, white, timid and modest'.[11] Men should, it was widely agreed, demonstrate deep voices, a developed musculature, a ruddy complexion and a beard, and possess the qualities of courage and generosity. It was in the vital force contained in precious seminal fluid that these qualities were to be found and through which they were to be carefully dispensed.[12] Male potency was connected with national power and progress. There was no possibility of the latter without the careful preservation and protection of the former.

Male public behaviour was also crucial in establishing a man's ability to fulfil his masculine role: his participation in male social rituals,

male institutions and the defence of male honour all signified in the matter of his masculinity. For the bourgeois male, the private domain of sex and the public one of work required similar efforts of self-discipline and self-control if honour was to be attained. Those men who could not or would not fulfil their responsibilities to the institution of the family were deviants. Chief among these were homosexuals, or inverts as nineteenth-century French experts called them, and bachelors, each in their own way betraying the destiny of bourgeois society by refusing to reproduce the institution of the family as it had been set up by society and codified by law. The bachelor could in some ways be seen to be even more suspect than the 'sodomite', for whereas the latter was widely thought to be 'sick' and obscene by nature, the former was wilfully perverse. He was motivated by a selfish and immoral disregard for the well-being of the Nation which led him to act against 'Nature' and against the interests of society.[13] By disrupting the sexual economy and refusing to spend their sperm productively, both bachelors and homosexuals threatened to upset the whole bourgeois order and thereby to contribute to a nation of enervated men whose manliness had been depleted through the wastage of a commodity that was vital for the perpetuation of the French Nation.

During the 1870s and '80s, in the aftermath of France's humiliating defeat by the Prussians in the Franco-Prussian War, fears about the emasculation of the French population reached a crescendo.[14] Military defeat, it was believed, had proven that French males were a pitiful lot, physically timid and indulged, and morally weak and self-serving. What was even more alarming than the current state of French masculinity was the fear that the population was declining and that the future of France looked increasingly precarious both because of the fall of the birth rate and the fact that fewer boys were being born than girls. It was to contemporary men that many commentators turned to remedy the situation. As the active agent in the reproductive process (sperm were thought of as dynamic, aggressive little fellows) it was the poor quality of the male's generative material that was responsible for a couple's failure to produce viable offspring. A healthy, virile and manly man would, it was believed, be more likely to produce healthy male children. Men were asked therefore to be thrifty in their sexual encounters, concentrating their attentions on their wives, whose role it was to be passive receptacles in the reproductive process. Any woman who deviated from this role (feminists for example) were ostracized and ridiculed as manly women even as their male counterparts (those with puny physiques, neurotic dispositions or no progeny, for example) were perceived as feminized men.

The defence against feminization and emasculation mobilized by bourgeois men is represented during the late nineteenth century both in the development of a renewed interest in the physique and health of the male body and in a form of dress which was meant to signify male power while it simultaneously defended against male lack. Men, in the nineteenth century, were required to 'dress'. Formality and form counted even if the flamboyant exhibitionism of the *ancien régime* was no longer permitted. The obligatory dark male costume, relieved only by the white shirt, elaborate neck-tie and pale gloves, expressed the new values of egalitarianism and stood for the the unified front of an enfranchised masculinity free from the sartorial and social dictates of the pre-revolutionary period. The eschewal of colour and ornament signified the renunciation of excess and luxury associated with aristo-cratic decadence. The 'triumph of black', as French social historian Philippe Perrot has named it, stood for a new political and social order, a new ethics founded on austerity and merit, work and the careful guardianship of money and property. Decency, effort, sobriety and self-control were the new bourgeois values, and the rejection of flamboyant costume, jewellery and decoration amounted to a stoical, masculine defence of propriety and property. In the words of the late nineteenth-century Republican arts administrator and historian of art and dress, Charles Blanc:

> If in our age a uniform costume has succeeded the intentional vari-eties which were the outward marks of social distinctions, it is because uniformity is now an external declaration of the principles of civil equality and liberty, inaugurated in the world of the French Revolution. I say Liberty, for formerly everything was regulated, settled and classified according to the laws of rigid etiquette. The royal laws of Louis XIV laid down regulations for the toilette as well as for commerce, industry and literature ... the costume of Frenchmen was at that time subject to regulations.... Velvet, satin, frieze and cloth were to be worn in winter, silesias and camlets in spring, and taffetas in summer.[15]

In bourgeois France, distinctions of class and breeding had to be expressed in the detail: in the cut of the suit, the quality of the cloth, the whiteness of the shirt. Hats, gloves, umbrellas and canes were the essen-tial accessories of the gentleman. Much rested on subtle distinctions in bearing, deportment and manners. Professional distinctions could still be sartorially coded and no one had any problem distinguish-ing between a cleric, a soldier, an artisan and a civilian. But among the

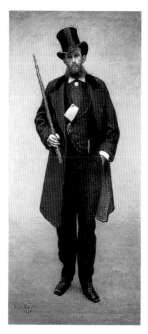

10 GUSTAVE CAILLEBOTTE Portrait of Paul Hugot, 1878

multitude of middle-class men, both elevated and lowly, uniformity rather than difference was stressed. Clothing served to conceal men's bodies rather than to draw attention to their corporeal idiosyncrasies. They were armoured and protected in their pantalons, coat tails and buttoned-up presences.[16] Jewellery became associated with women and 'inferior peoples', the mark of a civilized race being measured by the extent to which it renounced such frivolous excesses. 'In proportion to their elevation above savages', wrote Charles Blanc, 'men disdain jewels, leaving them for women. They only retain those worn as remembrances, emblems of attachment and fidelity, jewelled and wedding rings, lockets, trinkets, or rich scarf pins, which excuse their beauty by their utility'.[17] Modern man was, ideally, an altogether sober creature. Rigid, upright, serious and formidable, his austere presence and plain exterior testified to the strength of his character and the elevation of his purpose. Sheathed in his dark costume, a substitute skin without blemishes, wrinkles or tantalizing tints, he was to be judged by his actions rather than his appearance, by his bearing rather than his body.

As the psychoanalyst and historian of costume J.C. Flügel has argued, the phallic symbolism of nineteenth-century bourgeois male attire served men as a defence against castration anxiety, castration of

11 GUSTAVE CAILLEBOTTE Portrait of Jules Dubois, 1885

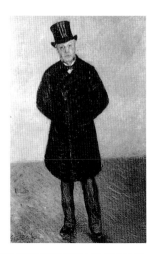

12 GUSTAVE CAILLEBOTTE Portrait of Jean Daurelle, 1887

course standing for more than physical loss and representing a loss of social and psychic power.[18] Individual garments and attributes, walking sticks, pipes, top hats and indeed the whole austere columnar structure of the male costume itself, could, for Flügel, stand for that very organ which men feared to lose, an organ over-valued for its apparent capacity to stand in for the phallus, symbol of power itself.[19] The very costume of urban masculinity, so confidently worn by Caillebotte's prosperous friends like Paul Hugot and Jules Dubois, insulated men of their class from the psychic vulnerability that was the inevitable condition of human consciousness, conferring on men the illusory comfort that the collective identity of their class and gender was a protective shield which would reliably provide them with a defence against being the objects of scrutiny. Caillebotte's bearded friends, whether posed in indeterminate space or seated in the comfort of the bourgeois interior, give the appearance of having their masculinity intact. Just how fragile this defensive posturing could be though is demonstrated in pictures such as *Interior, Woman Reading* of 1880 in which the reclining man, for all his male attire and copious facial hair, becomes an object of ridicule through his shrunken physical presence, engulfed, as he appears to be, in the patterned and assertively domestic sofa and dwarfed by the female figure in the forefront whose reading matter, even, seems to cut his down to size. The discrepancy in size between the two figures did not, of course, go unnoticed by contemporary viewers. Cruelly referred to as a 'General Tom Thumb', or a 'toy', the male figure was even seen, by one critic, as the child of the woman. In the words of Paul de Charry,

writing in 1880: 'The poor woman has given birth to a monster and is obliged to keep it near her; it is a quite small (grown up) fellow lying on a sofa by her side; she has neglected nothing in his toilette, has given him a newspaper to read; but the effect produced is unimaginable; it's as though one were in front of a side show at a fair, and one cries out despite oneself: Enter, ladies and gentlemen! Come see the little dwarf and the giant lady!'[20] The discrepancy in scale threatens to throw the whole world upside down. The private face of commodious bourgeois life risks becoming a grotesque parody of itself as fairground faces front room and freak show confronts fashionable society.

This then was the world into which Gustave Caillebotte was born: a world of wealth, leisure and status and one in which masculinity, for all its actual and symbolic power, was still structured around certain forms of psychic defence, expressing itself in social rituals and forms of self-

13 GUSTAVE CAILLEBOTTE Interior, Woman Reading, 1880

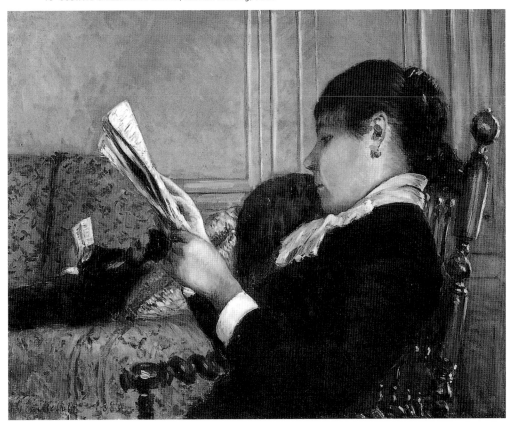

representation that were designed to guard against the suspicion that that power was both fragile and illusory.

How easy it was for the trappings of power to substitute for a power that had no legitimacy. That Caillebotte knew this, on some level, is evident in his manipulation of class costume to effect. When in 1887 he dressed up the family steward Jean Daurelle in the top hat and outer coat of the bourgeois for his portrait, Caillebotte seemed to be suggesting that there were no essential qualities possessed by a class that conferred upon it either rights or privileges.[21] Indeed it was only the appearance of things that established a class hierarchy, and this could be easily unsettled. Both through his work and leisure activities, Caillebotte lived in a way which gave him the opportunity to escape his class boundaries, allowing, however temporarily, for some suspension of his life as a gentleman. He was a keen gardener, for example, and when at home in his estate at Yerres would often dress in gardener's clothes, as contemporary photographs testify. Some of his most poignant images of labour are those of men working in the garden at his family home. In *The Gardeners* (1875–7) the bare-footed figures who tread on the flat earth and tend it with their hands and labour are rendered with a solemnity and dignity which is almost reverential. Paint and water gush from the watering cans onto the plants, the one substance standing for the other, productive, nourishing, abundant. The bourgeois landowner admires his property and surveys his employees, even as the naturalist artist reveres their toil and delights in the visual analogies and puns that the scene suggests.

14 Gustave Caillebotte with his gardener at Petit Gennevilliers, February 1892, photographed by MARTIAL CAILLEBOTTE

15 GUSTAVE CAILLEBOTTE The Gardeners, 1875–7

As we have seen, Caillebotte lived out an ambivalent and conflictive relation to his own class identity. While never eschewing the privilege into which he had been born, he was also never entirely subsumed into it. By that I mean that he always amounted to more than his money could afford, and less, in conventional terms, than his prescribed position demanded. As a bachelor and childless man, he occupied the position of a deviant and non-productive male, one whose masculinity had not been turned to the common good and remained always, therefore, in question. As a bourgeois who spent many hours a day in serious but non-lucrative physical work, he confounded accepted distinctions between labour and leisure. As a painter sympathetic to what was widely believed to be a radical and transgressive school of artists, he was estranged from establishment art institutions and professional bodies. And as a naturalist artist who was also an extremely rich man and generous patron it was never clear under what terms his fellow

Impressionists accepted him into the group: as a painter of quality and distinction and an equal, or as a rich benefactor whom they could not afford to offend.[22] He was, therefore, part of and yet apart from a number of different worlds. His wealth and privilege gave him the freedom to transgress social boundaries while his sympathies with the radical representatives of his own generation made him unable to live out his social destiny in the prescribed ways.

It was those sympathies that enabled Caillebotte to view the bodies of working-class people as a legitimate subject for his art, and it was in the context of realist and naturalist debates about the figure that his decision to paint heroic images of urban artisans makes sense. But there is something more than just the conventional modern-life pretext for the revamping of an exhausted tradition of figure painting in the uses to which Caillebotte put the modern, artisanal male body. He never, it seems, painted female workers in any significant way, so it was not just as a reliable chronicler of contemporary life that he painted tradesmen and artisans. Rather there was something about the labour of these men with which he could identify, something about their manly sociability and common purpose which he idealized and something about their bodies which made them an object of fascination, of desire. Although Caillebotte did not need to earn his living from the toil of his own body, his choice to become a realist painter and his commitment to naturalist aesthetics involved a physical engagement with the world, one which went beyond the supervisory gaze of the bourgeois employer. While the work of the bourgeois left his own flesh unscathed, that of the artisan, the craftsman and the labourer made its imprint on the body, marking it out as different. The artist occupies a curious midway point between these subject positions, and the worker can function for him as both surrogate self and ineluctable other. Identification and objectification operate simultaneously here. And while the artist's work is solitary, the communal nature of much artisanal labour made it a vehicle for the expression of a common endeavour, of a dream of collectivity akin to the one which Caillebotte had hoped to foster among his own professional peers in the Impressionist group exhibitions, but which was to become eroded by conflicting interests, commercial crises and personal antagonisms.

Caillebotte's identification with his worker subjects is figured in their labour, in their tools and in the physical traces on the surface which their labour produced. These, ultimately, are painted traces where the physical presence of the paint and the iconic significance of the image work together to invoke both the active hand of the artist (his work) and

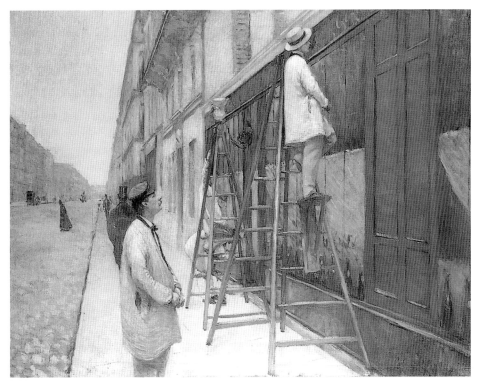

16 GUSTAVE CAILLEBOTTE House Painters, 1877

the labour that he images (their work). Perhaps this process is most literally figured in the paintings and many sketches on the theme of house painting that Caillebotte produced in the mid- to late-1870s. The analogies between house painting and art making are easy to see – the covering of a flat surface, the decorative ambitions, the careful measuring and planning of the design, the physical agility, balance and control needed, the back-breaking attention to detail, the mixing of pigments, the manual nature of the task. But there are of course significant differences in terms of the values attributed to each kind of work, the function of the end product and the construction of the identity of the worker. Of course, Caillebotte's social position was more obviously reflected in the casual bourgeois passer-by who walks away from the scene of the painters than in the smocked artisans who do the work in the foreground. But the attention that he pays to the worker's task tells of a closeness of observation which is highly invested and charged. As he mixes his own pigments, squares up his studies and surveys his work,

activities analogous to those that he represents, Caillebotte cannot but see himself projected into the bodies of those workers, figures who in this instance seem to stand so much more securely for the artist than the top-hatted gentleman who has just passed by. Indeed the letters, shapes and colours that the house painters have placed on the flat surface of the house are traced and recorded in paint on canvas by the artist who seems to echo their activity in the act of composing and recording their labour. The painted mark stands both for the labour of the artist and that of the house painter. In their painstaking application of a sticky substance to a surface, they share a physical relationship, however temporarily, to the world.[23]

The parallels suggested between house painter and artist are obvious. Less clear is the process of identification to be found in Caillebotte's monumental images of the backbreaking job of floorscraping, which he had explored a few years earlier (pl. II). Here, he had found a subject in which the labouring body itself could be made as much the focus of attention as the labour it performed. The clean-shaven faces, taut muscularity, elongated arms and sinewy torsos of these crouching, tense, semi-naked men occupy a world apart from the erect sobriety of bourgeois masculinity. These men have entered into the world of the bourgeoisie to sell their labour. On all fours, spread-legged, lean, animal-like, they perform their task. The smell of sweat, alcohol and dust pervades the grand room with its panelled walls and fancy ironwork as the men work to restore a polished harmony to the damaged bourgeois interior. Faces in shadow, hidden from view, they exchange furtive glances which exclude us, their surrogate employers who have walked in on them as they work. Their hands, so painstakingly observed by the artist in a number of studies, grip, pull and scrape away the old or wet layers of polish to reveal the young wood underneath. Rough, stained and scarred, the men's labour is vividly inscribed on their toiling bodies. Such work was painful and exacting, as all nineteenth-century observers of labour knew. The hands of the floorscraper or *raboteur* were characteristically scarred and damaged, as a nineteenth-century photograph by Albert Londe, official photographer at the Salpetrière, demonstrates. The *raboteur*, argued criminologists, could be identified by the particular deformation of his fingers, thumb and palm, where the task left its inevitable mark on the body.[24]

There was nothing easy or decorous about this job. It was hard physical labour and anyone who observed these men at work knew this. To paint the labour of these men was a truly realist gesture, one in keeping with the spirit of Courbet and Manet, wrote one critic.[25] Vulgar as the

subject is, wrote another, 'we can understand how it might tempt a painter. All those who have had the pleasure or the bother of having a house built know the way these robust fellows work, unabashedly putting aside any encumbering outfit, leaving only the most indispensable clothing, and thus offering to the artist who wants to make a study of the nude, a torso and a bust that other trades do not freely expose'.[26] For the critic and Salon audiences, the artist is positioned as a fellow bourgeois, the harassed houseowner or employer who hires the models and potentially the labour that he depicts. The depiction of labour and the scrutiny of the working-class body were the prerogative of those who did not themselves use their bodies to earn their livelihood. This framing economic reality makes possible a potential objectification of labour, a distancing of the body depicted from both the artist and viewer, and a lack of empathy and imaginative projection into the position of the model/worker. It is this distance that we hear in the voice of those critics who lamented the lack of idealization in the muscular but thin bodies.[27] To them these men were ugly, vulgar, debased. But for an artist as self-consciously aware of the physicality of his *métier* as Caillebotte, the arduous physicality of the work he depicts provides a point of contact between his own body and that of the labouring men. Indeed the knife, enigmatically entering the picture space at the front of the *Floorscrapers*,

17 ALBERT LONDE 'The Hands of Different Trades', from La Photographie Médicale, 1893

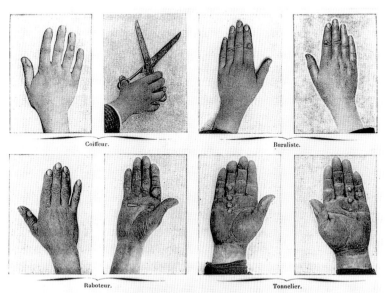

functions both as a floorscraping tool and as an emblem of the artist's hand. It projects from the space outside the canvas, the artist's space, towards the circle of men depicted on it, connecting thereby the artist with the work and workers he pictures. Tools in fact form one of the major linking elements in the composition, providing not only convincing realist detail but a chain of connection between the men, asserting both their common task and physical proximity. The figure on the far right is linked to his neighbour by the hammer while the figure to the left is linked to the central figure by his sharp implement. The clear connection between the figures makes of this a shared activity, a unified form of social action and interaction, and the foreground knife provides a potential way into the community for the male artist/artisan in front. Further, the marks and imprints that the scrapers make on the surface of the floor are lovingly traced by the artist's brush. The brush follows the rhythm of the plane and blade marking its imprint in paint, carefully delineating the direction of the woodgrain and cracks between the boards. Floorscrapers and artist are united in the physical nature of their *métier* and Caillebotte follows his realist predecessors here in proclaiming painting as, above all, a concrete art, a material practice.

Illusory as such an identification had to be (what similarities in life and status could there be between a wealthy landowner and a lowly floorscraper?) it was probably one of the reigning myths of Caillebotte's life and one without which it would not have been possible for him to imagine himself as an artist. But the ludicrous aspects of such an identification were picked up in a distasteful little caricature published by one contemporary in the 1880s. Here Caillebotte is indeed represented as a

18 Anonymous, Caillebotte as a Floorscraper, c.1882
19 Photographer unknown, Gustave Caillebotte with some of his boating friends, c.1877

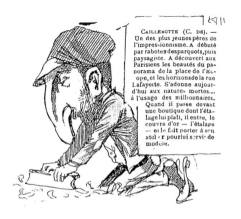

floorscraper. The mocking inscription describes him as 'one of the younger fathers of Impressionism' who while starting out as a floorscraper went on to become a landscapist. 'Today he devotes himself to still-lifes in the manner of a millionaire. When he passes the front of a store which pleases him, he enters, buys it and has it delivered to his studio to serve as his model'. The disjunction between the class position of the model and that of the artist was too much for this commentator to take. Realism is here conceived as an indulgence of the privileged. Placing his 'millionaire' in a cloth cap and equipping him with a floorscraping implement, he furnishes him also with a large nose, an antisemitic signifier of wealth and exploitation.[28] It is the nose that belies the integrity of the costume, exposing the floorscraper and artist as a fraud and an impostor. The identification is here revealed as illusory, a sham.

The lean masculinity of the *raboteurs* had provided Caillebotte with the opportunity to represent the unidealized body of the worker: muscular, pared-down, unindulged but strong. The rigid combination of muscle and bone revealed in the directed daylight presented an image of a frugal and yet fortified masculinity, one which though under strain from alcohol and hard work had not been diminished by a life of indolence or luxury. This was, in a sense, a noble masculinity, one worthy of a realist painter committed to chronicling the changing landscape of his own urban experience. But it was not a masculinity that the artist could easily occupy, for all his identification with the labour he pictured and fascination with the bodies it produced. Rather, there was another arena, one that served as a bridge between the toiling bodies of the poor and the leisured bodies of the rich, which offered Caillebotte the perfect site for the expression of a physically revitalized masculinity. This was the sporting body, the body strained by the physical exertion that leisure could afford, the newly idealized body of the modern enfranchised male on whom the future of France was said to depend.[29]

As we have seen, Caillebotte had himself photographed stripped down to the waist and engaging in a bit of playful boxing in the early 1880s. Interestingly enough, one of the other records that we have of his physical activities is a photograph of him posed casually with his boating friends and dressed in the characteristic oarsman's costume. Caillebotte was a devoted boatsman. He designed boats and sailed them, both for pleasure and competition. Rowing and boating were becoming increasingly popular during his lifetime and were promoted as a 'useful, moral and salutary' form of exercise by the moralists of his day.[30] Enthusiasts hailed it as an activity which allowed the lungs to fill up with fresh air, and the body to develop muscles and strength, work up

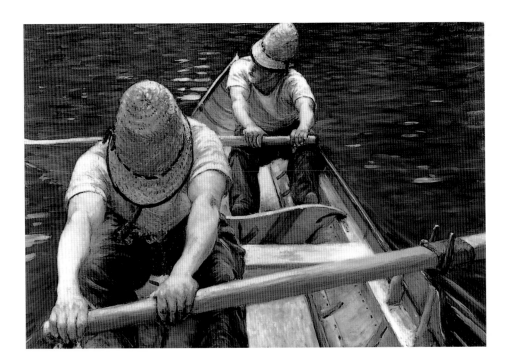

an appetite and become generally healthy. But even boating could not escape the frictions and fractions of class difference and was simultaneously claimed as the serious, high-minded sport of the bourgeoisie and the decadent pleasure-seeking form of entertainment of the vulgar, those raucous day-trippers who bathed along the Seine and made use of the hired boats that Monet and Renoir had so liked to paint. These figures were the butt of contemporary satire, their drunken, salacious revelries horrifying serious adherents to the sport.

Serious boating, the subject of Caillebotte's paintings of the mid-1870s, was an exclusively masculine activity in which strapping, well-fed, ruddy-faced, middle-class men, dressed in the appropriate costume, flexed their muscles and heaved their way along the water. These are the muscles produced by exercise rather than labour. They are lightly contracted and tense, luxuriantly rounded and narcissistically displayed. Like the clothing of the new bourgeoisie, they offer their own defence against nakedness, symbolizing a reassuringly tough and hard masculinity, one that was won through effort and exertion. Semi-naked, by contemporary standards, the body of the bourgeois oarsman offered a male modern-life painter a perfect focus for the study of an ideal modern masculinity: vigorous, active and purposeful. But only in their semi-

nakedness did they perform this function. Boating in everyday attire, top hat and all, could look faintly ridiculous, as a caricature of *Boating Party* of 1877–8 demonstrates. Here the rower's top hat is transformed into a chimney stack spewing out steam and pointedly referring to the new industries and communication systems through which bourgeois leisure time had been bought.

Such were the risks that the painter of modern life faced. The heroic could always collapse into the banal. This was particularly the case with the male nude, traditionally the subject of heroic actions or the repository of ideal beauty. The demand for contemporaneity in the depiction of the figure denied the body the trappings that had lent it stature, the swords, spears, cloaks and daggers of history painting, while the demand for naturalism denied it the classicizing and idealizing protective sheath which had made of it the symbol of a spiritual as well as a physical beauty. Realism had altered all that. Now the body had to be both life-like and credible according to the new rationalist criteria of the day. What this put at risk was the potential of the body to signify the power and potency that patriarchal culture continued to confer on its masculine subjects.

It was, as we saw at the start of this chapter, in the insertion of a male figure into a domestic bathing scene that Caillebotte made one of the most radical contributions to the reformulation of the genre of the male nude. While academic studies of the figure and classical precedents are referred to in the pose of *Man at his Bath*, the mundane setting, unidealized body and painterliness of the surface defy such allusions. Caillebotte's figure is placed uncompromisingly in the present. The existence of a permanently installed, large metal bath-tub in the corner of the room confirms this as a modern interior space in a well-heeled establishment. It was only the wealthy who had bathrooms installed in

20 GUSTAVE CAILLEBOTTE Oarsmen, 1877
21 DRANER (JULES RENARD) (Steam)boating Party, from Le Charivari, 23 April 1879

their homes during this time and though bathing was by now accepted as the primary means of cleansing the body, most of the population still used public bath houses or rivers for the purpose. While men of all classes partook of swimming as a pleasurable leisure pursuit, modesty and the fear of being observed prevented 'respectable' women from doing the same and bathing, even in private, still remained a potentially compromising activity for bourgeois women. As late as 1900, one woman spoke of 'plunging into water' as 'pagan, even sinful' and many upper-class girls were still bathed in their nightshirts in 1900. Greater freedom to reveal the body was allowed to men of all classes. Caillebotte's outdoor bathers in their striped bathing suits and rural setting are shown engaged in a leisure activity rather than in an act of cleansing the body. In his *Man at his Bath*, though, the emphasis is on preening and purifying a healthy, virile, manly body as an unglamorous, ordinary and regular activity. Friction generated by rubbing the body was regarded as an additional means of cleansing the skin and the 'man at his bath' is shown to approach this activity with appropriate concentration, determination and seriousness. The white towel is firmly grasped in his hands and seems to be moving methodically and vigorously along his wet back. His stance is solid and his feet are squarely placed on the plain wooden floor. Caillebotte has taken pains to root his figure in this setting. Not only do the figure's feet cast shadows on the textured floor but his wet footprints trace the messy path he has taken across its surface, invoking the abundant presence of water in this assertively modern domestic context. The model's body is erect and solid, buttocks tense and clenched, back slightly bent forward, scrotum outrageously visible, as if the manliness of this man, so evident in his well-defined muscles and sturdy open-legged stance, needed underlining, even affirming.

The ease with which this man occupies the space, his flagrantly displayed bottom and glimpsed genitals, make him appear uncompromisingly manly, and yet the question of his 'masculinity' remains laden with anxiety. The view from the back constructs a potentially vulnerable image of the male figure. Granted, the taxing problem of indicating the male genitals without actually showing them is not so vividly posed, but the depiction of the buttocks presents its own problems, proffering, as it does, a part of the male anatomy which is penetrable and therefore symbolically feminine. In a culture in which only the phallus dispenses identity and the penis is so easily taken as its representative, the absence of the male organ immediately invokes its opposite, either the necessarily different and castrated other, Woman, or the disastrously disempowered male who is the object of sodomical fantasy. In the famous, if

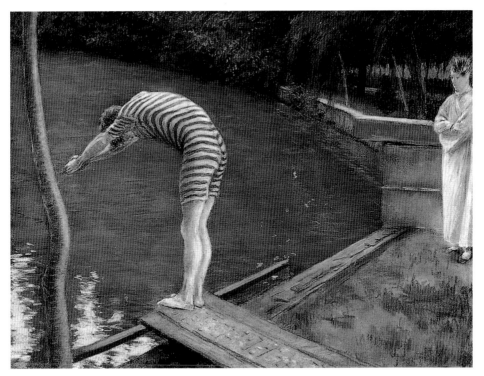

22 GUSTAVE CAILLEBOTTE Bathers, 1877

contentious words of the gay theorist Guy Hocquenghem, 'Seen from behind we are all women; the anus does not practice sexual discrimination'.[31] Caillebotte's rendering of the bather's buttocks is interesting in this regard. While undoubtedly a man's behind (shape and musculature make this clear) Caillebotte nevertheless seems unconsciously to focus attention on fantasies of penetration in his curiously displaced but overtly sexual inscription of an orifice at the top of the buttocks. Just above the line formed by the two clenched cheeks, the oval shadow of the small of the back, emphasized by fleshy pink brushstrokes, draws the eye in as if to an opening suggestive either of the female sexual organ, thereby affirming the feminization of the pose and domestic setting, or of the hidden anus, the devalued locus of a forbidden sexuality, one which was profoundly threatening to normative late nineteenth-century social structures. By asserting the penetrability of the male back view, Caillebotte unconsciously problematizes the 'healthy' masculinity so insistently invoked in the muscled body and glimpsed testicles of his bathing figure.

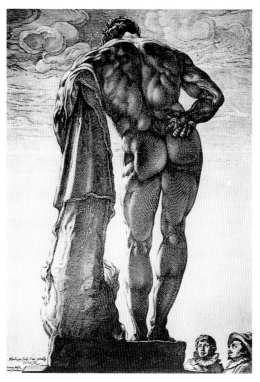

23 GOLTZIUS The Farnese Hercules, sixteenth century

Traditional ways of asserting masculinity from the back relied on exaggerated musculature, as exemplified in the quintessentially macho *Farnese Hercules* in which the cheeks of the bottom are almost squeezed closed by the contracted muscles of the buttocks and upper thighs. More feminized versions of the male rear end do of course exist in the idealizing Neoclassicism of early nineteenth-century France, where figures of youthful beauty and extraordinary powers are provided with the gentler contours of the Apollonian ideal and their ephebic beauty is allowed to remain a focus of erotic attention. We see, in these examples, neither the clenched muscles nor the outrageous glimpse of the male genitals which Caillebotte conferred on his figure.[32] Caillebotte's bather, on the other hand, is both assertive in his masculinity (the musculature and genitals far exceed the feminized contours of the ephebe), while flagrantly displaying the potentially vulnerable feminization of the male rear view – its penetrability.

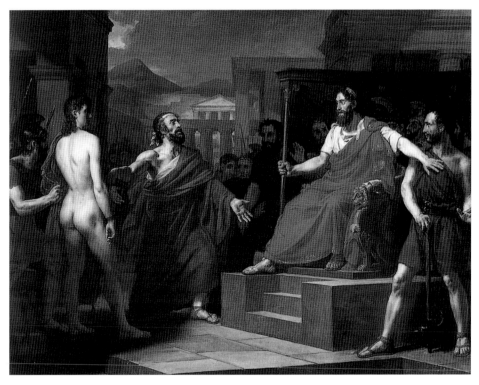

24 ELOI-FIRMIN FERON Pythias and Damon before Dionysius the Tyrant, 1826

As we have seen, the dangers of stripping the male body of its classical setting and idealized appearance were enormous, for it was now left to the body itself to guarantee its claims to power. What was more, there was no idealizing screen or remote fantasy setting to protect the male artist from the confrontation with a body which both mirrored his own and functioned as a forbidden erotic object. But in the dogmatically heterosexist culture of Third Republic France, the sexualization of the contemporary male body had to be assertively phallic even as the spectre of its own vulnerability was inscribed unconsciously on to its flesh. Both masculine and feminine, powerful and vulnerable, self-contained and yet spectacularly open, the importance of Caillebotte's *Man at his Bath* lies in its capacity to represent a consummate image of phallic wholeness which yet simultaneously betrays its own lack. Despite itself, it becomes therefore the quintessential image of modern man: muscular, masculine and yet curiously defenceless.

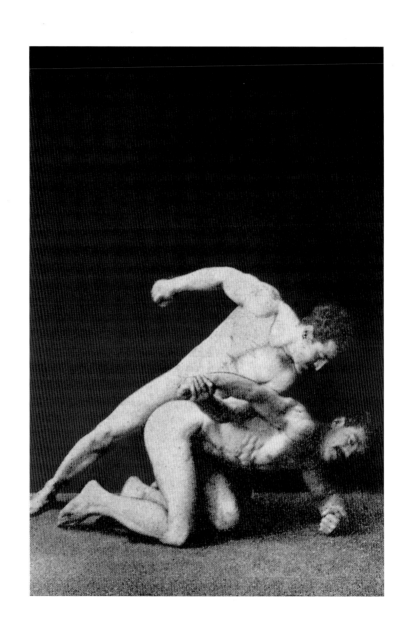

Modelling the Male Body:
Physical Culture, Photography
and the Classical Ideal

It was not by accident that a gentleman like Gustave Caillebotte had seen fit to indulge in playful wrestling or that he participated in the burgeoning industries of sport and physical training, fostered and endorsed by bourgeois republicanism. He, like his contemporaries, turned to ancient precedents in the elaboration of an ethics and aesthetics of the body that could fulfil the demands of modern France while claiming a classical heritage as its source. But where Caillebotte refused to endorse an art that mimicked the pictorial formulae of classicism, preferring to identify with the self-consciously modern schools of Realism and Naturalism, there were many among his contemporaries who were more than willing to imitate ancient precedents. Classical revivalists were to be found in the life rooms and art schools of modern Paris throughout the nineteenth century and still dominated the Academy and its teachings. But defenders of ancient prototypes were not only located in conservative fine art academies. It was the newest of pictorial media, photography, which became an important vehicle through which modern endeavours could establish their links with an ancient and noble past. The modern body-building or 'physical culture' movement, as it was then called, depended on photography for its publicity and for propagating an image of ideal masculinity based on ancient prototypes. Reproductions of ancient sculptures and modern men could be happily juxtaposed in the two-dimensional world of the photographic print, thereby setting up analogies and invoking comparisons between ancient and modern that were perfectly sustainable in the photographic medium.

The founders of the physical culture movement aimed to remodel modern man so that he could withstand comparison with the exemplary physiques of the athletes of ancient Greece. Ever since France's disastrous defeat in the Franco-Prussian War, commentators had been drawing unflattering contrasts between the spectacle of modern manhood and that of its ancient forebears. By the 1890s such observations had become commonplace. *La Revue athlétique*, founded in 1890, asked its readers in its first issue to imagine themselves at the public swimming

25. 'La Beauté Moderne', Milo and Millian, from La Culture Physique, January 1905

baths on a hot summer's day. What they were likely to see were all the 'deformations' of the human body: 'round backs, sloping shoulders, narrow chests, bulging stomachs, weak arms and knock-knees'. This, complained the editor, would make a striking contrast with ancient athletes, pugilists and discus throwers 'whose images Greek statuary had perpetuated and which now ornament the museums'.[1] Flesh could not stand up to comparison with stone. The juxtaposition of modern man and ancient sculpture was nothing short of embarrassing. A little over a decade later, G. Strehly, regular contributor to *La Culture physique*, the newly established organ of the body-building movement, defended the activity passionately in just such terms: 'What if', he wrote, 'while you were strolling about in a sculpture museum, a flick of a magic wand deprived all the visitors of their clothes... While those amongst them who despise physical culture would blush at the exposure of their physiological defects, the gymnasts would be able to sustain ... the comparison with ancient masterpieces. Puerile vanity perhaps. But this vanity is after all as legitimate as that of the poet proud of his verses or of the scholar who makes a show of his erudition.'[2]

Modern man, it was widely believed, was a weak replica of his ancient forebears, to whom alcoholism, syphilis and hereditary diseases were allegedly unknown. Moreover, while the ancients had neither to contend with the overworking of the intellect, the overpopulation of big cities, the withering effects of industrial labour, nor the anaemia of bureaucratic duties, modern man was gradually being destroyed by the effects of modernization. He was forced to live in overcrowded cities, breathe impure air and do increasingly sedentary work, and he fell prey to the vices of the city: excessive alcohol consumption, bad eating habits and the lure of prostitution. Modern means of transportation meant that people took less exercise and modern machinery involved little physical exertion. Modern men were in such a sorry state, claimed hygienists, doctors and politicians alike, that they threatened to produce damaged offspring whose progressive degeneracy spelled nothing less than the end of France.[3] France, it was believed, was already way behind Germany in military prowess and the cause of this was laid firmly at the feet of French men, inadequately prepared for military life, physically weak and lacking in that crucial constituent of a virile masculinity: vigour.

For the *fin-de-siècle* Frenchman troubled by the pitiful spectacle of modern masculinity, the Greek athlete, as immortalized in the works of classical sculptors, stood as the model of an ideal manhood which was not only attainable but essential to the survival of France. *La Culture*

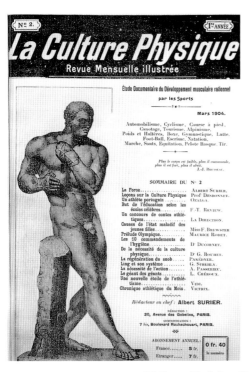

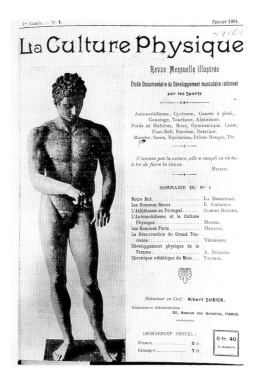

26 Cover of La Culture Physique, March 1904
27 Cover of La Culture Physique, February 1904

physique, founded in 1904, regularly used images of ancient sculptures on its covers to promote its ideal of physical beauty. Physical culture enthusiasts aimed at reforming the body for aesthetic reasons, aspiring to the beauty, health and strength of the ancient Greeks, but physical culture was also regarded as a potential means of safeguarding the race and the fatherland, widely perceived as threatened and degenerate.

The modelled, muscled, masculine body of physical culture came to represent the epitome of Beauty, Virtue and Patriotism. Indeed the vocabulary mobilized by the supporters of physical culture mirrored the moralizing rhetoric of contemporary apologists for academic art. Truth and Beauty, as essential abstract ideals, were the proper goals of physical culture in the same way as they were for idealist art practices.[4] The gymnasium, as much as the museum, was the temple in which one could worship 'the religion of Art'.[5] It was not surprising therefore that a number of famous body builders earned their livings as artists' models, claiming to be modern incarnations of classical heroes. The academic poses struck by models at the Ecole des Beaux-Arts, themselves

modelled on classical prototypes, could be mimicked by body builders keen to elevate their activity to an art form that transcended the merely physical.[6] The instructor Rodolphe's 'Academic poses' could just as easily have been produced by live models in the life room as in the gym. Countless academic drawings executed in the Ecole des Beaux-Arts in the nineteenth century had been based on just such poses. Small wonder that photographs like these were soon to rival live models as the sources for numerous figure compositions.

While the physical culture movement placed its emphasis on the aesthetics of body building, proclaiming bodily beauty as its ultimate goal, it did so in the name of general health and moral virtue. The well-developed body came to stand for the healthy body, the pristine condition of the internal organs supposedly represented by the perfection of the exterior form.[7] A large chest, like that belonging to the exemplary sculptor and body builder Alexandre Maspoli, would inevitably house vast and healthy lungs; a tight-muscled abdomen denoted the efficient functioning of the digestive system; well-developed arms stood for general strength and vigour; while strong-muscled legs indicated an aptitude for running and jumping.[8] The classical aesthetic ideal – its symmetry, proportions and perfectly balanced musculature – was appropriated for a new medical and social discourse which aimed at remodelling the enervated contemporary male body along ancient lines. The protagonists of physical culture were convinced that only supreme

28 Professor Rodolphe in a series of 'academic' poses, from La Culture Physique, November 1904
29 'La Beauté Moderne', from La Culture Physique, January 1905

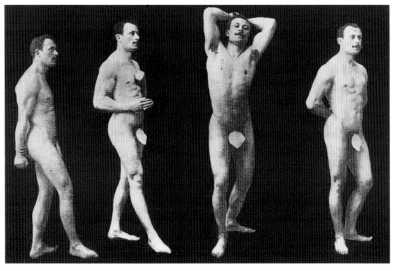

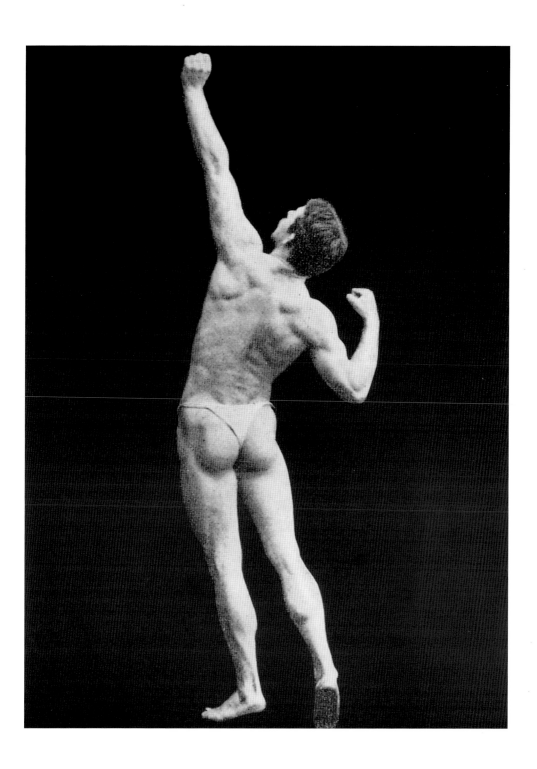

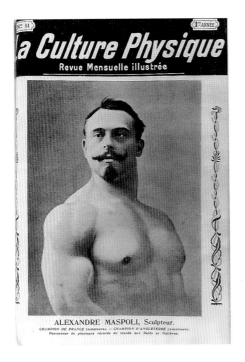

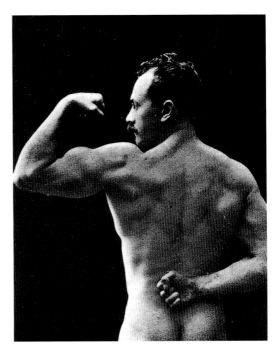

ALEXANDRE MASPOLI, Sculpteur.
CHAMPION DE FRANCE (amateurs). – CHAMPION D'ANGLETERRE (amateurs).
Possesseur de plusieurs records du monde aux Poids et Haltères.

effort and industrious attempts at self-improvement on the part of men themselves could counter the harmful effects of modern life.

The publicity poster for *La Culture physique* was a bald representation of the values for which the movement and its journal stood. Pasted all over Paris and in all the cities of France and Francophone countries, the poster was designed to attract all French citizens, men, women and children, to this redemptive movement. In this image, the normative French family, complete with protective father, doting mother and two fair-haired children, one of each sex, are directed by a brawny, sculptural male nude, abdominals strongly shadowed, towards a vision in the clouds in which the crowned Venus holds up a copy of the magazine complete with the photograph of the impressive back and biceps of the founder of the movement in France, Edmond Desbonnet. This image was used repeatedly to publicize the revolutionary method of body building pioneered by Desbonnet, based on the slow progression from light to heavy weights. For him, it was the overall harmony of the body that was crucial. He developed exercises for lengthening the body, broadening the chest, flattening the stomach, forming the thighs and upper arms, and working each muscle group so that no part of the

body would be more developed than another. For this reason he and his school disapproved of certain sports (such as swimming) as a form of training because they resulted in the over-development of some muscle groups at the expense of others.[9] For Desbonnet and the physical culturalists, the beauty of the whole body was paramount. Once this was achieved, individuals could, with care, partake in whatever physical exercise they liked.

The carefully posed body and flexed muscles of the father of French physical culture himself was used repeatedly to market his method of weight training and body moulding. An enlarged photograph of his back view appeared in a number of his publications. One issue of *La Culture physique* even published a picture of the master 'flayed' so that his perfect muscles could be revealed to aspirant body builders.[10] Such images drew on precedents that had appeared in physiology manuals for artists, such as that produced in the 1890s by Paul Richer, anatomy teacher at the Ecole des Beaux-Arts. Recent developments in myology had made the muscles an important focus of attention and pedagogues such as Richer claimed that it was more important for aspirant artists to understand the muscular structure of the body than the skeleton, for while the latter was almost identical for all humans, muscle development and

30 Cover of La Culture Physique, January 1905

31 Professor Desbonnet, in a frequently reproduced image

32 Publicity poster for La Culture Physique, November 1905

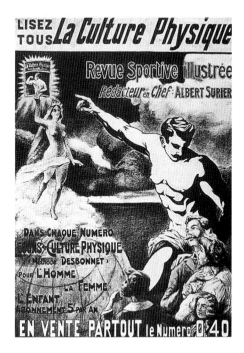

The labels on the figure read (top to bottom):
Splénius.
Sterno-mastoïdien.
Trapèze.
Deltoïde.
Trapèze.
Sous-épineux.
Petit rond.
Grand rond.
Triceps brachial.
Grand dorsal.
Grand oblique.
Moyen fessier.
Grand fessier.

33 The Muscles of the Torso, from Paul Richer,
Physiologie Artistique de l'Homme en Mouvement, 1895

definition varied enormously from individual to individual and pro-
foundly affected the surface appearance of the body.[11] French art
students had long studied the internal structure of the body in their
anatomy classes. Studying the human skeleton and drawing the struc-
ture of the muscles from famous statues of flayed figures such as Jean-
Antoine Houdon's *Ecorché* was standard practice in the art schools
throughout the eighteenth and nineteenth centuries. A telling early
painting by Gustave Caillebotte of his own studio contains a small
model of this figure of the type that many art students would have
known. This would be accompanied by studies from plaster casts of
antique sculptures and fragments. What the physical culturalists did
was to appropriate the practices of the art school for the context of
the gym. This lent an aura of high-minded scholarliness to the task at
hand. Desbonnet's 'measuring studio' was filled with antique sculptures,
including the much-admired Farnese Hercules, plaster casts of frag-
ments of the human body or sculptures, diagrams of the human skeleton
and of the muscle groups of the flayed body, together with measuring
instruments used to monitor the progress of the trainees. In addition,

34 GUSTAVE CAILLEBOTTE Studio Interior, 1872–4

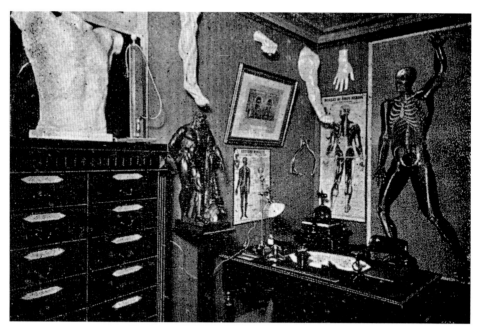

35, 36 Some of the models, diagrams and casts displayed at the Ecole Desbonnet
to inspire students of physical culture, from La Culture Physique, September 1904

a special room existed at the Ecole Desbonnet for casts of exemplary limbs, as well as for the maquette of the *Écorché* and the labelled diagram of the major muscle groups.[12] Developments in myology, anatomy and human hygiene provided the apparent scientific basis for the rhetoric of the physical culturalists while academic pedagogy was the source of its symbolic power. Armed with the authoritative backing of art and medicine, and the technical apparatuses of the gym and photographic studio, Desbonnet and his colleagues set out to shame and reform their fellow countrymen by setting them a good example.

Unlike the portly and puny members of official committees on health and the nation, repeatedly satirized in the pages of *La Culture physique*, the founders, theorists and instructors of physical culture were its best advertisements. Aspirant body builders and collectors of physique paraphernalia could purchase their own small bronze models of the statue of Professor Desbonnet that had been exhibited at the Salon of 1903. Alternatively they could pore over the much-photographed body of the master regularly reproduced on the pages of *La Culture physique* or in his well-illustrated monographs on bodily strength which appeared throughout the first decade of this century.

37 RENE PARIS, statue of Professor Desbonnet, from La Culture Physique, August 1904
38 Advertisement for the Ecole Desbonnet, from La Culture Physique, August 1904

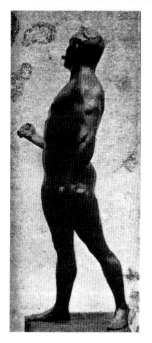

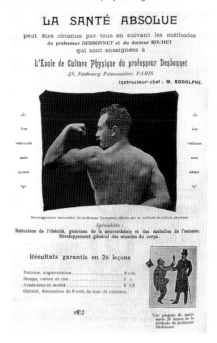

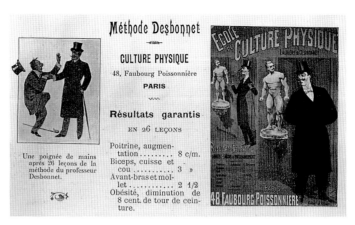

Méthode Desbonnet

CULTURE PHYSIQUE

48, Faubourg Poissonnière

PARIS

Résultats garantis

EN 26 LEÇONS

Poitrine, augmentation......... 8 c/m.
Biceps, cuisse et cou 3 »
Avant-bras et mollet........... 2 1/2
Obésité, diminution de 8 cent. de tour de ceinture.

Une poignée de mains après 26 leçons de la méthode du professeur Desbonnet.

39 The Desbonnet Method, from La Culture Physique, February 1904
40 'La Régénération du Snob', from La Culture Physique, March 1904

Desbonnet's newly founded premises on the Faubourg Poissonnière specialized in the reduction of obesity, the healing of neurasthenia and stomach disorders and the general development of bodily muscle. A handshake after twenty-six sessions of his method would, alleged advertisements, leave one's compatriot startled and writhing in pain. It was the transforming capacity of physical culture which was its greatest selling point. Aspirant body builders would enter the school embarrassed at the poor figure they cut in comparison with the Herculean master, but would emerge six months later with broadened shoulders, strengthened muscles and a filled-out form which bore comparison not only with the masters of the present but with the athletes of the past. Advertisements used humour to demonstrate the radical transformation of personality that a well-developed physique could produce. One advertisement showed the statue of Desbonnet first beside a puny cane-swinging dandy, and then again beside the same individual transformed after training into a cocky broad-shouldered specimen who positively dwarfs his magnificent, but now shrunken, mentor. Caricatures published in *La Culture physique* played on the unflattering comparison between contemporary French men and antique heroes. Only physical culture, it was alleged, could transform the timid and weak fellow, typical of the modern Frenchman, into a figure who would equal the Farnese Hercules, even offer him a direct challenge. In one caricature the narrative begins with a skinny gentleman (the 'snob' of the inscription) who cuts a sorry figure next to the archetypal strongman of ancient Greece. Humiliated by his physical decrepitude he is driven to

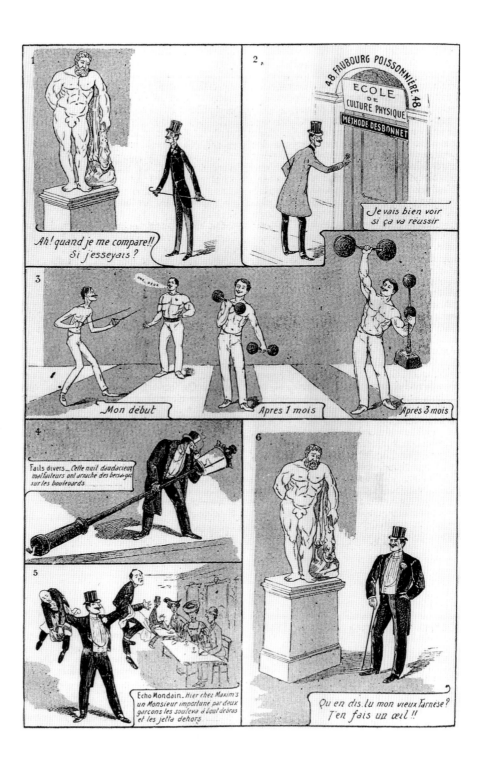

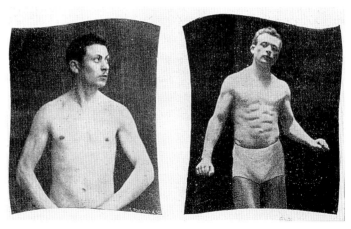

41 Professor Rodolphe before and after training, from La Culture Physique, November 1904

trying out body building and is transformed, in three months, from a skinny fencer into a muscled weight-lifter of impressive proportions. Emboldened by his strength, he becomes a daring man about town, uprooting gas lamps to light his cigar and evicting troublesome waiters from the fashionable restaurant, Maxims. By the end, he struts about defying Hercules himself to take a look at him.

Photographs of physical culture success stories were regularly published in the pages of the journal. According to the published photographs, the instructor Rodolphe himself had started life as a puny, narrow-chested specimen whose flattened, frontally lit body showed little muscle definition. After training, his body rippled impressively, the emphatic dark and light shadowing of the photograph functioning as testimony to its hard, muscular and undulating surface. The strategic lighting of the torso shows off the crucial abdominal muscles and the highlighting of the biceps testifies to the muscular strength of the body. As important as the actual physical prowess of this man was the difference his 'new body' made to his self-presentation. Proud, self-assertive and open, he presents himself to the camera without inhibition, a far cry from the furtive, haunted creature pictured in the 'before' image.

Proof of the capacity of modern man to achieve something close to the perfection of the ancients rested in the image of himself that he could muster. The expansion of the physical culture movement and its growing popular appeal was itself the product of the proliferation of images that the burgeoning industry of photography had produced. Participation, even at competition level, in the culture of amateur body building required no more than a do-it-yourself guide to muscle devel-

opment, a mirror, a store of photographs and the services of a hired photographer. While some committed enthusiasts joined the studios and gyms now proliferating in urban centres, other adherents remained at home content to work out in front of their mirrors, inspired by the images reproduced in photographs of ancient prototypes and contemporary experts and the occasional bronze model. As body building became big business, it depended as much on the modern postal service for its proliferation as on the newly expanding premises housing studios and gyms. The product on sale was health, happiness and physical beauty. The price was measured both in cash and commitment, and the commodity exchanged and circulated was the photographic image, multiplied, manipulated and free of any measurable relation to what it ostensibly represented.

Photographs of classical sculptures originated in the Second Empire, when the virtues of the new medium were extolled as a means of popularizing the masterpieces of antiquity. Many nineteenth-century images of ancient sculptures follow the same conventions of representation. The frontally lit figure is surrounded by deep shadows so that it stands

42 Discobolus, from La Culture Physique, January 1905

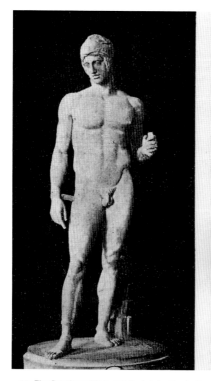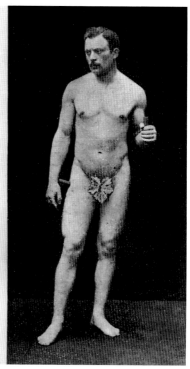

43 The Borghese Mars and Rodolphe the instructor, from La Culture Physique, January 1905

out from the surrounding space. The muscle definition is described through exaggerated light and shade contrast and the viewpoint is frontal and slightly low, making the figure seem to tower impressively over the viewer. Shadows usually conspire to emphasize the chest and the abdominal triangle, already expressing the idealization of the statues themselves but now exaggerated by the photographic process. Nineteenth-century anatomists noticed the abstraction of the abdominal area of ancient sculptures, attributing it to classical idealizing propensities, but this did not stop the modern body-building movement from integrating it into its aesthetic ideal.[13] Indeed, some apologists of modern body building spoke of an abdominal belt that was crucial for the development of healthy internal digestive organs: well-developed abdominal muscles were not only a sign of beauty, they represented the efficient functioning of the organs they housed.

A typical photographic juxtaposition which appeared in *La Culture physique* in 1905 demonstrates the way in which a canonical, classical view of the body served as a model for the emergent body-building

movement. Here the Borghese Mars functions as a prototype for the pose of Rodolphe the instructor. But pose alone would not have been a sufficient condition for the neat parallel that the two images set up. Had the comparison between these two figures been staged in the gym, studio or the sculpture museum, the distinction between flesh and stone, colour and monochrome, softness and hardness, hair and chiselled relief, warmth and chilled petrification would have seemed obvious. But the photograph dissolves all these crucial distinctions, allowing for a fantasy of equivalence to be sustained. Scale and proportion can here be shown to be exactly the same. The use of front lighting and the dark background make both figures emerge from the shadows, emphasizing their physicality, and the clever use of shading on the photograph makes for a similarity of muscle definition. This could be achieved by skilful studio lighting, by the retouching of the negative, a common feature of photography from its inception, or by the use of make-up on the body of the athlete so that shadows were deepened and muscles were highlighted. Sometimes the body would be dusted with reddish powder, which was then wiped off the high spots. The powder would adhere to the creases of the body, especially in the horizontal bands of muscle across the abdomen, increasing the effect of muscularity.[14] In this photograph, Rodolphe's abdomen has been shaded to make it conform to the triangular shape of the classical ideal. Bodies were carefully prepared before photographing. Hair was very often removed from armpits, chests and pubic areas to give a smooth veneer to the body. Sometimes the whole body was shaved and the skin could be oiled to bring out its surface sheen.[15] And the smooth surface of the photographic image itself served the purposes of the physical culture movement perfectly. Those bodily imperfections that remained could be wholly glossed over, projecting a fantasy of the body as sealed, contained and controlled.

Examples of modern body builders taking up standard classical poses for the camera abound. The famous German body builder Max Unger was pictured in a 1904 issue of *La Culture physique* on a podium, an often used convention which enhanced the sculptural reference of the pose. Even the latter-day addition of the fig leaf was often emulated by modern body builders when having themselves photographed, either worn suspended on a string, as in this case, or airbrushed on during the printing process. Greek myths and stories of heroic deeds often formed the framing narrative for the display of the trained and modelled body and helped to confer heroic virtue onto its physical presence. Favourite poses were those that invoked Hercules (fig. 1, for example), and models

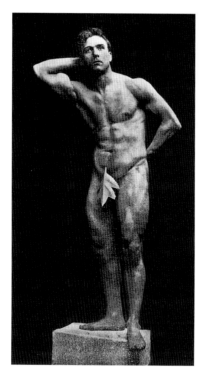
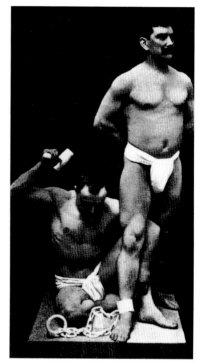

44 Max Unger, from La Culture Physique, June 1904
45 Cluzel and Gérenton, from La Culture Physique, June 1904

were regularly shown wielding clubs or performing acts of great strength (breaking chains was a sure winner!). The famous pair Cluzel and Gérenton were shown performing just such an act, while Milo and Millian took up classical wrestling poses for their photograph (fig. 25). The renowned German strongman Hackenschmidt is pictured as Hercules at rest, balanced precariously on a bench in a watery glade.

Ironically, it was through an emphatically modern method of reproduction that an equivalence between a redemptive modern masculinity and its putative ancient source could be set up. Only the technology that modernity had heralded could sustain the myth that modern masculinity could be redeemed through the emulation of a classical body type. And only the mechanical reproducibility of the photograph could make that myth available to thousands of men made anxious by the failure of their own bodies to match up to an ideal which had come to represent an identity that was strong, heroic and patriotic.

The proliferation of physical culture photographs in the *fin de siècle* was phenomenal. Desbonnet himself boasted a collection of some 6,000

images. Photographs of body builders were reproduced in specialist magazines, or available as one-offs which could be bought by mail order. *La Culture physique* tried to satisfy what it called the 'taste of its readers for *les photographes artistiques*' by publishing a special edition of 'studies from nature' which it would offer for sale by mail order. Although these would be nude studies of male and female models, the magazine assured its readers that there would be nothing immoral about such images. The images would stand to represent the 'strength of men' and the 'grace of women'. They would conform to the principles of the Ideal by representing only the most beautiful specimens of humanity. Drawing on the language of academic art critics who denounced realist modes as demeaning and vulgar, the editors intoned: 'We want to make ourselves familiar with the Nude, because the Nude is not immoral, a semi-dressed body is more perverse than absolute nudity'.[16] The editors informed their readers that they had no fewer than 600 poses to distribute. Soon, they

46 G. Hackenschmidt in a classic Herculean pose, from La Culture Physique, March 1904

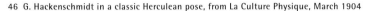

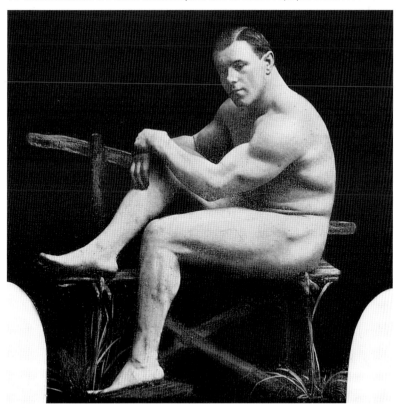

hoped they would have as many as 2,400. Images of body builders formed part of the burgeoning production of nude photography which passed as 'artistic', 'tasteful' and 'asexual'. These were used in artist's studios and the poses resembled those which had for centuries been taken up by models in the life classes of art academies. Their erotic potential was disavowed and ostensibly occluded by their use as icons providing a guide to the body beautiful for disinterested aesthetic purposes. The category of the *nu esthétique* – arty, high-minded and abstracted – provided a screen behind which the proliferation of erotic nude photography could flourish. And photography itself, widely thought to be a facile, mechanical and mendacious medium, claimed for itself the status of art by drawing on the pictorial rhetorics of classicism. The classical served therefore to give form, meaning and dignity to the modern physical culture movement while at the same time lending its high-minded allure to the processes and procedures of photography itself.

47 Eugen Sandow in a range of Herculean poses, from La Culture Physique, August 1904

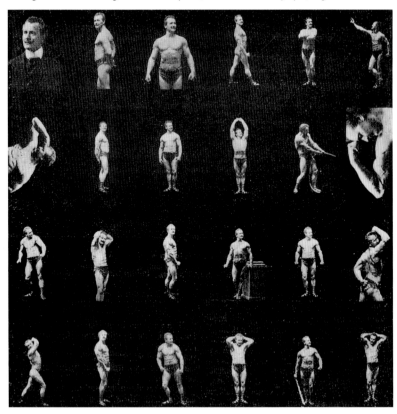

48 The reception room at the Ecole Desbonnet, from Edmond Desbonnet, La Force Physique, 1901

Body building photographs were easily available. *La Culture physique* regularly published new poses of renowned athletes which could be ordered by post. The world-famous body of Eugen Sandow, for example, was arguably the most photographed male body of the period and enthusiasts could buy images of him in a variety of Herculean poses. Described as 'the most beautiful specimen of the human race' in *La Culture physique*, which proclaimed this to be the opinion of the most celebrated sculptors and painters, his body was thought to 'unite all the qualities of the ancient athlete': 'beauty of form and countenance, suppleness, a pure contour and a gracious bearing'. Sandow was accordingly named by this magazine, 'the king of physical beauty, the complete man, and the most beautiful known model'.[17]

Gyms and physical culture studios became crucial sites for the display of imagery of this type. When they entered the reception room, visitors and aspirant students to Desbonnet's school would be confronted by an enlarged photographic print of the professor surrounded by smaller images of pupils and disciples who had developed exemplary physiques. In this photograph (fig. 48), which was widely published in Desbonnet's books on physical culture and the development of beauty and strength, the customary juxtaposition of the image of the body builder with the carefully chosen reproduction of a classical prototype is set up by the placement of the photograph of the latter on the table, functioning both as a source of the master's pose and as an authentication of the aesthetic for which body building stood.

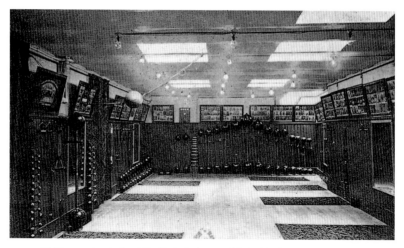

49 The exercise studio at the Ecole Desbonnet, filled with physique photographs, from Edmond Desbonnet, La Force Physique, 1901

The body-building studios were also filled with photographs. Above the free weights in the Faubourg Poissonnière were numerous images of body builders for students to pore over. All of these followed the conventions of physique photography, drawing on classical prototypes and conforming to accepted standards of modesty and bodily decorum. Desbonnet's studio was not the only one to boast a collection of photographs. The 'Cabinet Athlétique de Docteur Krajewski', a Russian physical culture expert and trainer, included a wall-to-wall display of physique photographs showing men in a variety of poses and attitudes. Positioned above the free weights that the men would have used, the images served to enshrine the aesthetic which physical culture endorsed, the endless repetition of pose and performance on the wall serving as an almost hypnotic spur to the aspirant athlete and as a narcissistic projection of the well-formed expert. Photographs from the period show contemporary strongmen posing in front of and peering at photographs of successful body builders (fig. 51). At their feet are the extraordinary weights that the strongest among them managed to lift.

To motivate its readers, *La Culture physique* ran body-building competitions which were judged entirely by the photographic submissions of the participants. Body builders had long been encouraged to exercise at home in front of mirrors and to use photographs and three-dimensional statues to help them develop their own bodies to the right proportions. Those who attained a fair degree of success could have themselves photographed and submit the results to the beauty competi-

tions which the editorial board organized. Finalists would have their photographic costs reimbursed.[18] The best photographs were made into collages and reproduced in the journal together with short biographies and the vital statistics of the men themselves. Standard poses were adopted, most standing, muscles flexed, their clean-shaven or moustached faces expressionless and intense. Exceptional body builders such as Paul Gasquet, winner of the first prize in the 'Concours de Beauté Plastique' for 1905, were rewarded by having their pictures reproduced alone. Replete with Roman sandals and classical drapery over his pubic area, he exemplified the modern man modelled to the perfection of ancient prototypes. Accompanying his photograph were the words: 'Paul Gasquet fulfils the perfect type of the fighting Gladiator from the Louvre. He is the complete man, capable of performing equally easily exercises of speed and endurance as those of muscular strength'.[19]

50 The 'Cabinet Athlétique de Docteur Krajewski', from Edmond Desbonnet, Comment On Devient Athlète, 1911

Photography had made such a comparison seem logical, even inevitable. When faced with a proliferation of different poses that made the judging of photographic competitions very difficult, *La Culture physique* decided to prescribe set poses for all contestants. These would be drawn from ancient prototypes and the judges would place the image of the modern body builder next to that of the antique sculpture to see which image most closely approximated it.[20] The competition, in this form, had arguably more to do with skill in manipulating the photographic *mise en scène* than with the discipline of body building itself.

In the context of *fin-de-siècle* France, the classical body came to have a highly specific meaning. For a nation haunted by recent military defeat, economic instability, threats of depopulation and late but rapid modernization, the canonical Greek body seemed to stand for a timeless beauty and strength which could redeem France from its current social and political impasse. Photographs helped to sustain the illusion that body building could form part of that redemptive project. The reproducibility of the photographic image, its nature as commodity and the ease with which it could be distributed made it potentially a powerful tool for the dissemination of an old aesthetic, now reframed and harnessed to a new political project. The classical body as projected by the

51 Body builders looking at photographs of successful strongmen at the Roubaisien athletic club, from Edmond Desbonnet, Les Rois de Force, Paris 1911

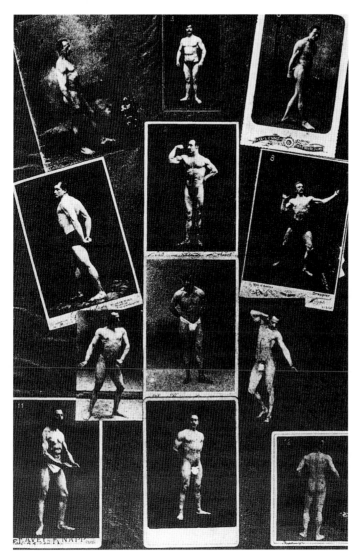

52 Collage of body builders featuring Paul Gasquet in the centre, winner of the 1905 'Concours de Beauté Plastique', from La Culture Physique, August 1905

physical culturalists of the *fin de siècle* became the standard by which modern bodies could be appraised and consumed. The putative veracity of photography made it the ideal vehicle for the mediation of this body to a new audience, testifying to the durability of traditional aesthetic values while at the same time providing the technical apparatus that made their emulation seem possible.

What does a man look like beside his wife? He, black, plain, dull,
smelling of cigars. She, pink, elegant, sparkling, her rice powder wafting
all around her the perfume of ambergris? Does he not look like his own
cook in his Sunday best?[1]

To Nestor Roqueplan, writing in 1869, men and women appeared
ineluctably different from one another. Seeing them together made
this absolutely clear. Exuding a characteristically manly smell in their
sombre suits, gentlemen were much more likely to resemble their own
male domestic servants than their made-up wives, perfumed, pink and
showy in their resplendent toilettes. Gustave Caillebotte had, as we saw
earlier, dressed up the family steward in his Sunday best for his portrait
and he himself was not averse to dressing in gardener's clothes when
at his country estate in Yerres. There was nothing to stop men in the
nineteenth century from manipulating the signs of class in order to live
out their masculine identities. The pre-Revolutionary sumptuary laws
which had dictated dress according to class and position had long been
repealed. Now dress was most strictly codified according to gender
and it was only in private that men could don richly coloured and
seductively soft dressing-gowns and exquisite embroidered slippers.
Decorated waistcoats in fine satins and silks had to be carefully tucked
away under the ubiquitous black coats of public life.[2] The outer husk of
masculinity was a dignified, sober affair. As the late nineteenth-century
commentator on contemporary fashion and manners Octave Uzanne
put it: 'The ordinary dress of a man is so much simplified that ... on state
occasions when he mixes with women, he looks like a humble grub
crawling among the flowers'.[3] If man had the right only to 'clothe him-
self', then 'woman has the right to ornament, to embellish herself, and ...
to introduce a little brilliance into the dullness of ... modern life.'[4] It was
left to women to present themselves as gorgeous spectacles, adorned,
bejewelled and gowned to perfection. A man's public appearance was

expected, increasingly, to differentiate him from women, not from other men, and class had come to seem less of an obvious barrier than gender. More subversive than the crossing of class boundaries therefore was the transgression of gender norms, so carefully policed by the medical, clerical, political and legal establishments.[5]

James Tissot's *The Political Lady* (pl. III) and *The Woman of Fashion* (pl. IV) both represent just the sort of couple of which Roqueplan wrote. Two of a series of fifteen paintings on the theme of the *Femme à Paris* exhibited in Paris at the Galerie Sedelmeyer in 1885, they show fashionable women in crowded public spaces, attended to by their distinguished, wealthy male partners. The women provide a flood of warm colour, a rosy presence alongside their austere companions. Elegant and youthful, their elaborate costumes of satin, fur and feathers beg to be stroked, while their haughty escorts seem remote and untouchable, framing their female companions rather than inviting the viewer to dwell on their own auspicious presences. Representative of the type of the 'Parisienne', the ultimate counterpart to the bourgeois male, in his columnar, egalitarian, black-and-white costume, the austere uniform of character and purpose, thrift and self-control, these women represent the glamour and superficial excesses that money and modernity could buy. If luxury was a necessity for a flourishing market economy, then women, adorned and ornamented, came to represent that luxury to itself. The 'Parisienne' stood for the bourgeois male's wealth and position, his status and achievements. To this end, her outer packaging, the turn of her head, the rectitude of her carriage, the extravagance of her attire, the quality of her coiffure, the length of her train and the spread of her fan all testified to the importance of her male companion.

In *The Political Lady*, the gentleman's face is altogether concealed. All we need to see is his slightly stooped posture, grey hair and customary costume to be assured of his position. It is his companion men whisper about behind their raised hands. It is she who must absorb their stares and delight their eyes at the same time as reflect back to them a belief in their own omnipotence and power. Woman's youth and beauty was her capital, that of her companion was money, position, status and, indeed, the woman he could muster at his side. Shrouded, as in *The Woman of Fashion*, in an abundance, even an excess, of lace, fur and cloth, Woman is the object of scrutiny, the admired, cherished jewel of which fantasies are made.[6] Attended to by what one critic described as 'her galley-slave of a husband', she is the superficial sovereign who presides over the pleasure palaces of the city.[7] While man's material wealth and power is attested to by the glamour and sophistication of his female

companion, he is at the same time constituted as a servant worshipping at the shrine of the idol he has created.[8] Ruthless in the manipulation of the only power that she wields, the attention of this adored and adorned creation is already turned elsewhere. It is the viewer who is hailed by her brazen address, he who is interpolated as the object of her attention despite the fussy (and almost pathetic) ministerings of her elderly escort.

When James Tissot set out to represent that mythic figure, the 'Parisienne', in his series of paintings and etchings, he stepped into a highly contested field. Tissot bravely – some thought presumptuously – aimed at mounting an exhibition of a group of large, almost life-size paintings chronicling the diversity of appearance, character and role of contemporary Parisian women. As a Frenchman recently returned from an eleven-year sojourn in London and now wishing to re-enter the Parisian art world, he would cast the eye of the partial outsider upon his countrywomen and subject them to close scrutiny.[9] He would show them at work and at leisure, at home and in society, indoors and outdoors, respectable and of ill repute. In addition to the series of paintings, Tissot planned an edition of etchings, expected to appear in three series of five, to be published at six-monthly intervals between December 1885 and December 1886.[10] Each of the prints was to be accompanied by a short story, commissioned from a well-known contemporary writer, centring on the principle figures of the paintings and etchings. As such the paintings would function as pictorial caesuras in a narrative outpouring which would be nothing short of encyclopaedic. For the 'Parisienne' was herself so suggestive a spur to narrative and so much the product of narrative structures that her figure alone could function as a distilled story. One had only to say the word 'Parisienne' to invoke a series of well-rehearsed narrative associations, expectations and assumptions grounded in nineteenth-century gender ideology. For Tissot, the entire endeavour would, ideally, constitute a taxonomy of contemporary femininity, combining image, icon and anecdote in what was supposed to be simultaneously a viable modern artistic project and a lucrative commercial venture.

In the event it was recognized as neither. While Tissot did indeed show his paintings at the Galerie Sedelmeyer in Paris in 1885 and at the Arthur Tooth Gallery in London in 1886, their reception was at worst highly critical, at best lukewarm.[11] The experts were out to judge them, not only as paintings, but as adequate representations of the French fantasy of femininity for which the 'Parisienne' stood. The series of etchings was aborted after the first five were produced and Tissot never issued the three editions of five hundred prints that he had planned. Few

of the stories were ever written and of those that were, most are difficult to trace and identify. But this does not mean that the works and the responses they stimulated are without interest. For this failed endeavour generated extensive copy and prompted much speculation on the state of contemporary French womanhood and the capacity of art to represent it. Most critics found Tissot's approach too 'English' and saw his wooden array of dressed-up mannequins as an insult to French femininity. In the words of one critic, he had repeatedly painted the same English barmaid and placed her in a variety of costumes and settings.[12] Another talked of young misses who had been transported from Hyde Park to the Bois de Boulogne, while another thought them quite charming tourists, indeed English women in Paris.[13] For some commentators the very illustrative and literary nature of the project tied it more closely to English than to French precedents.[14] Some saw the series as offering nothing more than banal illustration, a manifestation of a particularly English disease with which Tissot had been infected, while others were willing to capitalize on the anecdotalism of the project by weaving their own elaborate yarns around these works.

Tissot was by no means the first nineteenth-century artist who aimed at capturing the essence of the 'Parisienne'. In the same year as he exhibited his *Femme à Paris* series the popular dramatist Henri Becque put on his play *Parisienne* featuring a vain, self-centred manipulator of men who had, by then, come to embody the quintessential qualities of the 'Parisienne'.[15] Emerging as a type in the burgeoning print culture of the Restoration, the 'Parisienne' represented a commodified femininity, one which was packaged to create an alluring, eroticized spectacle centring on the fetishized, fashionable body and flirtatious address of the female figure.[16] Such a figure was characteristically represented either adorning herself for public delectation (a topic explored further in Chapter Four), posing for public acclamation of her physical charms, or selling something, the slippage between the merchandise on sale and the woman herself being easy to make. Charles Philipon's print of the *Pleasant Perfume Seller* from the late 1820s offers a typically suggestive image of a woman whose buttoned up and tightly corseted body and immaculate hairdo is juxtaposed with an open perfume pot from which the scent she has just mixed seems to emerge. The shape of the goblet and the promise of the perfume it exudes stand in for the woman herself, whose flirtatious glance and teasing gesture belie the rigid constraints of her demure costume and controlled coiffure. Women's presence was frequently invoked by the perfume that they left behind them after they had passed by. The 'scent of woman' provocatively stood for

54 CHARLES PHILIPON The Pleasant Perfume Seller, 1827–9
55 CHARLES PHILIPON Madame of the Sausages, 1828–30

the sexual promise that her rigid carriage concealed and contained.[17] The contemporary *Madame of the Sausages* (1828–30), also by Philipon, is an idealized representation of a pretty tradeswoman who traverses the old cobbled streets of Paris selling her hot goods. The steam that rises from her sausage pan, while not as sweet-smelling as the perfume seller's wares, is suggestively linked to the ardour that appears to emanate from this coquettish little creature with her trim exposed ankles and flirtatious glance. The selling of goods and the selling of flesh were intimately connected in the elaboration of a popular iconography of the feminine. Whether exchanged in the bourgeois business of marriage or bought and sold in the cold commerce of prostitution, woman's appearance was crucial to her perceived value.

The history of French popular imagery is full of representatives of Parisian womanhood whose sole purpose was to seduce contemporary men. The *grisette* (from the 1820s), the *lorette* (from the 1830s), and the *cocotte* (from the Second Empire), all with their specific class connotations, formed stock representations of the 'Parisienne', who while not necessarily publicly and legally branded as a prostitute was nevertheless engaged in the trade in sex.[18] Such image-types were widespread in the popular press and contemporary broadsheets, eventually influencing

LA MODE ILLUSTRÉE

BUREAUX DU JOURNAL 56 RUE JACOB, PARIS

Toilettes de la Mme FLADRY, Mme COESSIN et chez M43 e. Richer

56 Fashion plate from La Mode Illustré, 1882

the modern-life subject matter of realist and naturalist painting from
the mid-century onwards. The formulation of types had its origins in the
classificatory systems of Johann Kaspar Lavater (1741–1801) and his
Enlightenment colleagues, keen to classify and codify human nature
according to certain consistent rules and principles. Physical appear-
ance, when scientifically studied and observed, was alleged to provide
clues to character and conduct, and the 'sciences' of phrenology and
physiognomy evolved as the systematic reading of the inner essence
of a person via external physical signs.[19] The classificatory mentality of
early nineteenth-century taxonomers found its consummate expression
in the genre of the *physiologie*, the textual and iconic elaboration of
stock characters or types, ranging from the rag-picker to the laundress,

the blue-stocking to the 'lorette'. The *physiologies* which became so popular in the mid-nineteenth century were paperbound books on Parisian types, concentrating on societal roles and manners rather than on bodily features.[20] The 'Parisienne' became the generic term for describing the essence of a particularly modern, peculiarly French form of femininity, which could, ostensibly, encompass women of all classes by a shared *je ne sais quoi*, a quality which none could put their finger on but all professed to recognize when they encountered it.[21] Far removed from the court beauty of the eighteenth century, the 'Parisienne' connoted an urban creature, whose tantalizing presence and mysterious allure was linked to the enchantment and potential dangers of the modern metropolis. Tied to the ascendancy of Paris as a cultural and commercial centre and of the urban bourgeoisie as the newly empowered ruling class, the 'Parisienne' had become one of France's principal exports by the 1880s. Frenchmen claimed that women were a hundred times more feminine in Paris than in any other city and a whole industry developed dedicated to spreading their charms abroad.[22] By this time, the 'Parisienne' had not only been naturalized as *the* desirable representation of the feminine but 'she' had become necessary for the smooth functioning of the economy. Octave Uzanne chronicled the extent to which the fashion and cosmetic industries, aimed exclusively at women, contributed to the French economy by the end of the century.[23] Exports, tourism and trade needed the fabricated femininity of the 'Parisienne' to further their own interests. The department stores and shopping arcades offered an unprecedented array of goods aimed at seducing women and creating in them the desire to consume luxury goods indispensable to their identity as women. France's fashion industry and all its ancillary enterprises depended on the credibility of the 'Parisienne' as a living monument to modern femininity. Fashion plates, like those produced in *La Mode illustré* and *La Gazette des dames*, were one of the major forums for the elaboration of the type. It was these images which reached every salon and boudoir in the capital and it was to the authorities that controlled these publications that women deferred. The Parisian woman was said to rule the salons of Europe, setting trends in fashion and etiquette to which all women would soon aspire. She represented novelty, modernity and style. The newly asphalted surfaces of the boulevards were, according to contemporary commentators, 'made for her'. It was here that she could offer a tantalizing glimpse of her stockinged leg, the feminine equivalent of the soldier's sword, part of her offensive armoury in the ruthless battle of seduction that she waged.[24] Born of the modern metropolis, she embodied both its delicious

allure and its deadly dangers. The city constituted her stage. It was here that she performed her part, always aware of being watched, always watching herself. Her appearance was her most precious possession and it was to her appearance that she devoted all her energy and attention.[25] Women were simultaneously deified and enslaved by a system of exchange which depended on their consumption of commodities while they themselves were commodified.[26]

The power of Parisian women to compel men's gazes was the subject of an amusing caricature in *Punch* in 1886, the year that Tissot exhibited his series in London, when a bewildered young Englishman is shown to be so overcome by the beauty and elegance of the 'Parisienne' that he quite forgets to look at the paintings at the Salon which he has come to view. The sophistication and refinement of the 'Parisienne', especially in comparison with English women, became legendary at this time. While the idea of a 'Londonienne' was nothing short of a joke, the sovereignty of the 'Parisienne' was widely acknowledged. Superficial, stylish and sophisticated, her embellished person represented a femininity which was packaged for its display value. Her function was to be seen and her ideal milieu was the public spaces of the city: the boulevards, parks, balls, shops, theatres and salons for which Paris had become famous.

It was in these urban spaces that Tissot situated his *Femmes à Paris*. There are, as some critics were quick to point out, no representatives here of the *femme au foyer*: the mother, or the devoted wife.[27] Conceived of as belonging to the private sphere, these idealized types, widely promoted in Republican mythologies of femininity, were aimed at promoting a wholesome, redemptive image of Woman in direct opposition to her commodified, carnal construction in the metropolis. Such women were neither sexy nor seductive and were certainly not associated with the mythic 'Parisienne' of the popular imagination. It was the public face of femininity that Tissot explored, not its hidden depths or private permutations. Here, wrote one critic, one could only find manifestations of 'life out of doors', as paraded in the public domain. Nothing about the morals or manners of living women could be gleaned from these paintings. 'These were gracious puppets made mobile in the theatre in which they were accustomed to move about, calling for neither commentary nor annotation, neither inspiration nor admiration, neither repugnance nor desire, content with being interesting and pleasant to look at'.[28] Tissot's was the world of external appearances alone.

A number of artists before Tissot had tried to distil the image of the 'Parisienne' into a single icon. Some critics, however, declared that any one artist who tried to represent the 'Parisienne' in her entirety was

A LOST ILLUSION.

THE TOO SUSCEPTIBLE JONES GOES TO PARIS FOR THE FIRST TIME (TO SEE THE SALON, OF COURSE). LIKE A TRUE BRITON, HE HAS ALWAYS BELIEVED THAT BEAUTY WAS THE EXCLUSIVE MONOPOLY OF HIS COUNTRYWOMEN. HE FINDS, HOWEVER, THAT THIS IS FAR FROM BEING THE CASE——AND QUITE FORGETS TO LOOK AT THE PICTURES.

57 'A Lost Illusion', from Punch, 29 May 1886

over-ambitious and foolish. It would take the combined efforts of a wide range of artists to achieve this and viewers were advised to look to the forthcoming Salon for single representatives of the type rather than accept Tissot's array of fashionable women as a reliable overview.[29] In the 1885 Salon, which was open at the same time as Tissot's exhibition, for example, Ringel was showing a sculpture entitled *Parisienne* in which a single, seated figure dressed in low-cut evening dress revealing ample heaving bosoms swoons suggestively in her chair. Her semi-conscious state and languid limbs seem at odds with her tightly corseted bodice, and the combination of these elements produces an image of Woman as seductive but only semi-conscious. Here the 'Parisienne' is condensed into a single allegorical figure, resonant with associations. Renoir's *La Parisienne* of 1874 (fig. 107) had also isolated the figure. She is Woman conceived of as type, as ultimate embodiment of the 'feminine'. Her isolated packaged personage, her skilfully moulded and rigid silhouette, although represented on an indeterminate ground which

58 JEAN BERAUD Avenue des Champs Elysées, c. 1885

speaks of no specific context, is already implicated in an elaborate narrative about who she is. Jean Béraud's *Avenue des Champs Elysées* of 1885 situates the 'Parisienne' in the urban and uncompromisingly modern context which created her. Gloved, veiled and corseted, this fashionable woman alone on the boulevard is difficult to fathom. Unchaperoned and therefore brazenly available, she is also veiled and therefore shrouded in the garb associated with bourgeois modesty and bodily decorum. Prey to the gaze of passing *boulevardiers*, two of whom seem decidedly interested in her, the veil covers her eyes sufficiently to dim her vision, but not enough to hide the attractiveness of her features or the pout of her painted red lips. Despite this sign of respectability therefore, Beraud's solitary woman of the boulevards holds all the promise of the quintessential 'Parisienne', together with the delicious danger, the *frisson*, that accompanies the uncertainty surrounding her identity. While her own vision is dulled by the thin veil that covers her eyes, she is dressed to be looked at, to be admired, assessed and desired.

All of Tissot's *Femmes à Paris* are visibly haunted by a male presence. Not only are they themselves the products of male fantasy, both that of Tissot and the numerous writers and image-makers to whom he was heir, they are depicted surrounded by the men to whom they are accountable and on whom they are dependent. The female figures in *The Political Lady* and *The Woman of Fashion* are, as we saw at the beginning of this chapter, both chaperoned by elderly companions. Whether dressed up as *The Fashionable Beauty* (fig. 60) or undressed, as in *The Acrobat* (fig. 59), as the lowly tightrope walker, the least elevated of contemporary performing artists, women tightly held in by corsets or leotards are watched, surrounded and admired by what is predominantly a chorus of men. They form the framing reference point for Woman's highly polished and packaged appearance, her erect stance and frontally lit, frozen rigidity. As such Woman's physical presence in the paintings mirrors women's actual presence in the social and psychic economy of late nineteenth-century France. In the story commissioned from Ludovic Halévy to accompany *The Fashionable Beauty*, the main female character is shown to be dependent on the whim of an irresponsible young aristocrat who creates and destroys her reputation with impunity. Impressed by the appearance at the theatre of a demure young *bourgeoise*, wife of a lawyer of modest means, the promiscuous womanizer Prince Agénor declares her to be 'the most beautiful woman in Paris'. He is overheard by an ambitious gossip columnist who prints this information on the society page of his newspaper. The modest Mme Derline is transformed after reading the column into a rapacious

consumer of luxury goods who, in her attempt to live up to her new-found reputation, must buy compulsively. In order to present herself at a forthcoming ball she finds it necessary to order a sumptuous new ball-gown and jewellery. In addition she persuades her husband to replace their old horse and carriage and hire an English coachman so they can arrive in style. Mme Derline makes an impressive entry at the ball, Halévy taking his cue from the scene depicted in Tissot's painting:

> She entered, and from the first minute she had the delicious sensa-tion of her success. Throughout the long gallery of the Palmer's house it was a true triumphal march. She advanced with firm and precise step, erect, and head well held. She appeared to see nothing, to hear nothing, but how well she saw! How well she felt the fire of all those eyes on her shoulders! Around her arose a little murmer of admiration, and never had music been sweeter to her.[30]

Mme Derline's triumph is short-lived. To the horror of the heroine, the Prince is not present to endorse her appearance at the ball and confirm his first impressions. He has, by this time, already declared someone else to be 'the most beautiful woman in Paris' and Mme Derline is left deflated and humiliated despite her grand entry. While her beauty is, to a large extent, dependent on her elaborate toilette, she is nevertheless punished for her vanity and susceptibility to flattery. The 'woman of fashion' falls as quickly as she has risen. The ambivalent feelings of society towards the artificial beauty of the society woman are captured by Tissot in the way in which a number of the men surrounding the beauty seem to recoil with repugnance even as they gaze surreptitiously at her charms.

In Tissot's series women either implicate the viewer in a suggestive exchange of looks or are ogled from inside the picture frame. In *The Shop Girl* (pl. V) the enigmatic shop assistant locks eyes with the viewer/customer while the men outside, beyond the shop window, salute and peer at the ladies within.[31] The young wife in *The Artists' Wives* (fig. 61) looks around, quite unbelievably, her head turning impossibly on its axis as she strives to engage the look of the observer who is beyond the picture plane and about to take his seat at one of the empty tables in the forefront of the open-air restaurant. The extraordinary doll-like riders at the Hippodrome in *The Ladies of the Cars* (fig. 62) are surveyed by an audience which is predominantly male with just a smattering of brazen females who peer from behind their fans or cast sideward glances at the performers.[32] Some women are mysteriously followed: in *The Mysteri-ous Lady* (fig. 63), an odd cloaked figure, described by one critic as the woman's valet,[33] stalks her and her frisky little boudoir pups in an alley

59 JAMES TISSOT
The Acrobat, 1883–5

60 JAMES TISSOT
The Fashionable Beauty, 1883–5

61 JAMES TISSOT The Artists' Wives, 1883–5

62 JAMES TISSOT The Ladies of the Cars, 1883–5

in the Bois de Boulogne. Others are surreptitiously glanced at, as in the melancholy *Without a Dowry* where two soldiers, set discreetly off-centre, seem quite distracted by a dreamy, demure young maiden, placed mischievously beneath the naked, muscular legs of a male statue in the centre of the picture. One coquettishly dressed young woman is even the object of a crude call by a young ragamuffin in *The Bridesmaid* (fig. 53), at the same time as she receives the lascivious, sideward leer of the best man, whose face is dangerously close to hers. Her rigid, tight-laced appearance is offset only by her provocatively visible feet and suggestively gaping glove which affords a tiny glimpse of her otherwise concealed and contained flesh. Even when no men are actually depicted in the paintings, as in *The Liar* or *The Sphinx*, their hidden presence is invoked. In *The Liar* one is led to wonder about the nature of the lie and the possibility that it concerns a lover, perhaps the man responsible for financing the suffocating luxury of the gilded cage in which the woman is enclosed. In *The Sphinx*, the strategic placing of the cane and hat on the provocatively splayed-out tiger skin was recognized by a number of contemporary reviewers as a metonymic reference to a hastily departed or hurriedly hidden male figure, perhaps metaphorically mauled by the tigress within.[34] Most reviewers thought the narrative overkill of these

63 JAMES TISSOT The Mysterious Lady, 1883–5

64 JAMES TISSOT Without a Dowry, 1883–5

65 JAMES TISSOT The Liar, 1883–5

66 JAMES TISSOT The Sphinx, 1883–5

paintings ludicrous, and poked fun at the overblown pretensions of paintings that strove to tell a tale in so contrived a way.[35] If the figure of the 'Parisienne' herself was already the repository of elaborate narrative projection, then her placement in an enigmatic narrative setting seemed gratuitous, artificial and beyond the legitimate concerns of painting.[36]

That Tissot knowingly manipulated the sartorial signs of sexual difference is clear from two telling little etchings he made in the same year that he exhibited the *Femme à Paris* series. In both of these prints the men's outer garments are gathered, haphazardly, in an interior space. In *Letter 'L' with Hats* a collection of empty top hats pile up unceremoniously in front of a rack of rather rough overcoats and an umbrella propped up against the letter 'L'. It is likely that this and *The Cloakroom*, a glimpse into a theatre cloakroom, are two of a number of letters and vignettes designed to accompany the set of etchings planned for the *Femme à Paris* series. It is tempting to think that the *Letter 'L' with Hats* might be the first of the series and *The Cloakroom* the last, forming a framing masculine presence (signified in the evacuated clothing of contemporary men) for the series as a whole.[37] The stiff rigidity of the empty hats, which keep their form despite the fact that they have been discarded in so untidy a heap, seems like a touching reminder of the posturing and posing of contemporary men. Only hats, umbrellas and canes, those indispensable props to phallic propriety, remain firm and falsely rigid irrespective of the context in which they are found.[38] By contrast, the cloth of the overcoats is rendered rather pathetic without its portly bodies to support it, as the tailpiece so vividly illustrates. Here

67 JAMES TISSOT
Letter 'L' with Hats, c. 1885

68 JAMES TISSOT
The Cloakroom, c. 1885

the shed garments hang like discarded, wrinkled skins, strangely empty and flaccid, the shoulders drooping heavily, the arms hanging aimlessly at the sides. It is as if masculinity has had the stuffing taken out of it, as if its skin has been peeled off and left hanging so that it is both vulnerable and unguarded. The uniformity of masculine attire, rather than functioning as a shield and protection here, seems to connote conformity and a lack of distinction made explicit by the banality of the coat-checks pinned on the coats themselves. Even Tissot himself is implicated in this haunting homogeneity, for his own monogram appears on one of the uncannily empty garments on the left of the print. In the dull backroom of the cloakroom a relentless monotony is suggested, a grey monochromatic conformity. The grand pageant of modern masculinity, eulogized by Baudelaire, is dependent on the rituals of public life for its epic significance and monumentality.[39]

In the late 1860s Tissot had executed a painting of upper-class gentlemen relaxing at their exclusive gentleman's club in which hats and canes and discarded overcoats make unambiguous references to the men themselves. While some of these men seem to have just arrived, and still sport their full outdoor apparel, others have settled in and signify their attitudes of relaxed sociability by their bare heads and casual attitudes. It was men like these, the same men who had accompanied the so-called 'political lady' in the first painting of the series, who comically chose to undress themselves at the circus featured in the extraordinary painting *The Sporting Ladies* (pl. VI). Here '*clubmen*', as the critic for *La Gazette de France* called them, remnants of the declining aristocratic class who did not need to earn a living, could rough it by shedding the penguin suits that usually concealed their bodies and make a spectacle of themselves.[40] The central trapeze artist, his class position established by his monocled face, has been identified as Count Hubert de la Rochefoucauld, a regular performer at the Cirque Molier (an

69 JAMES TISSOT The Circle of the Rue Royale, 1868

amateur circus with a majority of performers drawn from the aristoc-
racy). He and his fellow trapeze artist, reputedly the painter Théophile
Wagner, were depicted by Henri Gerbault in a programme for the Cirque
Molier in 1886.[41] In Tissot's painting, they are watched by a rather dour
bunch of top-hatted gentlemen and a most animated crowd of ogling
female spectators. While they have stripped themselves of their gentle-
man's garb in order to play out a forbidden form of male display, the
women have dressed themselves up in their best clothes to come and
stare. Their brazen looking gives them away as demi-mondaines who
titter and giggle at the indecorous oozing of male flesh (the swollen
buttocks of the central figure positively spill over the thin bar on which
he dangles so comically while the bar of the distant figure cuts into his
meaty thighs), or look solicitously out of the picture at the spectator,
perhaps at a male occupant of the front gallery. So many women look-
ing themselves provided a spectacle tolerable only in the popular arenas
of the circus or the race track. Demure young ladies were required to
satisfy their curiosity by concealing their *lorgnettes* behind their fans
while looking surreptitiously through them. Nor should they be ges-
turing visibly or applauding too ostentatiously. Most importantly, they
should not be seen to be looking.[42] While the ogling women of *The*

Sporting Ladies are dressed like respectable *hautes bourgeoises*, with their demure necklines, elaborate headgear and gloved hands, their animated presences, rampant gazes and flamboyantly waving fans suggest that they are the coquettish creatures of public life: solicitous, sexualized and seductive.

The female figures in *The Sporting Ladies* give off confusing signals about their social origins and seem to be dressed in an elaborate disguise. Their flesh is contained and constrained by their bourgeois costume at the same time as their gestures and gazes reach beyond the confines of good manners. The trapeze artists, on the other hand, are isolated from their top-hatted class allies by their state of semi-undress and unseemly fleshly excess. Their ageing bodies are encased in wrinkled silk, forming puckers and pleats of fabric which stand in for skin and flesh in an outrageously provocative way. The effect is discomforting, even, to quote one critic, 'embarrassing'.[43] These men transgress codes of class and gender decorum. It is the licence that this context gives to such transgression that allows them to glory in the spectacle that they present. For a time, they find themselves allied with those (foreign) men

70 HENRI GERBAULT Programme for the benefit performance
of the Cirque Molier at the Nouveau Cirque, 1886

71 GIUSEPPE DE NITTIS The Grandstand at the Races, c. 1880s

who are permitted to assume the conventionally feminine role of self display, such as the English military men pompously strutting about in the lower men's gallery, or the clown curiously dressed in a Union Jack costume who looks up plaintively from the circus ring.[44] For the representatives of the army, this renunciation is replaced by an even more elaborate form of defensive armoury than the obligatory, anonymous black male costume, while the bathetic English clown, by contrast, is left looking rather vulnerable and pathetic with his garish make-up, ridiculous hat, carrot-coloured hair and frilly collar. He does not cut an impressive figure. Indeed his very renunciation of masculinity is part of what makes him a figure of fun. Foreign, English, an outsider who comments on society without being properly of it, his position mirrors that of Tissot himself, so resolutely defined as English by many of his French contemporaries. The clown as an obvious figure of fun deflects the humour away from the posturing aristocrats but at the same time serves as an ominous pointer to a well-known contemporary literary topos, the impoverished gentleman forced by financial hardship to become a circus performer and play the professional fool.[45]

The juxtaposition of the clown, the trapeze artists and the gentlemen in the crowd offers a tantalizing image of class and gender construction. While normative masculinity is embodied by the suited spectators, their compatriots exploit their own privileged position by taking on a less decorous, performative role which was ruled out of court in the mundane contexts of daily life but was licensed in the arena of the circus. The clown stands as a tragicomic reminder that this is a dangerous game, one which could all too easily become real and thereby divest the sport of its playful, fanciful allure. The aristocratic trapeze artist renounces his masculine costume in an exhibitionistic display which allows him to overstep traditional gender roles. But this game is not without its risks. The potential feminization of such a position is poignantly rendered in a watercolour by Théophile Wagner in which he renders himself in his costume in front of a mirror in a dressing room, accompanied by a female nude. The effect produced by the conventionally feminine setting, the pose in front of the mirror and the costume of leotard and tights is of a castrated man, one who aligns himself with the feminine at some cost.

It is the play with gender and class identities that *The Sporting Ladies* articulates. The picture is structured around a series of conventional polarities which are both staged and overturned. The oppositions between masculinity and femininity, France and England, the upper and lower classes are interrogated and explored here in a potentially open-

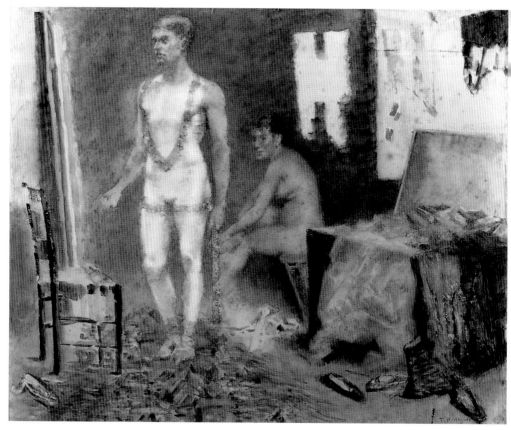

72 THEOPHILE WAGNER Self-Portrait in the Dressing Room of the Cirque Molier, c. 1890

ended way. But the punishment of male transgression remains hinted at by the comic presence of the clown, while the proper place of Woman as exclusive object of display is crucially maintained by the central importance of the pink-clad woman in the forefront who turns around to catch our attention and secure her position as the focus of our desiring gaze. She serves to remind us that it is *her* elaborate costume and finely wrought toilette that is, for the viewer at least, the principal object on display in the modern city, despite the complex games of renunciation and exhibitionism that the picture articulates.

Unlike the performers in *The Sporting Ladies*, the charioteers at the Hippodrome who feature in *The Ladies of the Cars* were drawn from the lower ends of the class hierarchy. While the circus could offer an arena for the enactment of marginal masculine subjectivities, the figures of the clown and the trapeze artist standing for the renunciation of prescribed

roles in favour of liminal, licensed forms of male deviance, it did not provide such a space for female performers. The female acrobats, tight-rope walkers and horse-riders of the fairgrounds and circuses which multiplied in the modern city were the least revered of performers, the least well-paid and the most exploited. In the garish artificial spotlight of the performance, their bodies shone and glowed in a mesmerizing splendour, creating a veneer of perfection and an impression of unblemished surface beauty that belied the actual conditions of their labour and the stresses to which their bodies were subjected. Only an uncompromising realist like Degas could make this labour legible on the strained, unidealized body of his acrobat in the extraordinary *Miss La La at the Cirque Fernando*. The dull scumbled surface and scrubbed materiality of the canvas articulates the labour and strain of performance as much as it reveals the craft of painting. Nothing is here subsumed into slick performance or gilded glamour. The duped crowd at the Hippodrome, on the other hand, was, according to at least one critic, hypnotized by the sight of so much flesh and gold. The seduction of surface glitter hid the stupidity and vacuity of the performers and their false glamour.[46] The massive arena of the Hippodrome provided entertainment on a grand scale. The hall could hold up to ten thousand spectators.[47] The sheer numbers are evoked in Tissot's painting by the sea of minute top hats and bonnets which are dotted in the distant raked seats. In the ring, the riders perform impassively on their chariots, their faces expressionless, their statuesque presences providing a marked contrast to the moving limbs and animated faces of the galloping horses. These stiff, frozen figures, with their scaled armour, padded hips, piercing headdresses and erect and upright carriage, seem like puppets[48] polished to reflect the garish electric light and gilded excesses of the massive entertainment hall. They are monuments to modernity, reminiscent of lofty allegories of liberty, justice and peace, but here reduced to mindless mannequins signifying nothing more elevated than the glitter of gold and the passing pleasures of empty pageantry. The audiences at the Hippodrome came to be amused rather than edified. As such, they regularly feasted their eyes on a diet of female flesh, spectacularly displayed, perfectly packaged and easily consumed.

The association between looking and consuming that was so crucial a part of the spectacle of modernity is brilliantly suggested in Tissot's *The Shop Girl* (pl. V) in which a series of enigmatic looks is exchanged in the quintessential modern and commercial context of shopping. Here the bustling boulevard and the intimate feminine interior of the dressmaker's shop come dangerously close together.[49] As in an anonymous pen and

73 EDGAR DEGAS Miss La La at the Cirque Fernando, 1879

74 Anonymous, Millinery Shop, c. 1870s

ink drawing of a milliner's shop from the 1870s, the door between the inner feminine sanctum, replete with braids, ribbons, cloth and lace, and the predatory world of the exterior is open, thereby revealing the inter-penetrability of these spheres. The transparency of the glass shop front provides another barrier which, while forbidding entry, facilitates the interchange of looks, indeed places the interior on display for the passer-by and potential customer. Prominently displayed in the window of *The Shop Girl* is a headless and limbless shop dummy sporting a tightly fitting bodice over a stylishly hour-glass body. This doll is moulded to present the ideal shape that only the tight-lacing of the corset could produce in actual women's bodies. The bodice hugs the body, forming its own curvaceous carapace for the corseted figure beneath.

The rigid scaffolding of the corset produced a stiff structure onto which clothing could be placed. The ideal figure of fashion was the shop mannequin, headless, lifeless and available for perpetual scrutiny. In Tissot's painting the dummy's contours are mirrored by the severely moulded shapes of the shop assistants, whose frames were expected to conform to the rigid requirements of fashion. These women, demurely clad in their black uniforms, are both involved in exchanging glances. The one that holds open the door looks at the viewer, here conceived, perhaps, as a woman who has completed her purchase and is about to be

handed her neatly wrapped pink parcel as she leaves. Her coachman and horse await her outside. Already she appears to be hailed through the window by the top-hatted gentleman behind the shop girl. Her purchase over, she herself re-enters the world of exchange in which she is perused, assessed and, if she's lucky, desired. The possibility that it is the viewer herself who may be incorporated into this drama of sexual exchange is disquieting. To look at the picture is to be subsumed into its narrative possibilities, and this position, for a female viewer in particular, is unnerving. While this invisible drama is suggested in the right-hand half of the painting, a more explicit exchange is enacted on the left. Here another top-hatted gentleman penetrates the interior with his stare. He, according to contemporary critics,[50] is exchanging a furtive glance with the shop girl on the left, their stance exactly duplicated in the position of two chairs in front of the table.[51]

The association of sex and shopping is perfectly articulated in French by the word for that novel experience, window shopping: *lèche vitrine*, or literally, licking the window. Women were thought to have a voracious and uncontrollable appetite for shopping which novelists such as Emile Zola represented in highly sexualized terms.[52] Describing a crowd of women before the shop window of the department store which is at the centre of his novel about modern consumerism, *Le Bonheur des dames*, he writes:

> ... groups of women [were] pushing and squeezing, devouring the finery with loving, covetous eyes. And the stuffs became animated in this passionate atmosphere..., even the pieces of cloth, thick and heavy, exhaled a tempting odour, the dresses threw out their folds over the dummies which assumed a soul, the great mantle, particularly supple and warm as if on real fleshly shoulders, heaved, panted and expanded its limbs.[53]

Lèche vitrine: consumption of goods and consumption of bodies amount to the same thing here. The delicious sensation of looking at desirable objects is akin to licking, a very physical way of describing the eroticized pleasures of looking. But it is not only the looking at goods on sale which is represented in *The Shop Girl*. For Tissot, more important than the desiring look of the female commodity-fetishist is the lecherous looking directed at women themselves. The penetration of the interior by the 'licking' of the external viewer's gaze is symbolized in the interior by the curious little griffin so conspicuously placed at the corner of the table. This masculine presence, its columnar shape comically echoing that of the coachman, is shown with a long curled tongue which is positively lewd in its associations. Vulgar, bawdy and mischievous, its intrusion into the feminine indoor space seems almost an affront, but it serves as a salutary reminder that even the realm of the intimate interior is circumscribed by its relation to a public realm to which it owes its existence. Indeed art itself was implicated in the eroticized commercialism of the day by the manner in which Tissot's paintings were exhibited. Placed under glass at eye level, they themselves are seen through windows, invoking objects for sale in shop windows. To see these works the viewer had to 'lick the window', to engage in a sensory experience which was figured in the body rather than in the disembodied eye of disinterested contemplation. He/she was constantly reminded by the glass that these works were objects for sale, commodities like the goods they represented.

Tissot's interest in the packaging of femininity in the context of the

modern metropolis is articulated very differently in the curious *The Artists' Wives* (fig. 61) which also formed part of the series. In *The Shop Girl*, Tissot had painted those young women of humble birth who learned to adopt the behaviour and mannerisms of their clientele in the course of their work. Their demure uniforms obviated the necessity for dressing up and their perfect demeanours and acquired manners served to hide their crude beginnings. The artists' wives, on the other hand, were dressed up in the fashionable regalia of the urban bourgeoisie. These women are consummate representatives of the new-found fashionable femininity available from the department store, 'the sham elegance born of the shop' of which Alphonse Daudet wrote. They came, wrote one critic, in all colours and in a number of different moulds.[54] Tissot paid minute attention to the details of their costume. Their hats are veritable bouquets over their swept-up coiffures, their dresses busily patterned and dotted, and their hour-glass figures as tightly laced as any shop mannequin's of the period. One critic described them as 'gracious puppets' content to be manipulated so as to be agreeable spectacles[55] for passing viewers. Their taut torsos, which seem to strain at the seams, are suggestively contrasted by the rounded contours of the lightly draped caryatids of the building behind, whose classical coverings seem to express the lines of their monumental bodies rather than transform or restrict them. Two of the women in the forefront are demurely gloved, making the hand belonging to the central female figure seem ostentatiously bare and exposed. The wedding ring on her finger, placed prominently in the foreground and framed in the starchy whiteness of the table linen, gives ample evidence that these dressed-up ladies are indeed wives. Out lunching flamboyantly 'chez Ledoyen', a fashionable open-air restaurant, on *le jour de vernissage* (opening day),[56] they are keen to be seen in their splendid outdoor regalia at the fashionable watering hole where *tout Paris* has gathered to gossip and gawp in the bright spring sunlight.

The pretensions and disappointments of 'artists' wives' had been the subject of some satire in the 1870s. Alphonse Daudet's collection of stories entitled *Les Femmes d'artistes*, published in 1876, chronicled a number of disastrous marriages in which artists – fragile, nervous creatures ('child-men' as he called them) whose talent needed to be nurtured and nourished – were destroyed by the rapacious appetites and superficial concerns of their status-seeking wives.[57] According to Daudet and many of his contemporaries, artists made lousy husbands. Genius was all-consuming and it left no room for the mediocre pleasures of the hearth. Artists' wives, Daudet concluded, would inevitably end up

embittered and disappointed and were bound to pull their unfortunate husbands down with them. Daudet's characters constantly advise artists not to marry. Marriage led to 'the degradation of one's talent' on the part of the artist and misery on the part of the wife: 'It cannot be very amusing to be the wife of a genius. There are plenty of labourer's wives who are happier', he wrote.[58] A classic Daudet example of the unfortunate artist's wife is Mme Heurtebise, a shopwoman of modest income who marries a writer. 'What pleased her in this marriage', wrote Daudet, 'was the idea of wedding an author, a well-known man who would take her to the theatre as often as she wished. As for him, I verily believe that her sham elegance born of the shop, her pretentious manners, pursed up mouth and affectedly uplifted little finger fascinated him and appeared to him the height of Parisian refinement, for he was a born peasant and in spite of his intelligence remained one to the end of his days.'[59] The 'Parisienne' confers status and style on her country bumpkin of a spouse, while his literary pretensions are expected to lend substance to her superficial, rather shallow existence. In the end neither one satisfies the other and the marriage, like all Daudet's cases, ends in disaster.

There were some critics who recognized in Tissot's painting the by now familiar combination of anxious artists and upwardly mobile wives.[60] One critic, writing for Le Figaro, saw the exhibition of The Artists' Wives as the perfect opportunity to contribute to the expanding discourse on a new social type.[61] To be married to an artist, the critic claimed, was a dubious pleasure: 'If the Parisienne was the bravest of women then the artist's wife was the bravest of Parisiennes'. The phenomenon of 'the artist's wife', wrote this critic, was in any case a new one. Any self-respecting artist of the 1830s would rather have been guillotined than married, but bohemian culture was a thing of the past and artists now sought respectability via the most conventional channels. Since the Franco-Prussian War, the critic declared, artists had seen fit to set themselves up in intimate ménages and were now lamentably bourgeois. Wives still had to put up with much eccentric behaviour from their artist-husbands (the very term seemed oxymoronic), but artists were no longer paupers and some could receive incomes of a hundred thousand francs a year for 'oiling a canvas'. As such they were good catches for grocers' daughters and other women with aspirations to rise above their station. But artists were always going to be disappointments to such women. Their eccentricities, penchants for fads and aberrant crazes – they would raise bears, keep lions, smoke pipes – would drive all but the most heroic and brave creatures to despair and it was only among 'Parisiennes' that such noble, brave and absolutely contempo-

rary creatures were to be found. It was these unlikely heroines of modern life that Tissot had captured and it was to them that critics paid a rather mocking homage.

There is something pathetically perky about the way the stiff figure in the brown dress in *The Artists' Wives* cranes her head to see who is looking at her in her feathers and finery. She seems to look out of the picture to proclaim her good fortune and revel in the limelight, or perhaps to check which renowned artist or critic is about to take his seat at the front table. Of course the viewer (another artist or perhaps a critic) is interpolated as just such a character, hailed by the solicitous glance of the over-eager young woman in the foreground. Across the table from her sits the only recognizable artist in the picture, John Lewis Brown.[62] The choice of this top-hatted, ruddy-faced gentleman for the image of the artist underlines the new-found respectability, even stuffiness, of the profession while invoking Tissot's own reputation as an 'anglicized Frenchman' functioning within the exclusive and jealously guarded networks of the Parisian art world.

The Artists' Wives raises questions about the legibility of class, gender and national signs as they are inscribed on the body in modern-life painting. Contemporary critical accounts provide an indispensable resource for reading beyond surface appearance and revealing the anxieties that attend attempts to fix identity and secure it for interpretation. The outer packaging of a woman did not, as we have seen throughout this chapter, necessarily reveal who she was or where she came from. The idea of disguise and display was at the heart of the modern construction of femininity that was articulated by the figure of the 'Parisienne'. Ostensibly egalitarian, the 'Parisienne' did not need to be born in Paris. Equally, birth in that city did not guarantee the possession of those enigmatic qualities, that *je ne sais quoi*, said to characterize the 'Parisienne'. Part of her allure was the mystery in which she was veiled. What lay beneath the veil was an object of unending curiosity, but the risks of looking at her too closely were always present. The venal power of Woman was only constrained by her costume, it was not vanquished by it.

In nineteenth-century mythologies, Woman always exceeds the parameters of her performance. Like the android of modern science fiction, her careful programming cannot always be controlled and the dazzling spectacle of her sexuality, however contained and packaged, can threaten her admirer with blindness or even death. It was this danger that was so enigmatically thematized in the first painting of the series, *The Political Lady*, with which this chapter began. Here the

excessively pink and pleated 'Parisienne', with her outdated black girdle, large presence and false smile,[63] causes havoc as she sweeps into a full room. The monocle of the elderly man placed in front of her commanding presence is transformed into an opaque eye-patch at the sight of the resplendent striding woman, an event mirrored by the sinister blinding of the figure in the violent scene depicted in the background sculpture in which a man's eye is shown to be penetrated by a horrific spear. Danger lurks beneath the glittering surface of this lavish occasion. From the start, Tissot had unwittingly articulated the double-edged nature of the fantasy of femininity embodied by the 'Parisienne'. Her fetishized body held in a nature and a sexuality that were deemed dangerous and threatening. Her beauty, alleged some commentators, was the 'beauty of the devil', concealing a duplicitous and deceptive nature.[64] The mask was indispensable to stave off the fear of castration and death which the spectre of femininity invoked.

But as the misogynist pornographer Felicien Rops knew, the mask of femininity could easily be peeled back to reveal the hideous face of

death. Woman was positioned as tantalizing temptress while being the source of syphilis, disease and ultimately death. The fascination with the mysterious allure of femininity was always, therefore, permeated by fear. The *Femme à Paris* series, with its cheerful banality and wooden female characters, represents the mask of femininity without, for the most part, dwelling on the anxieties at the source of this elaborate masquerade. Only unwittingly, in small asides like that provided by the blinding spear, does the threat of castration which fuels this fantasy of femininity find its place. And it is details like this one that suggest that it is the fear of women that contributes to the creation of Woman as type. Tissot's *Femme à Paris* series deals in just such a type. To remove the mask would have been to unleash the hideous monster beneath the fetishized image of femininity known as the 'Parisienne'.

Powder and Paint:
Framing the Feminine in Georges Seurat's
Young Woman Powdering Herself

Tissot's *Femme à Paris* series had presented the 'Parisienne' as an already fabricated creature, a puppet playing her part in the metropolitan spaces which she inhabited. She had been programmed to occupy her place and respond to the cultural cues that fuelled modern sociability. But everyone knew that the 'Parisienne' did not spring fully formed from the womb. Like a hot-house flower or an elaborately painted doll, she was the synthetic and finely tuned creation of culture, a testimony to all that effort and luxury could produce. Her hallmark was artifice: she was the sophisticated product of modern tailoring, grooming and cosmetics. Her outer bearing was dictated by fashion and fortune, while her manners, mannerisms and mode of relating were learned in the homes, drawing rooms, dressing rooms and department stores of the modern metropolis.

The process by which a woman could be transformed from a mere female into the epitome of feminine desirability exerted a considerable fascination over artists in the late nineteenth century. Especially popular were pictures of women assuming their public faces, their modern masks, in the ostensibly private sanctuaries of their dressing rooms. The application of make-up, itself a kind of painting, became the subject of high art and popular imagery alike. Oil painting provided a medium through which the interior could be exposed to public view and the inner sanctum of female artistry could thereby be put on display. The staging of the woman at her dressing table provided an appropriate setting for modern-life figure painting, offering a credible setting for a semi-dressed model in a modern context, as well as a revealing glimpse into a woman's most private quarters, her interior space.[1] At the same time it exposed the lengths to which women would apparently go to conceal their deficiencies and adorn their bodies in order to lure or keep their men. For many contemporary commentators, the theme suggested a comparison between the superficial artistry of women, endlessly and sometimes futilely preoccupied with their own self-preservation and presentation, and the elevated, disinterested concerns of Art and the Ideal to which the serious male artist aspired.[2] His privileged view into a

78 GEORGES SEURAT Young Woman Powdering Herself, 1890 (plate VII)

woman's private space allowed him to differentiate his own activity from hers while at the same time taking on the elevated position of an 'observer of modern life'. It is to the image of self-adornment, of semi-dressed women fabricating their femininity for public view, that we shall turn in this chapter, focusing in particular on a painting by the neo-Impressionist artist Georges Seurat in which a 'woman's sanctuary' constitutes the setting for a fantasy of femininity which was flagrantly exposed for public scrutiny.

Some time in late 1889 and early 1890 Seurat transformed a small, modest oil study of a woman at her *poudreuse* or dressing table, absorbed in applying her make-up, into an ambitious, finely crafted and highly finished canvas of the same subject. As in the study, the finished painting shows a woman in the act of powdering her bosom, her one hand poised on the edge of the table as if holding a powder pot, the other gingerly grasping the powder puff, suspended between furniture and flesh. Where the scale and haste of the study only allowed for the figure to be roughly sketched in, concentrating attention through an emphatic flurry of shadowy dabs on the rounded softness of the poised powder puff which punctuates the tense distance between mirror and chest, the finished painting gives a more complete, if enigmatic, sense of a person in a furnished room. The tall, columnar format of the prelimi-

nary study is transformed in the finished work into a squat, squarer shape which allows for a fuller expression of the figure's amplitude, her puffed-up pneumatic femininity, as well as the inclusion of the whole dressing table and the bamboo mirror or picture frame suspended on the patterned, almost undulating, wall. The table and mirror have lost their elongated, spindly unity, reminiscent in both colour and shape of that towering monument to modernity, the Eiffel Tower, a study of which Seurat had produced in the same year. Comparing the study for the *Young Woman Powdering Herself* (fig. 77) with the small sketch of the Eiffel Tower prompts an immediate recognition of the visual parallel between the tower in the one image and the table and mirror in the other, even if their identity as objects is markedly distinct. The structural connection between the *poudreuse* and the mirror that surmounts it, and the vertical tower then riveting Paris was no doubt subliminal for Seurat. Nevertheless, the juxtaposition of an overtly modern femininity, in the process of being packaged and produced for specular consumption in the most spectacular of cities, with the still incomplete but already quintessentially modern symbol of *fin-de-siècle* Paris, would

79 GEORGES SEURAT Eiffel Tower, 1890

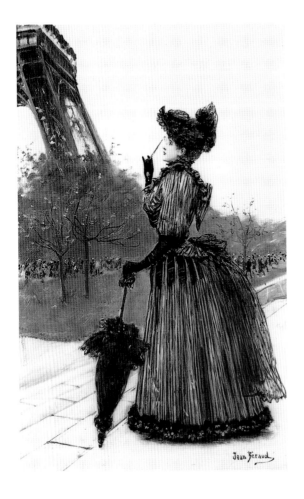

not have been idiosyncratic. Modern-life painters like Jean Béraud caught the flavour of the moment by setting up visual parallels between the corseted and erect figure of the 'Parisienne' and the newly proclaimed emblem of France's technological and aesthetic prowess in paintings such as *In Front of the Eiffel Tower* of 1892. Paris was proud of both its tower and its women and the conjunction of the two conferred grace and elegance on the steel structure while confirming the fashionability and metropolitan chic of its female subjects.

Femininity and the tower come together rather curiously in a contemporary advertisement for face cream published in *Le Dimanche illustré* in 1889. Here the tower itself is composed of the smiling heads of 'Parisiennes' mounted one on top of the other while the script below

says nothing about the tower, but extols the virtues of the 'Parisienne', whose renowned prettiness is the result of the care she confers on her complexion. Like the tower itself, she is the product of careful construction and deliberate design. The Eiffel Tower becomes the face of Paris at the same time as the face of the 'Parisienne' is the result of modern, even scientific methods of preservation. Tokalon cream, the advertisement claims, is scientifically formulated to rejuvenate the skin and reconstitute the tissues, suppress wrinkles and dilated pores as well as defects of colour, thereby rendering cheeks firm, fresh and faintly pink. The secret of beauty is in scientific advancement. The bold engineering of the tower is appropriated for the arts of adornment while the comforting face of female beauty is used to soften technology's steely veneer. The traditional association of women with make-up offers a reassuring gloss on the relentlessly modern structure, pasting pretty women over its empty steel skeleton as if to conceal its gaping, vacuous core, while the technological expertise to which the tower testifies gives credibility to the pseudo-scientific claims of the face cream's advertisers.

The link between high art and advertising is made more overt by a comparison between the *Young Woman Powdering Herself* and a contemporary advertisement for toothpowder. Here the commercial image draws on high-cultural precedents of women at dressing tables replete with mirror and perfume bottles in order to dignify the product on sale. Conversely women could be tainted by the vulgar connection to the

80 JEAN BERAUD In Front of the Eiffel Tower, c. 1892

81 'Pourquoi les Parisiennes sont si jolies', advertisement for face cream, 1889

82 Advertisement for toothpowder, late nineteenth century

commodity invoked by the display of their bodies in advertising. The direct address of the model to the spectator in the advertisement betokens a brazen lack of modesty which is different from the downcast eyes and introverted demeanour of Seurat's *jeune femme*, but the adornment of the body could itself be, as we will later see, a sign of vulgarity, a suggestion that the body was being packaged for sale, for circulation like goods in the context of the marketplace.

The image of a woman applying make-up, contemplating her reflection, or positioned in front of a mirror, however traditional, was, at this point, always double-edged. For like the newly built steel tower to which the crowds flocked, woman might easily have been accused of being *all* surface: showy, ostentatious, puffed-up and hollow. Contemporary men liked to make jokes about the lengths to which women would go to present a credible, attractive exterior. Some, we are told, even wore inflatable devices to expand their chests and were suitably chastened and mortified when amorous admirers pinned flowers to their bosoms only to find that they deflated instantly and the lady's charms were exposed as false.[3] Like the newly invented hot air balloon, inflatable bosoms were risky and dangerous, capable of inspiring great flights of the imagination, but also suggesting potential disaster. One fanciful commentator suggested that they would prove their usefulness if a woman were to fall into a puddle and find herself in need of a safety tube. The charm of false breasts rested on the multiple uses to which they could be put, he mockingly claimed.[4] The 'artificial chest', as it was called, was the subject of much satirical literature in the period. Men were shown staring at corset displays in shop windows, while duped husbands who were foolish enough to be taken in by their wives' amplitude before the wedding night, and were shocked to find that beneath their corsets and false finery their wives were skinny or flat-chested, became common characters in comic literature and caricature. Before and after shots appeared in numerous contemporary satirical publications showing plump women squeezed into metallic braces while thin ones were padded out and moulded to perfection.[5] The gap between nature and artifice was acknowledged to be wide and the burgeoning cosmetic and fashion industries tempted women with promises of a transformation that would bring beauty, happiness and certain success.

The habit of showing women in the process of masking nature through artifice, while offering a tantalizing glimpse of a private activity, also seemed to bear out assumptions about women's essentially duplicitous and deceptive character.[6] For while women were required to pay attention to their physical appearances in order to appear attrac-

83 Man staring at corsets in a shop window, from G.J. Witkowski, Tetoniana, 1898

84 'Before and After the Corset': a typical satirical caricature of the period, c. 1880s

LES FEMMES D'AUJOURD'HUI. — Iᵉ SÉRIE : AVANT ET APRÈS LE CORSET

tive, they were also blamed for over-investment in their own image. Lucy Lee Robbins, one of the few women painters to specialize in the nude during this period, exploited the potential of the toilette as a setting for modern-life nudes in *The Mirror* of 1895 (fig. 85). Here, the familiar dressing table and freestanding mirror, conventional props in works of this kind, provide the framework for a study of the female body in which Woman's narcissism is staged as spectacle, her self-admiration set up to provide the viewer with the opportunity to mirror the model's own admiring gaze with a parallel one. But such obvious

85 LUCY LEE ROBBINS The Mirror, 1895
86 'If I was a man, I wouldn't want to marry any woman but me!',
from Le Rire, 27 July 1907

pleasure in an image of the self was disquieting for critics. Here woman
fulfilled her function with a little too much pleasure. 'Does a pretty
young woman have the right to look at herself so indulgently and to
smile at her own attractions?', asked the critic for *L'Art français* on
viewing the work at the Salon. The painting amounts to a response in
the affirmative, he continues. In fact Mlle Robbins might just as well
have inscribed the picture with the words: 'Ah, I smile to see how pretty
I am in this mirror', he pointedly concludes.[7]

A slightly later image from *Le Rire* shows a woman who is ostensibly
so enamoured of her own image that she announces that were she a
man she would not want to marry anyone other than herself. She preens
herself revealingly at her mirror, her dressing table bearing the custom-
ary collection of bottles, flowers and circular mirror. A painting such as
E. Fichel's *A Kiss in the Mirror*, exhibited in the Salon of 1891, uses the

opportunity of the mirror to reveal both front and back views of the model while projecting a perverse autoeroticism onto the woman, who seems to caress and embrace herself as she perches precariously on a suggestive fur rug. This is narcissism run riot. The woman has turned her own image into the object of her libidinal investment, kissing it with the open-mouthed passion of an inflamed lover. She has literally fallen in love with her own reflection and seems unaware of its illusory nature.

Few contemporary works showing women in front of mirrors infuse such passion into the relationship between woman and reflection. More often it is the spectator who is knowingly addressed in an erotic triangle in which the unclothed woman looks from the mirror beyond herself to a presumed viewer, as in another of Lucy Lee Robbins' tributes to the toilette of 1892. As one contemporary commentator put it, the picture provides a privileged view, an indiscreet glance through the keyhole

87 E. FICHEL The Kiss in the Mirror, from Armand Silvestre, Le Nu au Salon de 1891
88 LUCY LEE ROBBINS At the Toilette, 1892

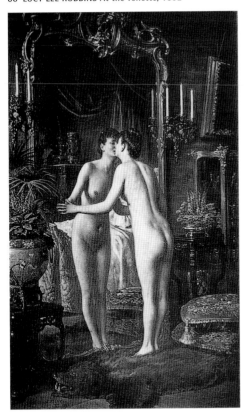

to the privacy of the boudoir, thereby revealing the 'whole arsenal of feminine coquetry' from powder puff to perfume bottles, all artifices and *aides de beauté*, designed to inflame the passion of an amorous admirer.[8] Here the seductive potential of make-up is powerfully suggested by the triangular exchange of looks that the model, reflection and putative spectator set up.

Writing on the abundance of images of women and their mirrors in the Salon during this period, the renowned art critic Armand Silvestre commented: 'Men have really got more important things to do than to contemplate the blossoming of their own questionable beauty' in their looking glasses. Women, on the other hand, were, in his view, justifiably devoted to turning themselves into deities which they could believe in and endlessly worship.[9] In this he followed Baudelaire who had extolled the virtues of make-up some thirty years earlier. But whereas for Silvestre women deified themselves for their own satisfaction, and only inadvertently for men's, for Baudelaire it was for men that women turned themselves into goddesses of artifice: 'Woman', he wrote, 'is quite within her rights, indeed she is even accomplishing a kind of duty, when she devotes herself to appearing magical and super-natural; she has to astonish and charm us; as an idol, she is obliged to adorn herself in order to be adored.'[10]

The image of Woman's self-adornment, it seemed, represented feminine narcissism at the same time as constructing women as objects of scopophilic desire. Pictures of women at the toilette testified to women's intrinsic vanity, their peculiar ability to turn themselves into objects of fascination both for their own autoerotic satisfaction and for the tempting and tormenting of their male admirers. Women trod a fine line here. In order to fulfil the requirements of femininity they had to demonstrate a concerted interest in their appearances while at the same time risking fulfilling expectations that they were vain and self-obsessed. Indeed, their vanity and self-containment formed one of their main attractions. It was, according to Freud, a certain 'self-contentment' which compensated beautiful women for the social restrictions that were imposed upon them. 'Strictly speaking, it is only themselves that such women love with an intensity comparable to that of the man's love for them', he wrote. Such women (that is beautiful women absorbed in their own appearance) exercised a deep fascination for men and played a crucial role in what Freud called 'the erotic life of mankind'. Like children and certain animals, particularly cats and 'large beasts of prey', they were inaccessible and self-absorbed, representing for men a blissful but unattainable state of mind, a sort of lost paradise, which men had been

89 After MME ACHILLE FOULD,
Rosa Bonheur in Her Studio, 1893

forced to abandon as adults.[11] They represented the plenitude of child-hood, the self-fulfilling autoerotic pleasure of an infantile state.

Women's femininity during this period was in fact measured in rela-tion to their narcissistic self-absorption. Those who did not devote a considerable amount of attention to their personal appearance risked being called monstrous or manly. A figure like the renowned animal painter Rosa Bonheur, pictured in a portrait by Mme Achille Fould in front of an easel rather than at a dressing table, and wearing painter's smock, trousers and comfortable shoes rather than elaborate female attire, constituted the antithesis of womanly beauty. Her unadorned hair, loosely framing her face, forthright stare and cleanly scrubbed appearance indicated a woman who looked beyond the conventional trappings of femininity, while the image of a pride of lions depicted on the canvas placed on the easel evinced a mind that reached beyond the confines of the boudoir and the ballroom. Rather than being herself akin to the 'large beasts of prey' with which Freud identified the beautiful woman, Bonheur paints these beasts, creating a distance between her own purposeful activity and the animals' vacant repose, and thereby assuming an active subject position which is culturally aligned with masculinity. Bonheur's tool is the paintbrush rather than the powder puff, her orientation is outward towards the world rather than turned

90 'An old woman at her toilette', from G.J. Witkowski, Tetoniana, 1898
91 JAMES GILLRAY The Finishing Touches, 1791

backwards upon the self. As such, she represents an aberration.[12] The only artistry deemed appropriate to women was self-adornment. Women artists, alleged their contemporaries, risked sacrificing their looks in the interests of a manly pursuit of professionalism. They would have been better off attending to their own appearances than worrying about aesthetic problems which were beyond their legitimate area of concern. True women embraced artifice and the conception of their own bodies as canvases to be turned to pictorial effect, or as clay to be moulded to the dictates of convention. As Octave Uzanne put it, if men were obliged to 'dress', women had the responsibility of ornamenting themselves, of surrounding themselves in a seductive envelope, a skin of allure and attractiveness. Indeed women's putative love of artifice, of 'rice powder, venetian tints, eye pencils, lip pencils, make-up and all manner of recipes for beauty', was, for the men of the nineteenth century, a necessary part of their charm.[13] Théophile Gautier wrote of women's understanding of the inevitable dissonance that existed between elaborate costuming and an unadorned face and figure. As painters harmonized flesh and draperies with fine glazes, so, he claimed, women whitened their skin to accommodate their satins and laces and create a unity of tone in their appearance. 'By the means of a fine powder', he wrote, 'they give to their skin the effect of marble' and remove the vulgar ruddiness that is a mark of excessive physicality and lack of refinement. In order to create a unified effect this powder had to be applied evenly

over neck, shoulders, breasts and arms, forming a light veil which 'concealed' the exposed flesh,[14] a superficial outer skin which testified to women's vain self-absorption at the same time as sealing in any expression of a febrile, flushed physicality.

Women's apparent attempts at self-transformation provided ample opportunity for vengeful satire. One image shows a woman staring admiringly at her own reflection while a man pulls vigorously at her corset laces. The result is that she is broken in half like a plaster doll with her head flying appropriately into the shattered mirror to which she has been too much attached.

Notwithstanding moralistic pleas to women's piety, and the widespread condemnation of their vanity, women of all classes were advised to make up. Advertisements and mail order catalogues appealed to their weaknesses, entreating them to spend their money on all manner of improving remedies. Modern science it seemed could help them to paste a brave face over their defects and defy the laws of nature and gravity. Wives were threatened with loss of their husbands, who could not be trusted to be faithful if they neglected themselves, while at the same time being warned that the artifice of the successful wife should be so skilful that her secrets were never revealed. In the words of one female commentator: 'The husband should always find his wife fresh, beautiful, sweet as a flower; but should believe her to be so adorned by Nature, like the lilies of the field'.[15] It was essential, therefore, that the dressing room be the most private of sanctuaries into which a husband should never be admitted. Modesty and 'a certain instinct of vanity', it was said, should prevent her from being seen in the act of self-adornment. She should appear like a finished painting on display, without revealing the effort of her execution.

92 'Tighter, tighter ... crack!', from G.J. Witkowski, Tetoniana, 1898

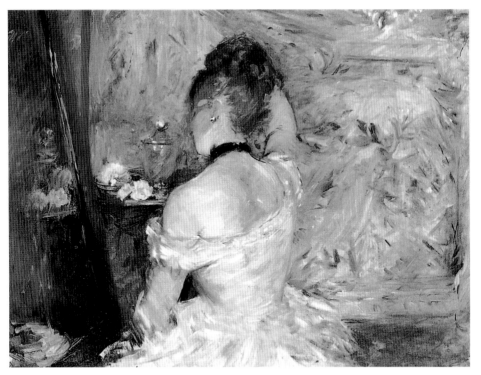

93 BERTHE MORISOT Lady at her Toilette, c. 1875

Analogies between make-up and painting are numerous in this period. Colour itself had long been the discredited term in discussions of painting, with line and design elevated to a lofty, idealized and masculine position in academic art theory, while colour was associated with ornament and the feminine.[16] But where the application of colour in painting could be denigrated by being allied to the superficial concerns of cosmetics, cosmetics could be, conversely, elevated by association with the high art of painting.

When women artists such as Berthe Morisot turned to the image of the woman adorning herself in front of the mirror as a suitable subject for modern-life painting, one which allowed them to focus on the semi-dressed female body in a contemporary setting without calling their own modesty into question, they found themselves in a curious position. For while they could easily identify with the model, having sat countless times at their own dressing tables in just such a fashion, the paintings nevertheless reveal a distance between artist and hired sitter, paid to represent the outer husk of bourgeois femininity as it is being

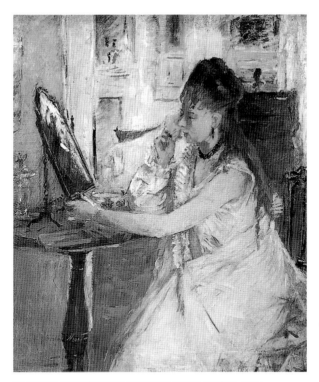

94 BERTHE MORISOT Young Woman Powdering her Face, 1877

fabricated. It is not *maquillage* which is on show here, after all, but an oil painting by a professional woman depicting another woman engaged in the act of making up, of constructing herself as feminine. And rather than mimicking the smoothing over, emphasizing and contouring which characterizes the art of make-up, more related to the skills of *trompe l'oeil* than the facticity of Impressionism, Morisot seems to revel in the abstract qualities of paint, its non-descriptive materiality and the way in which it forms its own dense veil over figure, reflection and surrounding space.[17] This virtuoso display of paint's autonomy frees it from its descriptive function both in its culturally debased form as make-up and in its academic form as a medium for illusionism. The very opacity of the painted surface points to the artifice of painting itself, so that while seeming to conform to an image of normative femininity, Morisot confronts this image with another kind of activity, one which dares to look beyond the self and to translate that vision into a picture for exhibition. A detailed examination of the mirror reflection in *Lady at her Toilette* of *c.* 1875, with its effusive brushmarks and autonomous

gesturing, provides a curious analogue of the painting as a whole, framing the marks on its surface as the products of a motivated hand rather than a passive reflection. The overt materiality of this surface is tantamount to an assertive denial of make-up as the equivalent of painting even while it subtly depicts a woman engaged in making up. For someone like Morisot, therefore, the image of a woman making up could function as an allegory of painting itself, in which the woman artist seems to embrace woman's role by depicting a suitably feminine subject at the same time as subverting it by refusing its terms of reference. In her *Young Woman Powdering her Face* of 1877 the model seems to caress her cheek with her powder puff as she adjusts her mirror the better to see her reflection. But the tool in Morisot's hand that has produced this self-referential caress is a paintbrush, just like the paintbrush that had been clutched in the 'manly' hands of Rosa Bonheur, here capable of creating a mirror which shows no reflection but rather displays a flurry of painted marks, a glorious opaque surface of blacks and whites. This is a painting within a painting which frames the act of painting itself and which, while depicting one woman at her make-up, frees another from it as her only legitimate destiny.

In choosing the image of the woman at her toilette as the arena for a demonstration of painterly prowess, Morisot chose well. The art of female adornment had long been a subject of oil painting. From the toilettes of Venus of the High Renaissance to the eighteenth-century genre paintings of fashionable beauties, the fascination with the appearance of femininity, the artifice of female beauty, and the relationship between

95 VICTOR JOZE, L'Homme à Femmes, 1889

painting, reflection, decoration and surface had regularly found expression in pictures of women at mirrors. Traditionally associated with vanity, the juxtaposition of women and mirrors became one of the stock ways of exploring the Vanitas theme, with its moralistic overtones of censure for over-indulgence in worldly goods and superficial appearances.[18] Eighteenth-century artists such as François Boucher drew on High Renaissance precedents in their sensual evocations of the adorning and adoring of the goddess of love. In his *Toilette of Venus* (fig. 96), a mirror is held up to reveal the profile of the goddess for the benefit of the spectator while she is surrounded by attentive putti and maidens who seem to present her carnal beauty to the viewer.

In eighteenth-century portraits such as that of Madame de Pompadour (fig. 97), the attendants are gone, as is the mythic context, and a recognizable contemporary figure presents her body for viewing even as she adorns it in preparation for being seen. This portrait constitutes an appropriate pictorial precedent for Seurat's *Young Woman Powdering Herself*. Here woman, make-up, mirror, bows and flowers are all equally present, but where Madame de Pompadour turns her attention away from her mirror to fix her confident gaze upon the viewer, Seurat's model stares inwardly at her reflection, her downcast eyes seeming half closed, her disposition dreamy rather than provocative.[19] Both Madame de Pompadour and Seurat's model are poised in the moment of application of their make-up, the one about to apply rouge over her powdered pallor in customary eighteenth-century French fashion, the other in the process of applying powder to her chest and cleavage. Both women reveal ample snowy bosoms, although the upper-class eighteenth-century lady is shrouded in lace and cape which frame the unblemished expanse of her smooth chest, while the scantily dressed woman pictured in Seurat's image wears what appears to be either underwear (corset and petticoats) or, as art historian Robert Herbert argues, the familiar costume of the café concert performer.[20] A contemporary cover drawing for Victor Joze's *L'Homme à Femmes* shows just such a bosomy figure, poised in profile ready to perform.

The excessive focus on the model's chest in Seurat's painting has led critics to see it as comic or ironic in tone, but if this image is a joke it is of a type exchanged between men at women's expense.[21] Large breasts, were, in the nineteenth century, a focus for satire and bawdy humour. They were not quite polite, perhaps because they declared themselves too forcibly. According to art historian Richard Thomson, an analysis of the structural principles on which the painting is based reveals an intersection of a central horizontal access, visible beneath the paint, and the

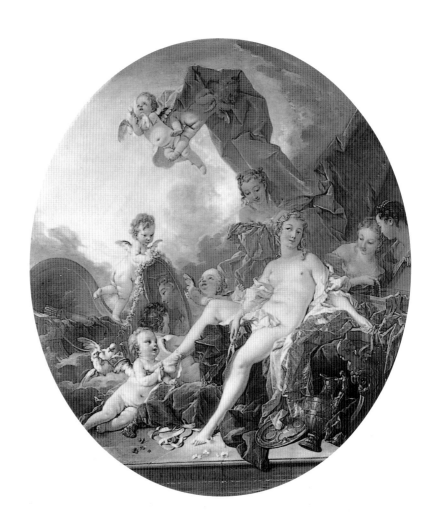

96 FRANCOIS BOUCHER The Toilette of Venus, 1743

97 FRANCOIS BOUCHER Madame de Pompadour at her Toilette, 1758

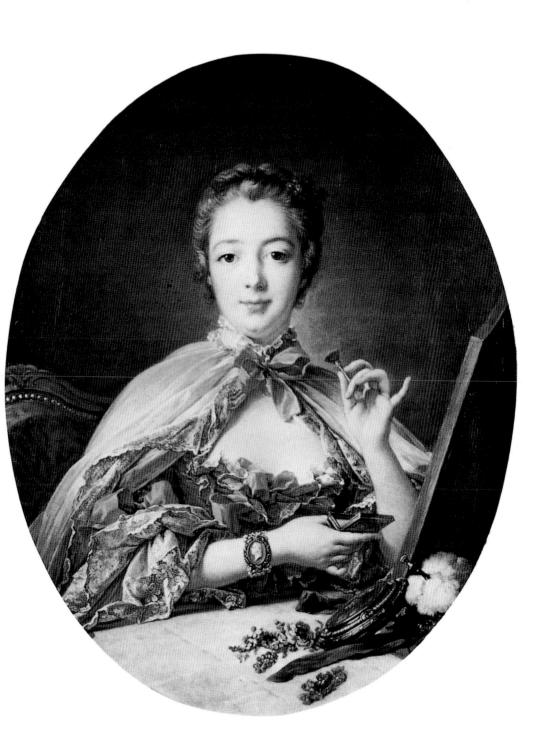

vertical line of the golden section exactly between the cleavage, riveting the spectator's eye on that highly charged, eroticized spot.[22] There was nothing casual or arbitrary about the amplitude and placing of the model's breasts. They are central to the picture's meaning and structural composition. Indeed, this is a painting which seems to echo with fantasies of breast-like protuberances which are by no means confined to the cantilevered organs upon the chest. The powder puff itself is a soft swollen sphere which emphasizes the tactile eroticism of fluff descending on flesh, while the elaborate hairdo consists of two mounds squashed close together to form their own mysterious cleavage, balanced precariously upon the model's head. This doubling of forms is repeated in the ample double chin which contributes to the round, puffy effect of the face. Behind the head itself is a mysterious light halo, described by art historian John Rewald (not usually one for florid language) as an 'aureole', a word sometimes used to describe the tinted flesh surrounding the nipple, while the nipple of the right-hand breast is half revealed at the same time as its coloration is suggested through the transparent bodice by a flurry of warm pink dots.[23] This reddening of the tip, creating a charged edge between figure and ground, was already present in the oil study where its juxtaposition with the blue bodice made it all the more pronounced.[24] Not content with multiplying the breasts throughout the picture, Seurat seems intent on doubling the woman as well, for the Eiffel-Tower-like table of the preparatory study is replaced, in the final work, by a structure that seems to echo the woman herself. Scarcely large enough to supply a reflection of the model's face, the spindly little mirror balancing precariously on the table serves rather as a duplicate of her person. The colour of the table mirror and its frame are exactly those of the model's garments, forming an echo of her body. The rounded back of the mirror is dotted with deep reds and blues to create a purplish torso while the gold frame echoes the colour of the model's ample skirt. Two bottles filled with a honey-like fluid protrude suggestively from the mirror's central ledge, while the top of the mirror is mounted by a gay pink bow, pointing perkily upwards.

This woman, it seems, is for Seurat all breast. The very wallpaper providing the floral backdrop to the scene seems to advance and recede like a billowing wave, the rhythm of light and shade creating the illusion of a heaving, pulsating chest expanding and contracting with each breath. The silent breathing of the model, her discreet but visible inhalations and exhalations, are tangible beyond her own throbbing bosom and seem to animate the surrounding space. The erotic tension invested in the tantalizingly revealed breasts, pushed up by the bodice to reveal

their luxurious roundness, is transferred to the surface of the picture as a whole. Such an overt sexualization of the breast is characteristic of the erotic economy of the time.[25] Breasts were primarily conceived of as sexual attributes in late nineteenth-century France and few women who could afford to hire wet nurses would have risked ruining the shape of their breasts by feeding their young themselves. Certainly no wealthy or society woman would have allowed herself to be seen in the act of breast-feeding her infant as this would have confounded rules of modesty as well as de-sexualized her own body. Women's breasts, for the most part, functioned as erotic objects for men, not mammary glands for the sustenance of the young. Their elaborate casing, framing and display were designed to invite a man's knowing touch, not the haptic fumblings of a hungry infant.

In the *Young Woman Powdering Herself*, the invitation to touch which the naked expanse of opulent flesh offers (its exhibitionist aspect) is paralleled with an autoerotic investment in touch (its narcissistic dimension). Both are necessary to present the spectacle of Woman for a guilt-free and dignified spectator, one who shields behind the protective cover of his own anonymity. It was necessary for Seurat that this work read as genre painting rather than portrait for this anonymity to be maintained. As such it could be seen to invoke the genre paintings of the eighteenth century, exemplified by Jean-Baptiste Greuze's *The Broken Mirror* (1763) with which it has often been compared.[26] But the painting's connections with moralizing allegories are tangential. The dishevelled bodice of Greuze's female character is also placed at dead centre, revealing the same focus on the breasts, but the shattered mirror that he depicts lying on the floor symbolizes the loss of virginity or a broken vow and the painting is in no way a thematization or celebration of the charged erotic pleasures of touch. Nor does it set up suggestive parallels between the 'feminine' touch of self-adornment and the 'masculine' touch of the artist. Rather, it tells a traditional salutary tale about lost virtue. There is no such didactic or moralizing message implicit in the *Young Woman Powdering Herself*. Here the model's presence seems to be asserted for no other reason than as a celebration of her fleshly excess. No cautionary tale lurks beneath this surface, no punishment seems in store for a guilty spectator or a sinning subject. Indeed, we now know that the *Young Woman Powdering Herself*, although originally exhibited as a modern-life painting, also happens to represent the artist's companion, Madeleine Knobloch, who was probably pregnant at the time of modelling for the painting with their child, Pierre-Georges, born a month before the picture was exhibited. It was only after Seurat's death

that the identity of the sitter was disclosed. None of the picture's first viewers was aware that Seurat's model for the *Young Woman Powdering Herself* was his mistress. Seurat kept Knobloch's identity secret from his family and friends until just before his death. It was Knobloch who, after the artist's death, would claim this painting as her 'portrait', and it was she who was the painting's first owner. For its initial viewers it was just a generic 'toilette scene'. The model held no particular significance.

While the *Young Woman Powdering Herself* invokes paintings such as Greuze's, therefore, it is also appropriate to relate it to a portrait such as Boucher's *Madame de Pompadour at her Toilette* (fig. 97), despite the fact that it was exhibited as a genre painting in 1890 rather than as the portrait of an individual. Comparing it with the Boucher enables us to see the specificity of the Seurat work more markedly. For one thing, the vulgarity of the nineteenth-century scene is apparent when juxtaposed with its eighteenth-century precedent. Both of these paintings are in fact portraits of kept women, the one the clandestine lover of a lowly artist, the other the powerful mistress of the king. Their difference in status, however, is inscribed both on their person and in their settings and is tellingly revealed in a comparison of the bracelets they each wear. Madeleine Knobloch's plain, brassy bracelet gleams garishly with reflected light; Madame de Pompadour's exquisite jewel grandly displays the head of the monarch, a portrait within a portrait, twisted around for the benefit of the viewer. The representation of the king in a picture of the courtesan who had come to be accepted at court confirms her status and power. His heraldic head, worn so extravagantly on her arm, stamps her with official approval. The blank emptiness of Knobloch's jewel, on the other hand, its shiny patina revealing nothing but its cheap self, stands poignantly for the social position of the model. She has nothing to show for herself except her corporeal charms. There is no official stamp of approval on her apparel. Anonymous and unnamed, she represents a type more than an individual. A working-class woman whom Seurat had befriended when she was only sixteen, she remained, six years later, the mysterious model for a putative genre scene, without name and without claim to the man who kept and painted her. Her bracelet reveals no insignia, no special mark. It shines somewhat too brightly, like the sparkling, meretricious earring placed a little too conspicuously on her ear. Madame de Pompadour shows no such sign of vulgarity. Her ears are neatly tucked beneath her coiffured locks. She needs no jewel other than her bracelet to testify to her status. The contrast between these two figures could not be greater. Where Madame de Pompadour sits perfectly poised and in command behind an

ample table surmounted by a wooden mirror, Seurat's made-up model towers awkwardly over her strange little *poudreuse*, an example of the mass-produced reproduction furniture then popular in Paris. Her table has barely enough room to support the humble flower cutting that fuses with the wallpaper behind it, while Madame de Pompadour's floral tributes lie discreetly next to her jewels and nick-nacks spread out on the ample cloth-covered surface. The curve-legged table is of a type that was found in cheap interiors like that represented in René Gérin's *The Manicure* (1896), where it is surmounted by a bouquet which partially conceals a male admirer who has been admitted to the woman's private quarters. The little griffins and monster heads mounted above the legs of the table on the three visible corners of the *poudreuse* in Seurat's painting invoke the hand-crafted ornaments of a bygone age while testifying to the tacky cheapness of the interior inhabited by this young woman. It is as if the later image is a farcical re-enactment of the former, the grand eighteenth-century courtesan who proudly confronts her viewer replaced by a mournful dreamer, more surface than substance, a glorious inflated modern doll filled with nothing but air.

The anonymity of the sitter was crucial if she was to be emblematic of the modern. To endow her with a name would have altered the painting

98 RENE GERIN The Manicure, 1896

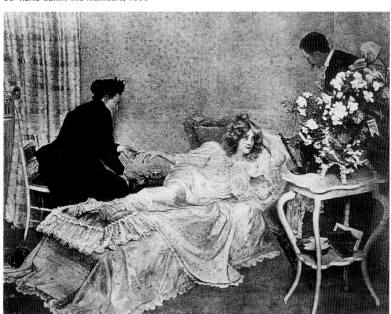

99 'Sa Crotte', cover of Gil Blas, 27 January 1895

100 EDOUARD MANET Nana, 1877

from a monument of modern life to a picture resonant with personal and private associations. Seurat was keen to mask his presence from the picture at all costs. Anecdotal evidence has it that he had originally placed his own image in the curious little *japoniste* bamboo frame suspended on the wall behind the model before painting it over and replacing it with an awkward and angular flower pot. In the 1930s a friend of Seurat's apparently told the art historian Robert Rey that Seurat had painted his own reflection there, but that the artist had erased it after being told that he would be laughed at if he allowed himself to remain in the picture. In 1958, when the painting was X-rayed in Chicago, experts indeed detected the erased traces of the figure of a man in the mirror, but when it was X-rayed again at the Courtauld Institute in 1987 another group of experts declared that there was no substantive evidence that this was the case and that the sighting of the man had been the result of experts reading in what they expected to see.[27]

One can hardly blame them. The inclusion of male figures in dressing room scenes had become almost a cliché by 1889 and continued to be explored throughout the next decade or two. Seurat's presence in the picture was feasible, not only because we have his friend's eye-witness account, but because the *Young Woman Powdering Herself* could be seen to fit into a tradition of late nineteenth-century images in which the inclusion of a man in a painting that showed a semi-dressed woman adorning herself made absolute sense. It had come to be expected of a certain type of risqué *fin-de-siècle* image, examples of which abound. In

1895 *Gil Blas* published a particularly vulgar example of the type on its cover: an engraving by Steinlen to accompany the publication of a story by George Auriol with the dubious title *Sa Crotte.* The word '*crotte*' refers to both mud and excrement, so the title could read 'her mud' or 'her excrement', and be a slighting reference to the make-up with which she is occupied. It could, however, also refer indirectly to her bottom, at which her male companion seems to look and towards which his ample moustache points. A similar fixation on a woman's behind is suggested in the most obvious precedent for Seurat's painting, Manet's notorious *Nana* of 1877. In this picture the corseted, coiffured and painted courtesan, complete with lipstick, earring, shiny brass bracelet (here pressing suggestively into the flesh of her plump forearm) and fluffy powder puff, is accompanied by her lecherous companion who leers suggestively at her swollen buttocks, his cane placed strategically in his lap. Small wonder that *Nana* was rejected at the Salon of 1877, and that Manet resorted to displaying it in a shop window, where it created a minor scandal by

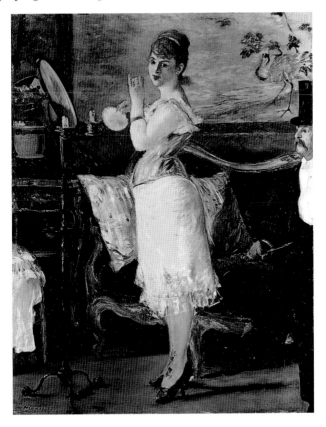

101 ARMAND GUILLAUME Woman Powdering Herself, early 1900s

evoking a double commodification: that of women's bodies in prostitu-
tion and that of art in the commercialized context of the art market.[28]

The presence of a male figure in a toilette scene made the identity of
the woman explicit. It was for *his* benefit that she adorned herself and it
was on his money that she depended for her livelihood. Guillaume's
later busty model, replete with powder puff, maid, bouquet and amorous
companion, makes this connection explicit. Small wonder that Seurat
did not want to include his own image in the final version of his paint-
ing. His presence would, in this scenario, have been read as that of a

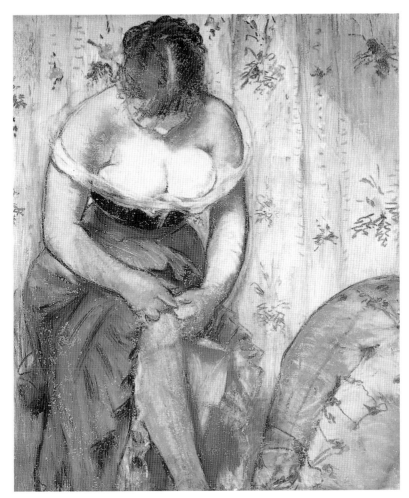

102 EDOUARD MANET The Garter, 1878–9

lecherous lover, jealously guarding his prize possession as she made
herself beautiful for him. It was safer to be anonymous, erased as witness
of the scene, present in the ordered precision of the painting's execution
rather than in the compromising circumstances of its *mise en scène.*

The legibility of the setting and the identity of the model are clearly
established, even without the presence of a man in Seurat's picture. The
young woman who powders herself, with her emphasized eyeliner, rouged
lips and semi-naked appearance, is presented as a demi-mondaine, close
in class and attributes to the figure in Manet's *The Garter* of 1878–9, in

103 'Monsieur Manet Studying Beautiful Nature', from Le Charivari, 25 April 1880
104 'L'Homme qui pique', from G.J. Witkowski, Tetoniana, 1898

which the model's breasts spill out from their bodice as if a gift to the spectator. Such opulent offering was regarded as obscene, as an affront to beauty by at least one critic, who sarcastically paired a cowering artist with a corpulent, chesty harridan in a caricature for Le Charivari in 1880. Naturalism and nature are both the targets of satire here, the sacrifice of the ideal in the figure and the slavish attention to nature by the artist producing an image of Woman and an image of art that are equally ugly and debased, associated with the smutty and sordid exchanges of the street rather than the lofty ideals of the Academy.

And yet for all the similarity in the models' attributes, the appearance of Manet's and Seurat's works is markedly different. For where Manet's direct technique – the fluid, tactile quality of the pastel, the rubbing, scrubbing and smoothing of the canvas – allows for a sensual encounter between artist and surface which is analogous to that of a lover, with all its attendant tenderness and violence, Seurat's strained and disciplined touch, punctuating the ground in evenly applied dots, speaks of a control which seems to be about the ordering and mastery of nature as much as the celebration of her charms. The contours here are fixed, the boundaries firm. Even the feminine interior, the space of the boudoir which is the space of the picture, is bounded by a painted frame, a membrane made of carefully controlled, evenly applied dots, moving rhythmically from light to dark, from warm to cold, and encasing the scene in a thin border which evokes the porous quality of human skin while functioning like a hardened, impervious shell, clearly separating the world of the picture from the world beyond its edge.[29] There is little

room for seepage, for spillage, for overflow. The strain of containment is visible everywhere. It is hard-won, painstakingly achieved. The effervescence of Impressionist colour has been rationally dissected into its component parts. Rather than stroke the surface, the point of the paintbrush, its laden tip, seems to puncture it, constructing an image that reads as a tapestry of pin pricks as much as a powdery residue. It calls to mind the notorious *homme qui pique*, a well-known lecher of the period who derived sexual pleasure from pricking the breasts of prostitutes, enjoying the sight of the tapestry of blood-stained dots which spread across their chests.[30]

The sadistic dimension of idealist aesthetics in combination with modern corsetry and cosmetics is disturbingly evoked by a parallel between the Pointillist's precise dab and the pervert's pin prick. For Pointillism posited an authorial subject who was entirely in control. He had as his alibis both traditional aesthetic principles and modern scientific wisdom and he strove to construct a world that succumbed to the ordering principles of both. The female body epitomized nature at its most potentially unruly. Science set out in the nineteenth century to explain nature, while idealist aesthetics had long spoken of taming her, of making her disorderly excess succumb to the ordering principles of art.[31] Pointillism offered itself as a modern painting technique, employing the rhetoric of science in order to do just that. The *Young Woman Powdering Herself* is a testimony to the effort involved in such a project. Curiously, its own contrived and artificial surface, denuded of any naturalist pretensions, paralleled the effort required by women themselves to conceal the defects of nature. It was through make-up, scientifically applied, that the modern woman could guard against the ravages of time which threatened her continually with the perils of disease, ageing and death. And it was through the image of Woman, idealized, abstracted and captured in paint, that men could allow free reign to a fantasy of fecund, fleshly abundance which, while generous in its proportions and unthreatening in its address, could still be mastered through the precision and procedures of rational thought. The young woman powdering herself strains at the seams of her own construction. A giant blown-up doll, a grown man's toy, she is just sufficiently hemmed in to make us believe that she will not pop and humiliate her lover, at least not quite yet.

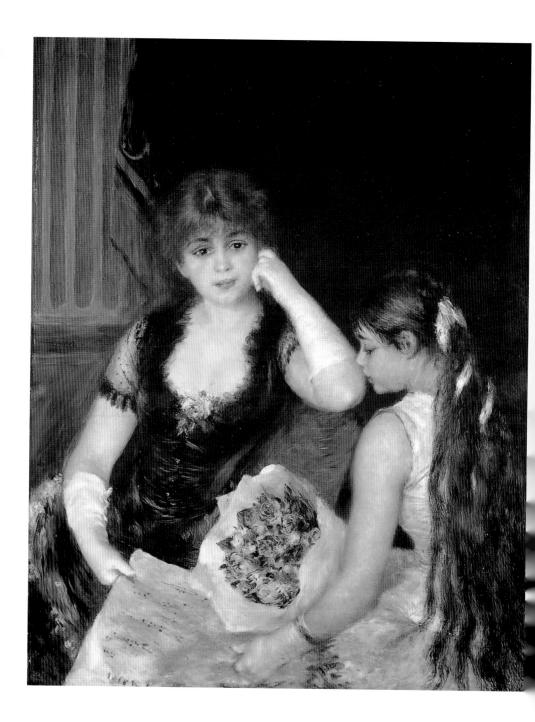

Painterly Plenitude:
Pierre-Auguste Renoir's Fantasy of the Feminine

Two Renoir paintings of the early- to mid-1870s serve as a useful start-
ing point for this chapter. Both depict single female figures, but they
represent two different types of femininity as conceived in Paris in the
early Third Republic. As such, they function as polar opposites, mean-
ingful only in relation to one another as two parts of a dialogue about
Woman. The first of the pair, *La Parisienne* of 1874 (fig. 107), a single
standing figure, clothed in full outdoor regalia of the type made familiar
through countless contemporary fashion plates, is dressed in the height
of fashion, her tightly corseted torso with buttoned bodice and protrud-
ing bustle proffering the latest in feminine silhouettes. She is robed
from ruffled neck to peaking toe, her hands are gloved, her hair is
pinned up and adorned by a perky hat. Notwithstanding the indetermi-
nate blue ground and lack of specificity in setting and location, she rep-
resents the type of urban creature for which Paris had become famous.
She is the product of commerce and culture, an icon of the fetishized
femininity associated with the modern metropolis that Tissot would set
out to capture in his *Femme à Paris* series.

The *Nude in the Sunlight* (fig. 106; pl. VIII), painted two years later,
offers a significantly different fantasy of the feminine. Here a naked
woman is represented in the open air, her ample body and tumbledown
hair constructing a vision of a femininity free of the constraints of mod-
ern costume. Little of the coquettish artifice of the 'Parisienne' is contained
in this fanciful figure. Her rounded belly and ample breasts, her plump
arms and placid face provide a sumptuous surface for the play of light
and reflected colour tones. Like a nymph of the woods drawn from some
timeless Arcadia, Woman takes her place in a world of water and foliage,
feathery and full in its textural evocation, in which flesh, vegetation, hair
and cloth provide a soft and downy pillow on which the weary urban
viewer can rest his eyes. Nature is here conceived as the site of solace, and
Woman, devoid of the artifices of culture, fits seamlessly into the natural
world that provides her setting. Her skin reflects its colours, her body
absorbs its hues, her hair fuses with its painterly profusion. The youthful
breasts with their frosted pink nipples are highlighted and moulded by

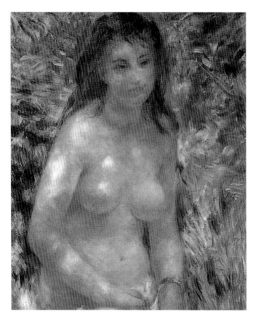
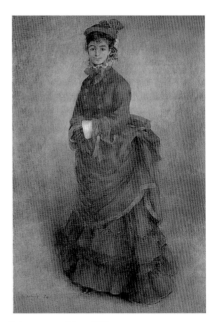

106 PIERRE-AUGUSTE RENOIR Nude in the Sunlight, 1875–6 (plate VIII)
107 PIERRE-AUGUSTE RENOIR La Parisienne, 1874

dappled light and subtle shading as if the elements themselves paid homage to Woman's abundant corporeal gifts.

Where the image of the 'Parisienne' had shown Woman formed by culture, her nature tamed and contained by the dictates of society, the *Nude in the Sunlight* presents Woman as an elemental creature, frolicking freely in the undergrowth. Apparent authenticity is contrasted with artifice, truth with capriciousness and coquetry. But even here, in Renoir's painterly paradise,[1] signs of modernity can be detected, for far from being entirely denuded of contemporary cultural referents, the model for the *Nude in the Sunlight* is shown wearing shiny earrings, a glittering bracelet (not unlike the one that Madeleine Knobloch was to don some fifteen years later, see p. 136) and a showy ring complete with sparkling stone, all remnants of an urban costume that has been removed. Such signs clearly remind us that this bathing beauty is a Parisian model, only partially performing her part as natural goddess in the pre-Lapsarian paradise which the world of painting constructs. What is more, her jewellery reminds us of the world of exchange on which hired models were dependent. Paid to embody the unfettered femininity of an ideal world, she takes up her pose without relinquishing the trinkets which her position has afforded her. The landscape set-

ting provides a painterly context for the elaboration of Renoir's fantasy, but escape from the circuits of exchange that characterize modern life remains illusory.

There is, in fact, nothing 'natural' about the nude's demeanour or placement. For all its immediacy of light effects and temporal specificity, the pose invokes such classical precedents as the *Venus Pudica*, a marble sculpture of a bare-breasted standing female figure with one hand placed defensively over the genitals, serving both to preserve the figure's modesty and to draw attention to her sexuality. References to contemporary costume are tempered by the traditional overtones of the pose and setting. Clutched in Renoir's model's hand is a swathe of cloth concealing the pubic area and invoking both dress and drapery with their well-trodden connotations of concealment, shame, and sexual knowledge. The nakedness of the model and her depiction in a wooded glade raise the spectre of a 'natural' femininity unfettered by artifice, but the picture remains haunted by referents to a context in which femininity is festooned with ornament, dressed in the attributes of civilization and burdened by guilt and shame. The nymph in the glade is after all the 'Parisienne' denuded of her costume, corset and coiffure and temporarily reunited with her natural roots. She is Woman restored to the source, Woman returned to her mythic origin, Woman liberated from modernity's artifices, but never entirely free from them – even in paradise.

The restorative vision of nature, encapsulated by the naked bathing female figure in the luscious landscape, is, of course, dependent on the culture which produces it.[2] There is nothing natural about the act of painting an unclothed female figure in an open-air setting. Nor of course is such a practice without precedent. The covering of the lower body in cloth is reminiscent of classical drapery and connects the figure to a tradition of representation of the female nude that traces its lineage back to classical prototypes and their subsequent reworking in European oil painting from the High Renaissance to the nineteenth century, each period producing its own acculturated fantasy of the feminine.[3] There is nothing 'natural' about the careful combination of draped cloth and revealed flesh, modestly clutching hand, and slightly twisted torso. This painting draws its meaning from the countless historic images of bathing women which supply its visual language and cultural pedigree.[4] Particularly important for Renoir were the Rococo reworkings of the bathing theme, which symbolized for the late nineteenth-century conservative a lost pre-Revolutionary authenticity which had come to seem quintessentially French. While late eighteenth-century Republicans had eschewed Rococo decadence, preferring the high-minded sobriety of

108 JEAN-ANTOINE WATTEAU Diana at the Bath, 1715–16

Neoclassicism for the elaboration of the enlightened rationalism on which post-Revolutionary France was supposed to be built, traditionalists hankered after what they constructed as the sensory delights of a lost aristocratic culture, seeing these as the hallmarks of a peculiarly French sensibility which was lamentably gone. In the name of both patriotism and patriarchy, wonderfully encapsulated by the French term *La Patrie*, nineteenth-century Rococo revivalists sought to reinstate the notion of painting as the appropriate arena for the exploration of sensual pleasure, and the eroticized figure of the female bather – part goddess, part mortal – provided its perfect vehicle.

Eighteenth-century artists such as François Boucher and Jean-Antoine Watteau, artists whom Renoir admired enormously, had revelled in the display of female flesh which such mythical scenes required. In Watteau's *Diana at the Bath* (1715–16), a single naked figure, skin infused with coral flesh-tones, is seated on her luscious discarded robes and dries one foot unselfconsciously while the other dangles idly in the stream. The arrows and their container which lie beside the disarmed huntress on the river bank provide a minimal narrative pretext for this sensory dreamscape in which the tactile qualities of flesh and foliage are skilfully translated into paint. In Boucher's *Diana at the Bath*, the classi-

109 FRANCOIS BOUCHER Diana at the Bath, 1742

cal goddess and her attendant again provide the pretext for a painterly paean to sensual pleasure in which toes dip tentatively into water and flesh sinks heavily into discarded drapery, situating the female body in the sylvan surroundings that provide the perfect backdrop for a display of its corporeal abundance. Here the presence of the male hunting dogs, one of which drinks thirstily from the pool, and the dead hares and birds lying on the ground beside the goddess, introduce a dangerous predatory element into the Edenic scene, creating a certain tension between the abundant and overblown eroticism of the figures (with the pink creases in their flesh and rosy nipples) and the deathly mission they have just accomplished. Like so much meat themselves, the obviously undressed women, still adorned in ribbons and fingering their jewellery, seem perfect prey for observers who could be lurking anywhere in the dark, mysterious foliage which frames the group. Arguably, the viewer himself occupies just such a position as he peaks illicitly in on the intimate scene. Another eighteenth-century precedent is provided by Jean-Honoré Fragonard, Boucher's student, and probably Renoir's favourite artist, whose *Bathers* (fig. 110) presents an image of an elemental sensuality in which frolicking female figures disport themselves with abandon in a celestial watery glade. Here flesh collides with flesh, foliage

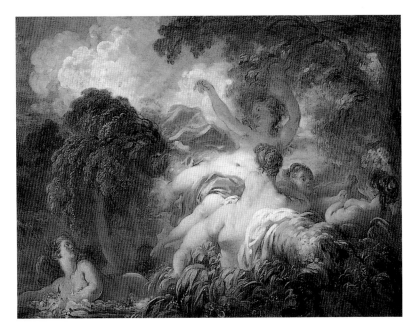

peeps suggestively between parted thighs and the lush landscape cushions and enfolds the carefree creatures who seem to float effortlessly between water and air. Watteau, Boucher and Fragonard provide obvious models for Renoir's conception of painting as the arena of sensual pleasure, a tactile universe in which women's bodies are the ideal vehicle for the thematization of an eroticized relationship to the physical environment. Woman, a creature corrupted by modernity, claimed Renoir, should be restored to a pre-modern state of sensual simplicity (her true destiny) through the artisanal skills of the painter, who himself was threatened by the industrialization and mass-production of commodities that characterized modern life and promised to destroy the traditional craft culture of France. The eighteenth century provided the perfect prototype of the apparently fecund, free femininity for which Renoir yearned, captured by a virtuoso, finely crafted painting practice with which he identified.

By the late nineteenth-century, Renoir's fantasy of a femininity beyond culture, a femininity constituted in the realm of nature, was a tried and tested product of culture. The scene depicted in *Nude in the Sunlight* was, after all, conceived as an appropriate subject for an oil painting destined to be shown in the commercial context of the Second Impressionist exhibition in 1876. It must, therefore, be seen within the institutional networks of the nineteenth-century art world. Painting

provided the fictive and physical space for a transformation of modern woman into the elemental natural woman of which Renoir's dreams were made. In the context of the Impressionist exhibition and late nineteenth-century aesthetic debates, the *Nude in the Sunlight* stood as a naturalist manifesto, one which sought to refigure the traditional genre of the nude via the dictates of naturalism and to transform Woman (that abstract, idealized trope) into the tangible embodiment of nature, sufficiently present in paint so that her physicality could be experienced, even touched. Her body bathed in sunlight in a sun-drenched universe stands for a bountiful nature invented as culture's Other, while the vestiges of culture worn on the model's person testify to the renunciation on which that fantasy is dependent. But not all contemporary viewers found the fusion of flesh and foliage that characterizes this painting a comforting vision. For some, Albert Wolff of *Le Figaro*, for example, it held hidden dangers. The ability of the body to blend into its surroundings and the reflective qualities of skin that so anchored the figure in the natural setting for the naturalist artist could read not as the wholesome celebration of the body's freedom from artifice but, rather terrifyingly for academic critics, as the sickly dissolution, even putrefaction, of a corpse or mass of moulding meat.[5] For while even eighteenth-century bathers, themselves overly physical for many academic critics, remained conceived in flesh tones, orchestrated in porcelain pinks, coral shadings

110 JEAN-HONORE FRAGONARD
The Bathers, c. 1772–5
111 JEAN-AUGUSTE-DOMINIQUE INGRES
La Source, 1856

and pearly highlights, the skin of Renoir's nude functioned as a reflective surface speckled with tones varying from deep blues to acid yellows. Used to the stony skin surfaces of academic nudes such as Ingres' *La Source*, with their modulated tones and graduated shading, or the powdered pallor of the modern beauty, with her carefully contrived alabaster-like veneer, Wolff must have been startled by the patchy worked surface of the nude's skin, replete with mauves, violets, greens and golds, which in terms of prevailing pictorial expectations could quite easily read as diseased, rotting flesh rather than reflected light. Woman's fearsome physicality, which make-up was designed to conceal, was here inadvertently revealed in the reflective surface of the sun-splattered torso, while the skin's capacity to reflect the colours of the surrounding space served to dissolve the distinction between figure and ground, invoking the demise or even death of the body, a reminder of its physical rather than spiritual dimension. The analogies between marble and flesh which the smooth surfaces of classical renditions of the nude had institutionalized were relinquished in the naturalist encounter with the figure. The effect was to produce an image of the body that seemed horrifyingly naked and vulnerable. Denuded of its idealist immortality, its capacity to stand for timeless virtues, the naked body was now subject to the ravages of time and the stench of inevitable decay was already detectable in the skin's capacity to reflect the arbitrary and fleeting effects of atmosphere and light.

Nature was always the product of culture. And the fantasy of nature that culture constructed could be perceived as either wholesome or destructive, beneficent or terrifying. Constructions of women's nature in the nineteenth century veered from the extreme and oppressive idealizations of 'experts' like Jules Michelet and Jules Simon, who conceived of Woman as an innocent and sickly victim of male machinations who needed to be protected and policed, to the extreme demonization of Baudelaire and the Symbolists, who saw Woman as a malignant manipulator of men whose meretricious nature and dangerous sexuality threatened to devour them. While many writers and artists were fascinated by the mask of femininity, as we saw in Chapter Four, and indeed regarded the artifice of cosmetics and fashion as a necessity for the masking of Woman's imperfections, they nevertheless believed that the masquerade of femininity only served to disguise the rapacious nature of women, which was never far beneath the surface. Painting provided one of the sites for the fabrication of an image of femininity in which surface was paramount. The artifice of painting and the artifice of the exterior manipulations that produced the mask of femininity seemed

112 ERNEST-ANGE DUEZ Splendour, 1874

made for one another. Artists such as Ernest-Ange Duez, painter of a work called *Splendour*, executed in the same year as Renoir's *La Parisienne*, revelled in the capacity of paint to picture the commodified corporeality of the Parisian courtesan. A pasty white paint signifies the pallor of rice powder applied to a puffy face, while black eyeliner, lipstick, artificial blond hair and fake jewellery are brilliantly suggested by the slickly applied oil paint. Feathers, fur and fluffy boudoir pup offer a flurry of surface textures that positively beg to be stroked, while the provocatively naked bejewelled hand clutching the dog brings to mind the touchability of the woman herself. This is the 'Parisienne' in all her demonic glory. She epitomizes all that Renoir detested about modernity and what he saw as its corrupting effects. Modernity found its most disturbing image for Renoir in the commodified body of the prostitute, the figure who symbolized the mercenary dealings of the metropolis and who would allow no illusions of a wholesome or spontaneous sexuality to be sustained.[6] This is the figure which Renoir's *La Parisienne* hints at

113 PIERRE-AUGUSTE RENOIR La Loge, 1874

but never quite articulates. For Renoir's fantasy of femininity, even in the meretricious context of the modern metropolis, can never quite embrace the demonic in the manner that some of his contemporaries did. Even his over-blue 'Parisienne' proffers an image of a pliant femininity, cheeky and mischievous perhaps, but never, like Duez's dubious figure, downright bad.

Anxiety about the respectability of Parisian women permeated descriptions of paintings of the period. Artifice and artistry were necessary in the packaging of a desirable femininity, but they brought their own dangers for they constituted an elaborate disguise behind which all manner of women could hide. Who was to know whether the beautifully adorned woman in *La Loge* was a respectable wife or a brazen courtesan advertising her wares outrageously at the front of an opera box while her distracted companion looked elsewhere for his diversion?[7] The elaborate packaging of femininity constituted an outer shell of tantalizing desirability, but one which was always tinged with danger. If the fetishized body of Woman functioned as a defence against anxiety, its excessively defensive display of surface substitutes also testified to that very anxiety which it sought to deflect. In the theatrical setting of the Opera House, nature is clearly subsumed into the remit of culture, both off stage and on. Woman herself is like a cultivated hot-house flower, carefully prepared for public exhibition, while flowers are plucked and arranged in hair and bodice to adumbrate the vision of a blossoming, fecund femininity which is brimming with promise. Cultivated pearls adorn the neck like gilded chains, harnessing the woman in her jewelled captivity, framed as she is by the restrictive barrier of the *loge* in the front and the enfolding presence of her companion behind.

In *At the Concert* of 1880 (fig. 105), Renoir revisited the theme he had already made his own in the remarkable *La Loge* of 1874. Both of these paintings represent fashionable people in a private box at the opera and although they have substantial similarities, there are also marked differences. Whereas the 1874 picture invites speculation about the nature of the woman and her relationship with her distracted companion, the virtue of the two figures in *At the Concert* is never a matter of conjecture. This painting reads as a society portrait in which analogies are set up between women and the natural world that are entirely flattering and wholesome. Although both figures are fashionably gowned and adorned, they seem to nestle discreetly in the back of the opera box rather than peer beyond it. What's more, the discrepancy in age between the two figures lends an air of respectability to the scene, perhaps depicting a mother and daughter. They hold between them a musical

score which seems to bear the signature of the artist and suggests a serious engagement with the music to which they listen. But this does not mean that they are not seen in sexualized terms. Their rounded forms and bare expanses of flesh are contained within the straining contours of their garments, like ripe fruits bursting forth from their skins. The cultivated flowers in the bouquet between them are contained in an open white paper wrapping which suggests a correspondence with the young girl's dress. The pinks and reds of the flowers themselves are picked up mysteriously on the white dress of the profile figure, creating a direct link between the proffered blossoms and the virginal young girl herself. Renoir once described a still life of roses to his dealer Ambroise Vollard as an 'experiment' in 'flesh tones for a nude'[8] and repeatedly said that he liked the skin of his female models to be pink and healthy. The warm presence of the flowers in their cool wrapping at the bottom centre of the picture helps to construct an image of voluptuous and yet innocent sensuality. While the girl is turned away from the viewer, her bouquet is oriented suggestively and openly towards him, providing the possibility for an encounter between viewer and model. The discreet placing of a single blossom on the bosom of the older woman draws attention to her rounded chest, and its nipple-like configuration stands in for what is constrained beneath the bodice. Floral accessories suggest female sexuality both iconically and in their painterly presence. The soft, circular rhythms of the brushstrokes which describe the blossoms set up a series of rounded forms which echo the sumptuous curves of the female bodies and create a seductive textural circularity which itself signifies the feminine. This is a fantasy of femininity almost saccharine in its sweetness. Docile, and resplendent in their female finery, the ladies of this *loge*, for all their elaborate costuming and the meticulous refinements of their toilette, offer a reassuringly placid vision of nature tamed, timid and suitably seductive.

The juxtaposition of flowers and female figures was a ubiquitous signifier of femininity in nineteenth-century Europe. *Girl Gathering Flowers*, painted two years before *La Parisienne*, provides it with an interesting companion piece. Here the quintessential city girl seems to have repaired to the country to do what young women were expected to do: pick flowers and pose decorously in country fields. Dressed for an urban excursion, the cumbersome skirts seem to impede the passage of the 'Parisienne' in nature. Her parasol discarded, she is subsumed into a screen of painted blossoms, almost as if she is being reclaimed for a nature she has betrayed, even deserted. Adorned with flowers on her hat, flowers in her hair, flowers which cascade from her bouquet of freshly

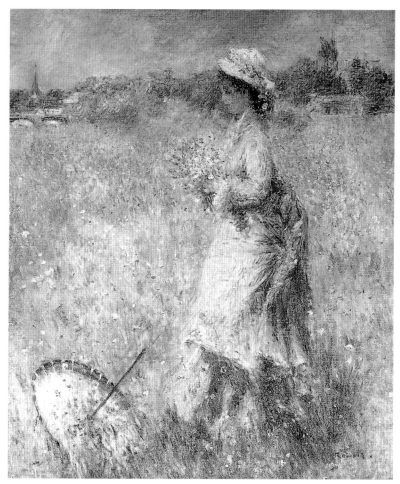

114 PIERRE-AUGUSTE RENOIR Girl Gathering Flowers, c. 1872

picked country blooms, and even flowers which hover mysteriously about the flounces of her capacious dress, she herself stands like a tall reed in a country field. City girl is subsumed into a world of floral excess; nature takes its revenge on culture by subsuming its product into its own tactile universe of strokes and spots, dabs and patches of agitated paint.

The familiar combination of flowers and female sitters is apparent in *A Girl with a Fan* of c. 1881 and *Marie-Thérèse Durand-Ruel Sewing* of 1882. Both these young women are enveloped in a flurry of floral excess which is very nearly claustrophobic in its intensity. The effect produced is of animated surfaces, highly textural in appearance, which invite an

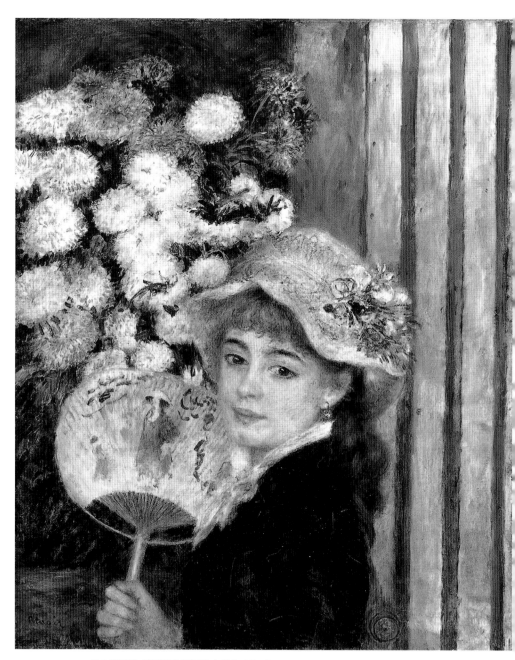

115 PIERRE-AUGUSTE RENOIR A Girl with a Fan, c. 1881

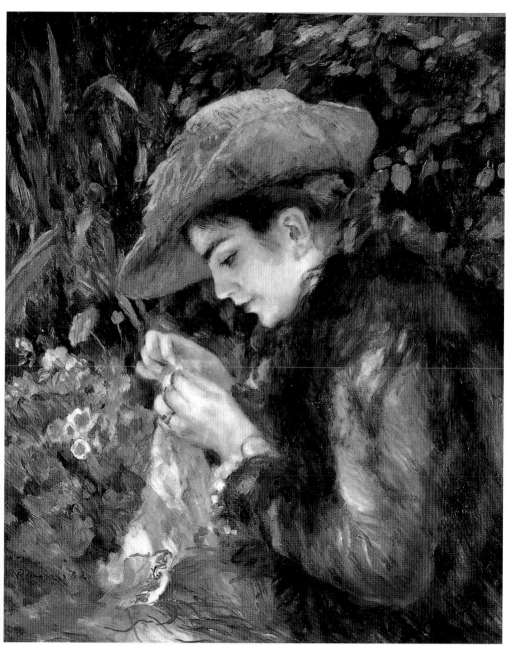

116 PIERRE-AUGUSTE RENOIR Marie-Thérèse Durand-Ruel Sewing, 1882

almost tactile, visceral engagement on the part of the viewer. In *A Girl with a Fan*, an indoor scene shows a young woman posing in front of an enormous bouquet which seems to advance and encircle her bonnet and cascade over her fan. The fusion of surface textures and the analogies set up between flowing hair, cloth, flesh tones and blossoms naturalize the relationship between female and flowers so that they seem to be constituted of the same matter. Paint is the medium in which their identity is fused. It is in the painted surface that the analogy is most seamless, creating a continuum between Woman and nature which is entirely in keeping with nineteenth-century preconceptions. Nature enters into the cultivated interior in the form of floral excess anchoring the fashionable young girl into a metaphorics of the natural which is both reassuring and comforting. The portrait of *Marie-Thérèse Durand-Ruel Sewing* is provided with a floral backdrop which advances to such an extent that it seems, in part, to sit on the same pictorial plane as the model herself. There is little space or atmosphere between the plants, cascading cloth or dissolving blue dress in the bottom left-hand corner of the picture. Woman's handiwork, her legitimate contribution to culture, seems to fuse with the flowers that provide her natural setting. Her flowing hair (Renoir abhorred hair that was pinned up in what he thought of as an unnatural and artificial manner) fuses with the dark and dense undergrowth behind her, anchoring her in an organic material universe from which she appears to emerge and into which she is shown to dissolve without conflict or difficulty. The matter of Woman is both iconically captured and physically expressed in the material qualities of paint. In the process, subject and surface are feminized. Both are subjected to the systematic caressing of the paintbrush as the artist leaves a painterly residue of that encounter with the visual which painting translates into touch.

Small wonder that Renoir used the most sexualized vocabulary to describe his physical engagement with the practice of painting. For him the act of painting could only be described as a caress. Whether he was painting a vase of fleshy pink peonies or a group of carefully poised onions, he was involved in an act of translation of sight into touch which always held for him a sexualized connotation. This did not only function on the level of the iconic equivalences between rounded forms and surface textures in objects and people, but the very act of painting could only be imagined by him as an extension of a sexual encounter. The motif or model had to be confronted, seduced, captured, and conquered in paint. In the words of one of his models: 'Renoir marries all the women he paints – but with his brush'.[9] The struggle with nature was

always imagined by Renoir as a sexual conquest. When he was old and decrepit and unable to hold his brush in his arthritic hands he was asked by a young journalist: 'With such hands, how do you paint?' 'With my prick', Renoir is reported to have responded, in what has become by now a manifesto statement of modernist mastery.[10] Looking was always libidinous for Renoir, and Woman, as erotic object and the ultimate embodiment of the natural, constituted the obvious site to which that look could be directed. As the male sexual organ could substitute metaphorically for the brush, conflating the motivation and orientation of each of these tools, so the canvas surface could stand in for the body of Woman. But this substitution worked best for Renoir in what he perceived as the encounter with nature. Women, unlike men, were subsumed into that category. For this reason Renoir preferred to paint women rather than men. He found male sitters disturbing for, he alleged, they thought too much and this interfered with his capacity to observe them.[11] When, as an old man, he embarked on a traditional figure painting, a reworking of the theme of the *Judgment of Paris*, Renoir used a female model for the male figure of Paris, whom he depicted as the only clothed figure in the scene. A plump Paris, dressed in flowing robes, proffers ripe apples (a traditional symbol of women's breasts) to

117 PIERRE-AUGUSTE RENOIR Judgment of Paris, 1908

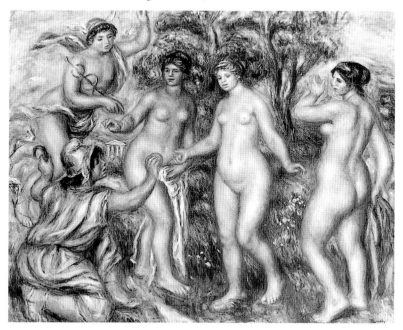

the goddesses, his face turned from the spectator, his gesture leading the eye of the viewer to the full-figured contestants whose bodies have just been judged.[12] Paris functions as a conduit for the viewer's gaze which is directed at the three women, all of whom have the gigantic bodies and tiny heads that became the hallmark of Renoir's late figure style. The women are admired for their physical charms: their ample thighs, rounded haunches, and breasts shaped like ripe fruits. Their pretty little heads contain no thoughts of any consequence.

There was little room in Renoir's painterly vision for an encounter with the consciousness of the Other. His remonstrations against sitters who thought or spoke are legendary. Renoir preferred his female models to exude the animal-like passivity of cats. Women, he often proclaimed, were much like cats in their self-absorption and mindless narcissistic obsessions. And this was how he preferred them. The more mindless and thoughtless the better. Renoir was not alone in this conception of true femininity. Even Sigmund Freud, as we saw in Chapter Four, likened women's enduring narcissism with the enviable self-containment of cats and beasts of prey. One literal-minded contemporary saw fit to place a cat's head on a woman's body in his elaboration of the quintes-sentially feminine being. There was no danger that such a creature would challenge social and political hierarchies. As long as she was petted and stroked, fed and fêted, she would be content.

Sleeping Girl with a Cat of 1880 was a perfect subject for Renoir. Sleep involved the absence of any encounter between seeing and seen. The innocent slumber of the pubescent girl mirrors the mindless aban-don of the prostrate animal in her lap. Her semi-naked body with its tantalizing promise of a tumbling petticoat, open mouth, heavy lids, and slumped relaxed posture, provides an image of innocent young womanhood taken unawares. The feline creature positioned over her pubic area presents an image of her sex which is unthreatening and yet suggestive. It constitutes a textual as well as a textural pun, the furry

118 Anonymous, Catwoman, from G.J. Witkowski, Tetoniana, 1898
119 PIERRE-AUGUSTE RENOIR Sleeping Girl with a Cat, 1880

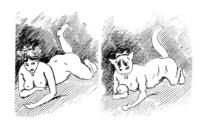

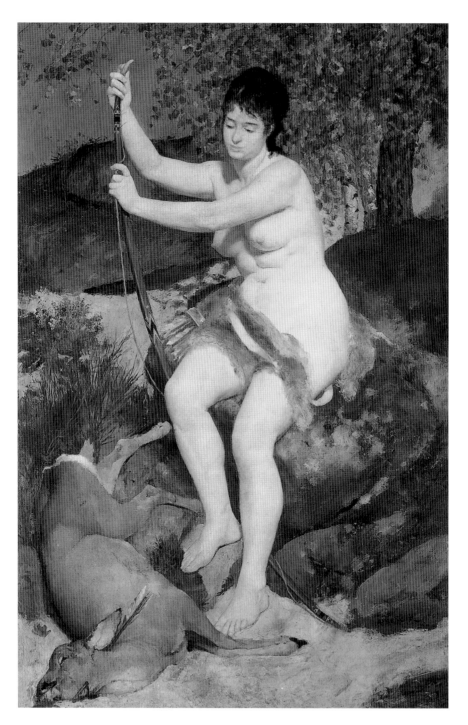

120 PIERRE-AUGUSTE RENOIR Diana, 1867

pussy slumped between parted thighs involving a predictable displacement from genitals to substituted sexualized object. The girl's physical closeness to the cat suggests the analogy between them while functioning as a perfectly credible naturalist scene. The artist's brush caresses the model's contours, tracing the curves of her body without fear of reprisal. Placid, pliant and pretty, here painting constructs a vision of Woman as wholly unthreatening. Too young to be self-aware, too unconscious to offer resistance, this pubescent girl is arranged to absorb the libidinous look of the observer and allow free reign to his fantasies. He will see only his own desires reflected here: she provides the screen onto which these can be projected.

For Renoir, like many *fin-de-siècle* men, only those roles that were conceived of as an extension of women's biological and organic constitutions were regarded as appropriate. Modern aspirations and fashions destroyed women's essential reproductive and nurturing capacities, he believed. High heels led to the dropping of the womb, corsets constrained the uterus, and elaborate hairdos distorted women's natural beauty. In his attitude to female fashion, Renoir's views coincided ironically with feminist dress reformers, but where they aimed to reform women's dress codes the better to equip them to function in the world of work, Renoir loathed any task which took women away from what he saw as their natural and all-consuming destiny. Any women who deviated from their role as mothers, wives and housekeepers – feminists or women with professional aspirations, for example – were not, in his view, true women. They represented the perverse distortion of nature which modernity had heralded. Painting was the medium through which Renoir could elaborate his fiction of an authentic femininity, free from the corrupting influences of a changing world. In painting he could give free reign to his fantasy of a redemptive femininity in which an equivalence between the restorative powers of art and the nurturing qualities of true womanhood could coexist.

Nowhere is this search for painterly plenitude more consummately expressed than in Renoir's representation of the female nude. In his early works, such as the *Diana* of 1867, in which he revisited the classical subject made memorable by his mentors Watteau and Boucher, the mythic setting and narrative associations provided the context for the elaboration of an image of female fecundity which is far removed from the sexual trafficking of modern life. Attributes and accoutrements make ample reference to the story of the huntress, while the traditional choice of a moment of repose rather than action allowed Renoir to provide an image of Woman as monumental and static, earthbound and as

elementally rooted as the trees and rocks that surround her. The massive hips and haunches, the play of light on the full breasts and shoulders, the teasing tactility of the fur draped suggestively over the pubic area and thighs, and the pensive, recognizably Parisian face call to mind an actual woman, here subsumed into the space of myth, as if to assert the eternal continuum of Woman's nature, regardless of time and situation. Woman, the subject of history painting, is beyond history; her body is the repository of values which exist in the ideological language of myth. And classical mythology, in the 1860s, provided the narrative framework for the elaboration of that female type which would remain Renoir's favoured subject throughout his career.

The 1870s, as we have seen, saw Renoir involved in naturalist debates and swept along by the impetus to represent modern life. But like many modern-life painters, he was not willing to relinquish the time-honoured genre of the nude, specifically, in his case, the female nude. *The Bather with Griffon* (1870) transplants the same mythic heroine that we saw in the *Diana* from the world of classical narrative to a quasi-contemporary setting. Here the *Venus Pudica* is transposed in typical realist fashion to an enigmatic island location in which contemporary signifiers and traditional narrative indicators coexist awkwardly on the surface. Observed by an oddly placed, fully dressed woman, and accompanied by a pet dog which hails from the boudoir rather than the forest, the female figure still holds on to her fashionable clothing, which is slumped, like a heap of drapery, on the grassy bank. Her nakedness is asserted as a state of undress, but her contrapposto pose, protective hand, tilted head and body type are more evocative of classical prototypes than contemporary women. Modernity and tradition collide head on in a painting which invokes contemporary sexual mores (the ring on the model's finger for example) but frames them in the familiar language of the grand-scale figure composition.

By 1875, when Renoir embarked on the *Nude in the Sunlight*, the mythic Arcadian setting was signified in the broadest terms by the natural surroundings and the pose and attitude of the model. This was no Venus in a watery glade. Only generic mythic associations between Woman and nature were claimed. Having eschewed the anecdotalism of traditional art, Renoir relied by this time on the deeper narrative structures of Western society, those habits of thought and embedded cultural assumptions whose residues remained present even when the stories of Diana, Bathsheba and Susannah had long been discarded. Gone are the voyeuristic tales of the Old and New Testaments, the bacchanalian and hedonistic revelries of classical mythology and ancient precedent, but

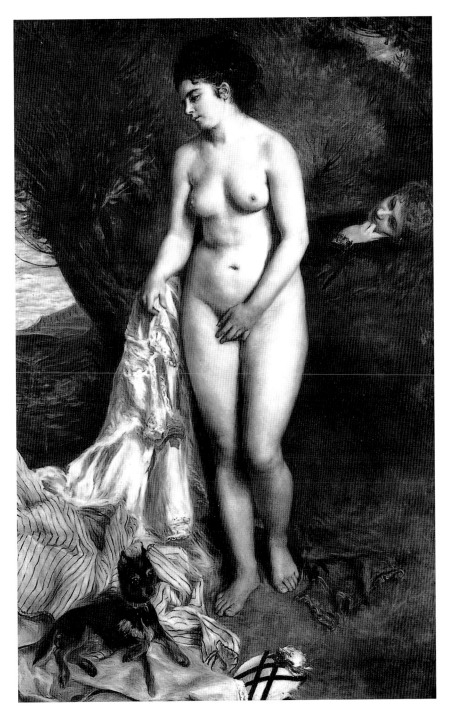

121 PIERRE-AUGUSTE RENOIR The Bather with Griffon, 1870

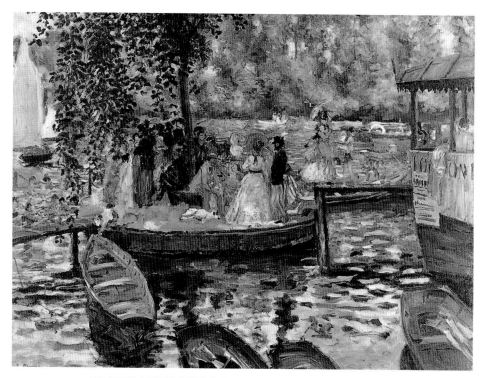

122 PIERRE-AUGUSTE RENOIR La Grenouillère, 1869

they are replaced by a sinister recourse to the laws of nature as verified by science, the new religion of modernity, in which women remain depicted in their time-honoured roles. The authoritative discourse might have changed, but the position of women has not. Instead of giving form to traditional patriarchal truths encoded in the authoritative tales of religion, literature and myth, Woman's position is now explained in terms of the universal laws of nature, scientific fact and biological evidence, and art is revealed as the medium through which these empirically based epistemologies find their consummate expression.

If, for Renoir, modernity had produced a femininity that was corrupt, menacing and mendacious, then tradition would constitute the repository of a timeless and redemptive femininity rooted in the natural. Already in the *Nude in the Sunlight*, the signifiers of modernity were subsumed into the suspended time of art. But in this case, as we have seen, the tension between these was articulated on the one hand by the traditional pose of the model and on the other by the screen of sensation provided by her skin, which acted as a reflective surface for the play of

light. Traditional pose and transient light effects sit uncomfortably together. Perhaps it was this assault on the timelessness of traditionalism that so upset academic critics. If this woman could be depicted as a mortal creature whose skin reflected the transient effects of light, how could she simultaneously stand for the eternal values of art? Only the monochromatic pallor and porcelain-like smoothness of the idealized nude could successfully sustain the illusion of a timeless beauty for critics like these.

The *Nude in the Sunlight* is situated in the cusp between Naturalism and traditionalism, immediacy and the suspension of time. As such, it failed to make sense either in terms of the embrace of the modern which was the hallmark of Realism and Naturalism, or the suspension of time which was the concern of traditionalism. But this transitional and somewhat uncomfortable picture represents a brief moment in Renoir's trajectory as a painter of the female nude. Gradually, for Renoir, the impetus to negotiate tradition via the demand for contemporaneity would be sacrificed to an image of Woman which would stand for modernity's Other, the repository of all that was good and true, old-fashioned and authentic. The radicalism of a painting like *La Grenouillère* (1869) would be short-lived. Painted at a time when Renoir was closely identified with the newly emergent group of naturalists who saw themselves as the disciples of Manet, this work transposed the subject of bathing from the generic world of art to the specific environs of Paris. But Renoir's innate conservatism and commercial interests would ensure that he did not tarry long with the politically tainted '*Intransigeants*' who had refigured the nude according to the dictates of Realism. From the 1880s on, his ideal woman would be the personification of all that was wholesome, bountiful and sustaining to modern man, a nostalgic fantasy typified by the retardataire *Blonde Bather* of 1881. Her rounded forms, carefully licked by a loaded brush, her erect and highlighted nipples mounted on full breasts, her remote expression fixed on some indeterminate spot in the distance, her flowing hair and rosy countenance would symbolize the eternal values of art and the sensual properties of Woman. Plump, pink and pliable, the blonde bather, with her slightly swollen belly and rounded haunches, represented a sexuality that was tangible in a setting that was tantalizingly remote. Art was at the service of a femininity at risk from the corruption of modern life, and the nude, as reconceived by Renoir, was the perfect means for the reaffirmation of traditional values in art and traditional relationships between the sexes. The caress of a woman's body and the encounter of the brush with the painted surface had, as sensory experiences, an equivalence that only

painting could articulate. And the image of Woman on the painted surface could not only provide the perfect residue for the painted caress, but as its ultimate image she would herself stand simultaneously for the reassuring embrace of the lover and the protective sustenance of the mythic mother of memory. She was an imaginative spur to a place beyond the present, situated between the past and the future, a place of ideal beauty and unmitigated sensory pleasure.

Seated in indeterminate landscapes, standing in front of backdrops of sea and sky, Renoir would place his naked female figures in a world removed from contemporary concerns. The elemental configurations of water, earth, foliage and sky provided the pictorial settings for his voluptuous female figures. Only the persistent appearance of wedding rings and the inescapably contemporary features on the faces of the women would remind the viewer that the models for these painterly exercises in escapism were drawn from the collection of servants and hired helpers on whom Renoir depended. Perhaps these signs of contemporaneity rendered the remote outdoor settings and fleshly bodies of the bathers accessible to the artist and his viewing surrogates, establishing this fantastic universe as tantalizingly present, even attainable. For the scenes Renoir evokes are always sufficiently remote to reside in the realm of dreams, but often also powerfully present in their tactile, painterly realization, so that they suggest the illusory possibility of actual fulfilment in the here and now. This is nowhere so clearly articulated as in the tensions between dress and undress suggested by the drapery that covers the lower bodies of his figures. In the *Bather Arranging her Hair* (fig. 124), for example, the white sheet hugs the legs in a manner reminiscent of a half-removed petticoat rather than an antique cloth. The waistband and gathered cotton show a sewn garment, one which has been removed to reveal the buttocks and to suggest the fold between belly and thigh. Balanced precariously on the lap and held in place by the weight of the body and the clenching of the lower leg against the thigh, the skirt could easily slip down and leave the model vulnerably undressed. In the *Standing Bather* (fig. 125) too, the waistband and gatherings of what is clearly a falling petticoat are abundantly apparent. As the bather's hands reach down to hold on to her tumbling skirts, she simultaneously gathers them up to reveal her ankles and feet. Neither entirely goddesses nor contemporary women, the sexualized presence of these figures is situated between the states of dress and undress, past and present, remote fantasy and tangible reality. Natural woman is a painterly construction which reconciles the irreconcilable, tantalizingly invoking the present while dressing it up in the

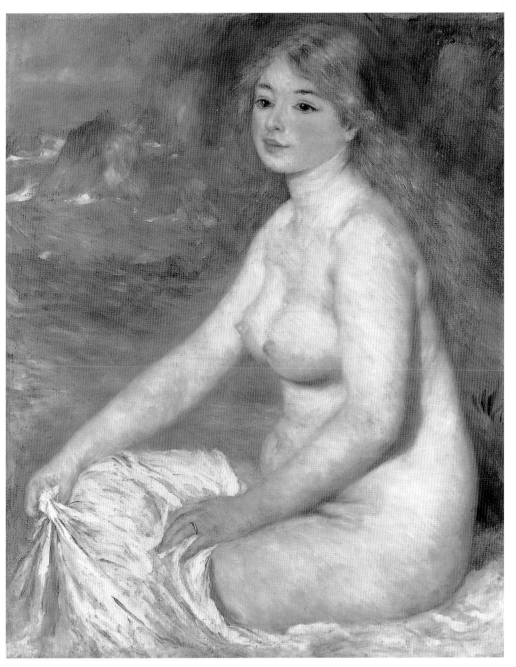

123 PIERRE-AUGUSTE RENOIR Blonde Bather, 1881

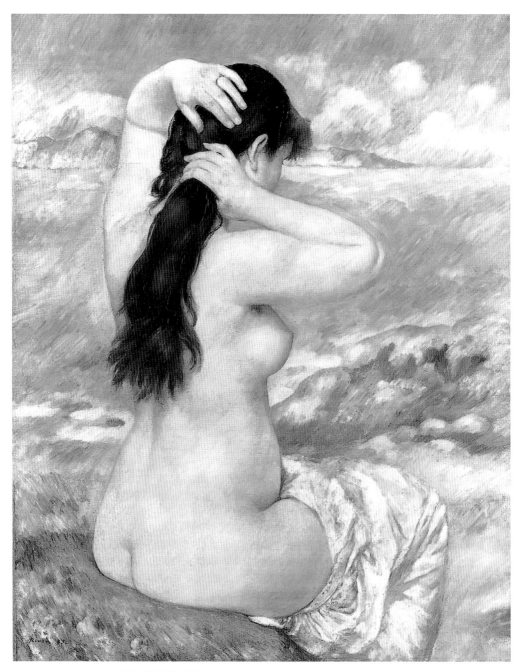

124 PIERRE-AUGUSTE RENOIR Bather Arranging her Hair, 1885

125 PIERRE-AUGUSTE RENOIR Standing Bather, 1887

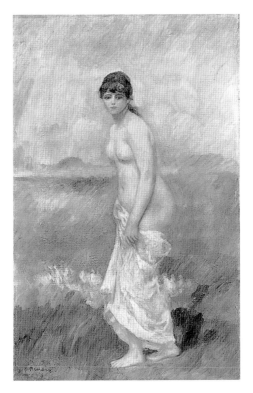

moralizing rhetoric and pictorial packaging of the past. Rendered per-
fect by paint, the once constrained hair and body are now liberated in
the painterly universe over which the figures preside. Remote and yet at
the same time attainable, the bathing figure is the perfect embodiment
of a nature that is never too wild or unruly, never hostile or forbidding.

In the 1880s and '90s, Renoir was to produce many images in which
the triumph of nature over culture was expressed in the detail. Jewellery
remains visible in his monumental multi-figured composition *The Large
Bathers* of the mid-1880s (pl. XI). Once again drapery, remarkably mod-
ern in its character, functions as much to reveal the nakedness of the
figures as to conceal it, and the faces and gestures of the models invoke
the superficial frivolity of the 'Parisienne' as much as the nymphs of
water and woods that the setting suggests. Contemporary woman is
subsumed into the generic landscape of myth. Despite the lack of overt
narrative content in these pictures, the story that they tell is abundantly
clear. In fact it is so naturalized and pervasive a tale that it needs no
named heroines or hidden heroes for it to make sense. Far from being
renounced in paintings like these, narrative is so deeply embedded in

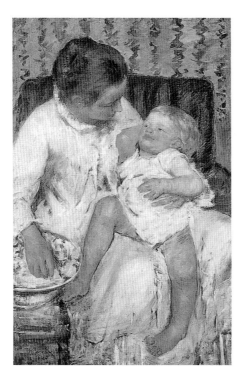

126 MARY CASSATT Mother About
to Wash her Sleepy Child, 1880

127 PIERRE-AUGUSTE RENOIR
Maternity, 1885

the canvas that it needs no paltry pretext in order to be legible. Narrative is the very stuff of which these paintings are made, for they are imbricated by the well-trampled stories of masculine mastery and feminine display which underpin so much of Western pictorial culture. In a culture in which traditional gender roles were being challenged both by the increasingly vociferous demands of feminists and social reformers and by the inevitable effects of modernization, Renoir promoted a vision of the world that recalled a mythic golden age in which women were nothing like men, they were ineluctably different, deferential and desirable.[13] In such a world, women would devote themselves to the rearing of children and the sustenance of men. Epitomized by the nursing mother (a subject to which he devoted a number of works) as much as the nubile nymph, Renoir imagined a state of blissful harmony which the world had lamentably lost. Decrying the tendency of wealthy women to farm their children out to wet-nurses, Renoir opined on the emotional and physical advantages of maternal breast-feeding, insisting that Aline, the peasant woman who was to become his wife, nurse their sons herself. Aline Charigot provided an image of rustic maternity in a series of works in which the feeding infant is placed at an ostenta-

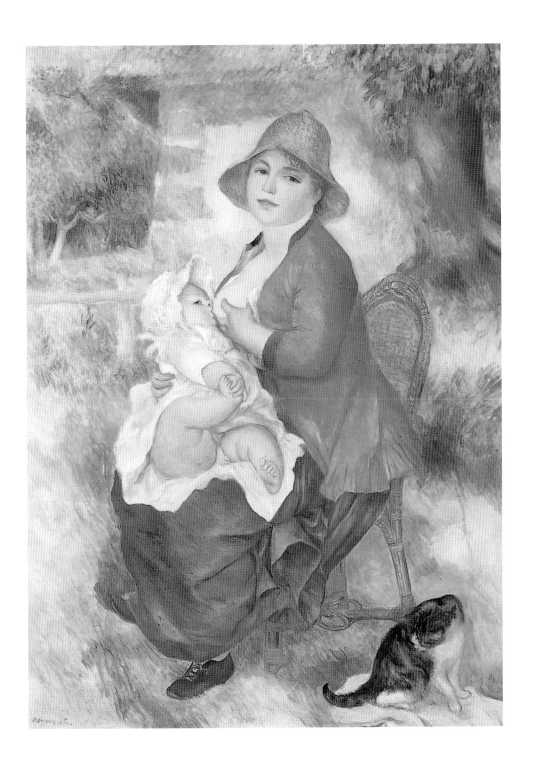

tiously exposed breast which functions as part mammary gland, part erotic object in the organizational structure of the picture. Renoir shows little interest in the affective bond between mother and child, the charged relationship which his contemporary Mary Cassatt had so powerfully evoked in paintings like *Mother About to Wash her Sleepy Child* (1880), and instead invokes predictable analogies between women and cats, milk and cream, hungry male infant and orally-fixated viewer. Like the infant at the breast of the fecund and ever-nurturing mother, Renoir looked to a mythic Woman to shelter him from the ravages of modernity. Painting was the space for the elaboration of that phantasmatic plenitude which is associated with early infancy. The mother exists for the infant only as a projection of his or her psychic and physical need. The withdrawal of the mother and the gradual realization of her separateness produces immense psychic pain for the infant, but a pain that is necessary in order to enter into the symbolic languages of culture. Renoir's art amounts to an elaborate defence against the pain of separation. For Renoir produced an art in which the exploration of conflict, of pain, of alienation, of separation itself, had no place. In his art, Woman as mother, as nature, as goddess was to function as the sign of eternal reparation in a painterly practice which became increasingly a defence against the ravages of adulthood. Infantile in the most profound sense, Renoir's art remained locked into the pursuit of pleasure, a pleasure symbolized in the rapacious suckling of the infant at the mother's breast. It never moves therefore to an art of desire, for it remains fatally locked in the realm of wish-fulfilment and the gratuitous gratification of appetite.

By the time Renoir was a very old man, painfully thin and crippled with debilitating arthritis, Woman would have grown in his imagination to immense, even grotesque, proportions, so large in fact that her image could not fit onto a canvas supported on an easel and he was obliged to have a contraption built that would function as an endless screen mounted on rollers so that his all-enveloping canvas of female bathers could be rolled cinematically round as he painted.[14] Consuming his entire field of vision, the enormous canvas would show two naked giantesses sprawled in familiar poses on the well-worn drapery and foliage of oil painting, their garments discarded beside them. Like billowing fleshly pillows, an image of soft, supine femininity was to provide the final resting place for the weary imagination of the ailing artist. Here Woman, larger than life, more supernatural than natural, seems to represent an overblown and exaggerated defence against mortality. The politically and psychically regressive fantasy of the elemental, earth-

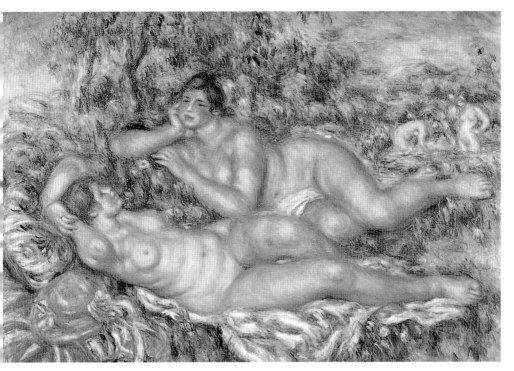

128 PIERRE-AUGUSTE RENOIR The Bathers, 1918–19

bound, natural Woman which was so fundamental to Renoir's painting practice had finally produced an image so excessive in its scale and metaphorical language that it enters the realm of the absurd. Mindless and mountainous in equal measure, the mythic Woman of Arcadia becomes a grotesque parody of herself. Made of multiple breast-like shapes (elbows, navels and knees all seem to echo these tumescent protrusions) and surrounded by a painterly profusion of flowers and foliage conceived in feverish hues and heated contrasts of yellow, orange and mauve, she represents the fantasy of a fecund femininity run riot. As the sprawling infant plays onanistically and unconsciously with his toes at the blank screen of the mother's breast, Renoir resorts in old age to a vision of Woman as enveloping presence, as monumental maternal matter. The repository of fantasy, the material of dreams, the matter of painting, Woman represents nature to a culture which while defining itself as masculine and masterful nevertheless holds on to the maternal embrace in its final and futile protest against the ultimate separation, death.

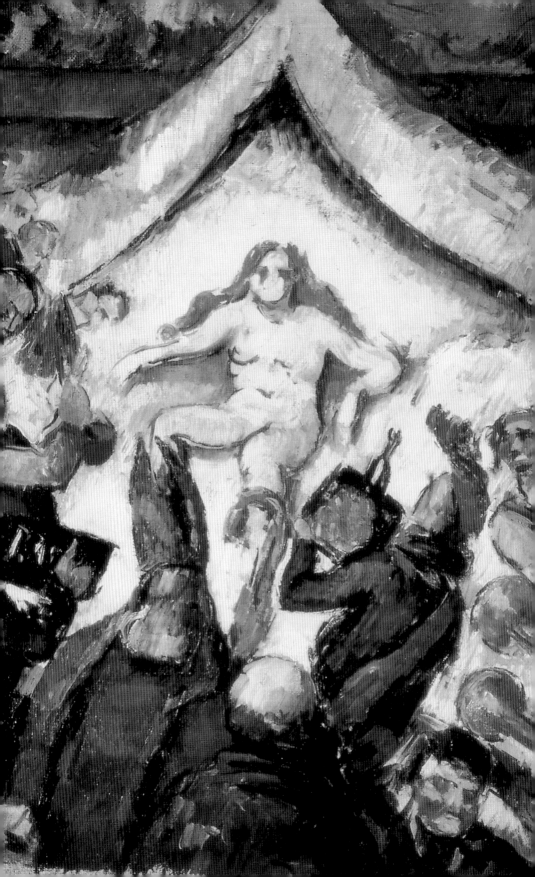

Unlike his contemporary Renoir, Paul Cézanne's encounter with the genre of the female nude offered neither succour nor solace to the troubled imaginings of this nineteenth-century artist. Instead it constituted the terrain of maximum struggle, both with the languages of painting and with the libidinal impulses which the genre provoked. Joachim Gasquet described Cézanne as 'bedding' his nudes in his paintings, subduing them, tussling with them and lashing them with 'great coloured caresses'.[1] Painting is here subsumed into the language of erotic gesture and it is the encounter with a sexualized body on the surface, the attempt to capture its physical presence in paint, that makes that elision possible. Skin and surface are metonymically linked, while psychic and sexual struggle function as the metaphor through which artistic endeavour can be understood. If for Renoir this conjunction made of painting a sensuously rich and rewarding endeavour, for Cézanne it explained its compulsive, almost addictive character, which allowed him no release or respite from what he perceived as the tortuous nature of the quest. The conflation of Woman and canvas was a commonplace in literature and criticism by the late nineteenth century. The artist Frenhoffer, the tragic hero of Balzac's *The Unknown Masterpiece* of 1832, a story much admired by Cézanne, had fatally invested painting with such a libidinal charge, declaring wildly that the painting of a female nude on which he was working 'is not a canvas, it is a woman! a woman with whom I weep and laugh, and talk and think.' Describing himself as more 'lover' than 'painter', he jealously guards his painted idol's modesty, shielding her from the invasive glances of other men.[2] There is no separation here between the artist's brushstroke and the lover's caress, and it is the female nude which serves as the medium through which the heroic delusions and tragic downfall of the Romantic genius are figured. Sexual passion and the passionate struggle of the artist are intertwined and the female nude provides therefore the naturalized vehicle for an interrogation of the language of painting itself. For Cézanne too, figure painting would function as one of the central arenas for an investigation of the nature of art, providing a forum for

experimentation with traditional figural arrangements and contemporary imagery, as well as an integration of naturalist and realist impulses into the most elevated of artistic genres. The final two chapters of this book will explore different (but not unrelated) moments in Cézanne's encounter with the figure, the first offering an interpretation of a characteristically highly charged and erotically loaded early painting, the last an analysis of Cézanne's late bathers in relation to the psychic defences evident in their very compositional structures.

In the mid- to late-1870s Cézanne made at least two (probably more) allegorical paintings entitled *The Eternal Feminine*, in which a supine, naked female figure is shown surrounded by a chorus of clothed men, many distinguishable by their costume and attributes as representatives of characteristic French social types.[3] Naked, elemental Woman, all body and matter, is juxtaposed with clothed, social Man, empowered and yet imprisoned by his duties and desires. By deploying the well-known phrase 'the eternal feminine' as his title, Cézanne ventured into a modern discourse on female sexuality which attributed an essential, timeless character to femininity, irrespective of variations in class, costume or context. The category of 'the eternal feminine' (to which Simone de Beauvoir was later to object so strongly) presupposed a pre-cultural, eternal corporeality which could be seen to constitute the very essence of Woman. But unlike the comforting, vacuous vision of femininity adumbrated by Renoir, Cézanne's 'eternal feminine' is a dangerous, devouring force which is so fearsome to behold that it threatens the structures of sight itself. *The Eternal Feminine* thematizes sight, sexuality and representation through the curious juxtaposition of the body of Woman (no particular woman this, but Woman in general), the body of the artist (symbolized by the figure working at his easel in the upper right-hand corner of the picture) and the mediating function of the work of art (here placed on the easel depicted within the painting itself).

The Eternal Feminine represents an elaborate fantasy, one which draws on predictable nineteenth-century notions of the 'feminine', staging Woman as both idealized and vilified, enthroned and debunked. Placed on a pedestal, but denied any of the sacramental attributes of a madonna or saint, it is Woman's naked body which must express and symbolize the essence of femininity, its mysterious and menacing power. If Woman is the 'idol' to be worshipped, the image to be adored, she is also a threat which must be contained, a vision to be captured. Cézanne's watercolour (fig. 130) and oil (pl. IX) versions of the theme deploy some highly idiosyncratic devices in the fabrication of his fantasy. In both, Woman is centrally placed, surrounded by men who

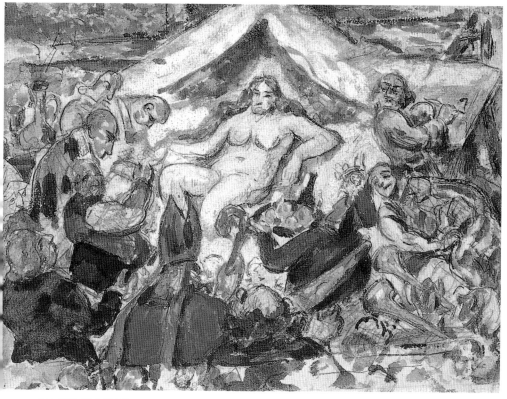

130 PAUL CEZANNE The Eternal Feminine, c. 1877

trumpet her praises and proffer gifts in adoration, but the manner of depiction and positioning of the central idol and her surrounding supplicants make of this homage a double-edged affair. Woman is here framed in the curious canopy which surrounds her. She constitutes the riveting central axis of the picture, but despite the clichéd adoption of a semi-recumbent position, abundant white bed linen and flowing golden tresses, the lack of resolution in figure drawing and the absence of superficial seductive charm in face, features, flesh and body parts make a mockery of conventional contemporary tributes to feminine beauty. Here idol turns into despot, the supplicants become slaves, and the frightening figure of Woman is both symbolized and mastered in the act of painting. Her power to disturb is asserted in her besmirched and bloodied eyes which, while contributing to her identity as nightmarish phantom, also render her blind and wounded, seen but unseeing. So horrendous were these blood-filled cavities to some of their first viewers

131 PAUL CEZANNE Self-Portrait with a Rose Background, c. 1875

that they were apparently painted over in the early years of this century and were only recently uncovered when the painting was cleaned at the J. Paul Getty Museum, its current owner.[4]

In both versions of the theme, Cézanne represents, among the encircling crowd of men, the figure of the artist, poised at the easel. The artist takes his place among the full array of social types on which Cézanne has drawn: the excitable wrestlers, the noisy trumpeters who have quite lost their heads in their excitement, a troubadour in a feathered hat proffering a tray with fruit and wine, a bishop with a mitre and crosier, a man with a black box or banner, a half-obscured soldier with impressive epaulettes, a man in a red vest shaking what looks like a money bag, and various bowing and scraping pilgrims, all ostensibly worshipping at the shrine of femininity. The Catholic Church is explicitly implicated in this profane adoration. The hunched back of the bishop lurches towards the naked figure, his crosier making contact with her one leg, his mitre obscuring the other.[5] Next to him, in the centre, directly beneath the apex of the dark triangular space formed by the canopy which frames the nude, is a bald man. In the watercolour his head, like the body of the nude, is turned awkwardly to the side. In the oil, the

more highly finished and deliberated of the two pictures, the erect figure in the forefront faces directly towards the centre, fixated, we must imagine, on the body of Woman, now fully frontal and painfully, distressingly foreshortened, here seen from below. Although we do not see his eyes, we can trace the path of his gaze, which travels via the bishop's crosier up the leg of the figure to the torso and head above it. The positioning of this viewer within the picture most closely mirrors that of the viewer of *The Eternal Feminine* itself and also that of the artist. What is more, his hunched shoulders and bald head, so familiar from contemporary self-portraits by Cézanne – such as the *Self-Portrait with a Rose Background* (c. 1875) – suggest a man who, if he does not represent Cézanne himself, is one who is remarkably similar to him in age and physical type.

In the early 1870s Cézanne had repeatedly used his own image when satirizing the voyeurism implicit in nineteenth-century modes of viewing.[6] His *A Modern Olympia* of 1873 (fig. 132) showed a scene of unveiling and display which made the process of viewing the revealed body of a woman explicitly part of the picture rather than its undeclared subtext, as it had been in Manet's *Olympia* (fig. 133), painted some ten years before it. One of a number of exercises on the theme, they show Cézanne to be totally cognizant of the spectatorial relations of his time. His work makes caricaturally explicit what Manet had implicitly staged. The erect Baudelairean black cat of Manet's grandiloquent vision is here transformed into a boudoir pup, cheeky, flirtatious and frisky. The ambiguous flowers, so enigmatically carried by the female attendant in the earlier picture, here make an excessive and flamboyant display of themselves, while the insertion of the cane-bearing, bare-headed male figure into the picture space proclaims unambiguously the relationship between the naked body in the picture and the desiring gaze of the male customer/viewer. The dog's attention, like that of the black-coated figure, is fixed on the unveiling that takes place before it. It seems to yelp in anticipation and excitement. Sitting on the edge of his seat, the man's whole body is orientated towards the reclining female figure, his cane suggestively bridging the white expanse that separates his body from hers. Much is made of the conspicuously placed discarded hat balancing precariously on the sofa. We know to whom it belongs. It casts its presence not only by providing a solid black shape and a useful (overtly phallic) shadow which draws our eye into the picture, but it serves as a narrative and satirical signifier: the gallant gentleman has removed his hat, is preparing to stay and his attitude is comically reverent. His naked head humbles him. It lays his desire bare.

132 PAUL CEZANNE A Modern Olympia, 1873

133 EDOUARD MANET Olympia, 1863

134 PAUL CEZANNE Olympia, c. 1875

In a later watercolour variation on the same theme, entitled simply *Olympia*, in which Cézanne seems intent on restoring Manet to Titian, his male figure, top-hatted and formally posed behind the maid, looks more like an undertaker surveying a corpse than an ardent admirer or paying guest. His defensively folded arms and curiously attentive, almost professional concern have none of the naked vulnerability of his comic predecessor. Class and costume provide all the defensive armour he needs. And as if that were not enough, the maid, now restored to the uniformed presence with which Manet had endowed her, provides an added barrier between the man and the object of his attention. The back view of the strategically placed, bald-headed man at the bottom centre of *The Eternal Feminine* conjures up a much more engaged form of viewing. The fleshy solidity of his pate, carefully modelled and round like a peach, rises provocatively before the idol of femininity so flagrantly displayed in front of him. Indeed, it brings to mind the bare-headed kneeling monk in the contemporary *Temptation of St Anthony*, who, while drawn to the figure of the flamboyant temptress who bares herself to him, blocks his vision with his hand so as not to see her nakedness. Cézanne had annotated a preparatory watercolour of this picture with the woman's words: 'See my body's dazzling complexion / Anthony, and do not resist seduction'. Sight and resistance are explicitly linked here. The defensive gesture of the monk must blind him to woman's seductive powers. Only if he does not see her is he safe from her. Spiritual salvation lies in shielding himself from the spectacle of woman's sexuality.

No such defensive gesture is explicitly attributable to the central viewing figure in *The Eternal Feminine*. He seems poised in front of the nude, looking up past her groin to her torso and head. His bald head and hunched shoulders form the apex of his own inverted triangle, one that helps to frame the nude and anchor it securely in the centre of the picture. The left-hand corner of this triangle is marked by a curiously fleshy vase sprouting foliage which links the space of the interior to the fictive space of the landscape on the wall behind, at the same time as echoing the round spherical presence of the tumescent head in the fore-front, while the right-hand corner is occupied by the bald man's surro-gate, the image of the artist himself, poised in front of his easel, his head turned round to confront the body of Woman. The artist's activity mir-rors Cézanne's, even as his demeanour resembles our imagined picture of him. Let us call this fictive artist Paul as a way of linking him to Cézanne without conflating the two of them entirely. Paul, like Cézanne, is confronted with the daunting task of painting a female nude. But

135 PAUL CEZANNE The Temptation of St Anthony, 1873–5

unlike Cézanne, who for the most part resisted painting from the live
female model, and ended up here with a violently abstracted image of
Woman, Paul is shown painting in front of a figure, to whom he turns
his head, ostensibly engaged in painting what he sees. Indeed some
commentators on this picture have been so convinced that this is what
he should be doing that they have been blind to what is actually repre-
sented on the small canvas within the picture. Witness art historian
Henri Loyrette when he writes: 'It would seem that we are in the studio
of the painter himself, who is shown working on a small canvas like the
present one, transcribing what he has before his eyes.'[7] Loyrette's sight,
his trained eye, fail him here. His need to portray Paul as a witness to an
empirically observed scene, as a naturalist in fact, inhibits his ability to

notice the oddness of what is actually represented on the small canvas. Instead of a nude, the artist has painted a dark triangular shape which looks much more like a mountain peak than a conventionally observed woman's body. His physical orientation, the way he turns around to look at the woman, functions as a thematization of the aesthetics of naturalism which is at the same time undermined in the evidence on his canvas. True, Paul may have eclipsed the woman and concentrated on the triangular canopy framing her, but that does not explain the solid, dark mass and filled-in space that appears on the canvas. Nor does it explain why the image of the woman needs to be erased in favour of the space that surrounds her. No, an explanation for this image needs to be sought outside of the empirical evidence confronted by Paul. Its lack of fit is the most important thing about it. Its relationship to that which it purportedly represents is unclear, a mystery, and can better be understood as a product of what Freud was to call 'the blindness of the seeing eye' than as the result of the eye's omnipotence.[8] Crucial to Freud's discovery of the unconscious was the realization that the symptoms expressed through the bodies of his hysterical patients could not be understood at face value. Only by moving beyond the reigning framework of empiricism with its reliance on the evidence presented to the eye could interpretation begin.

In the enigmatic juxtaposition of Woman and Art that is staged by this painting, neither survives the exercise as a fixed, knowable category. The curious transformation of the one into the other is shown to be as much the result of a refusal to see, a resistance to sight, as the product of visual experience. And the artist himself is figured here both as a blind man and a visionary, a witness and a traitor. It is the riddle posed by *his* testimony that alerts us to the deceptions at the heart of both naturalist aesthetics and misogynist mythologies alike.

The picture within the picture suggests more than meets the eye. If the emphatic erasure of the woman in the small canvas is performed in the interests of landscape, with Woman functioning as facilitating muse rather than motif for the depicted work, then illustrious predecessors can easily be found. At the heart of Courbet's allegorical painting of *The Painter's Studio* was just such a juxtaposition. In his ambitious painting Courbet had depicted himself engaged in painting a landscape. The contrived nature of such an endeavour could not have been more explicitly staged than in this image. The female nude stands as a guarantor of the elevated character of the pursuit of painting: as a muse, studio prop, realist totem and sign of the nature that must be mastered through the disciplines of art. The elaborate artifice of an ostensibly realist picture

136 GUSTAVE COURBET The Painter's Studio, 1855

which presents a studio of assembled types and social representatives, a female model and a painter painting an imaginary landscape points to the very conventionality of realist and naturalist modes and of the relative autonomy of painting from the world that it represents.[9] The subject matter on the canvas bears no visible relation to any scene here witnessed. It is a curious manifesto for an avowed realist but one which foregrounds the allegorical nature of painting, the complex relationship between representation and the real and the slippages between signifier and signified which the painted surface of the canvas necessarily portends. Crucially, the absence of Woman in the landscape combined with her central significance in *The Painter's Studio* alerts us to the uses to which Woman's body can be put in allegory – it is Woman's erasure signalled by the assertion of her presence and the thematization of her absence that provide the vehicle for a complex meditation on meaning and representation.

Cézanne's erasure of Woman in the internal canvas represented in *The Eternal Feminine* functions as an allegorized representation both of the artifices of naturalism and of the psychic defences of masculinity. At the heart of Cézanne's painting is a failure of sight: it is suggested by the invisible gaze of the bald-headed man positioned in the centre of the

137 PAUL CEZANNE Bathsheba, 1875–7

painting, the turning to look of the man at the easel who functions as his surrogate, and the bloodied, wounded image of a blind femininity which is the object of their gaze. What is more it is symbolized by the curious visual testimony placed on the small canvas which shows not a woman but a shape, one that strongly resembles the elemental structure of a mountain peak – triangular, opaque and familiar. It would not be far-fetched to read this shape as substituting for the body of Woman. The corporeal contour of the mountain and the mountainous nature of the female body were invoked in a number of Cézanne's paintings. The reclining body depicted in the contemporary *Bathsheba* is overtly echoed in the fleshly forms of the mountain side. Such analogies of shape set up satisfying pictorial harmonies at the same time as natural-izing the relationship between Woman and nature. The soft mounds of her flesh and the curvaceous contours of her body enshrine Woman's identity as matter. This was the kind of identification on which Renoir's paintings of the female nude depended. The mountain on the canvas in *The Eternal Feminine* conforms to a kind of pictorial and cultural logic, therefore. But its assertively triangular form, its specificity as a particu-lar shape, suggests more than just the generic association of Woman with nature. After all, that relationship is already set up in the strange backdrop to the scene, the disproportionately large landscape which is positioned behind the canopy and which, as we have seen, spills its con-tents into the scene below. No, the sign for Woman on this small canvas is altogether more enigmatic and opaque. While invoking women's sex (its dark triangular form signals the place between the thighs which is the site of women's castration even as it invokes the pubic mound that surmounts the vaginal opening), it stands also for the unrepresentability of the feminine, the necessary transformation of Woman's lack into the defensive language of allegory.

As such, it deploys a procedure which had become habitual even in so apparently detached a science as anatomy. The naming of the female sex organs in nineteenth-century medical parlance reveals the same ten-dency to allegorize as did the disciplines of art and literature. One par-ticularly telling instance of this process is provided in G.J. Witkowski's *Anatomie iconoclastique* published between 1874 and 1877, an illus-trated textbook in which readers are invited to peel back parts of the body in order to penetrate the layers concealed underneath. The volume on the 'Anatomy and Physiology of the Genital Apparatus of Woman' included vividly coloured fold-out diagrams which attempted to give a sense of the three-dimensional character of the female sex organs. As the diagram shows, the space above the vaginal opening and beneath

138 'Anatomy and Physiology of the Genital Apparatus of Women' 1874, from G.J. Witkowski, Anatomie Iconoclastique, 1877

the abdomen is labelled with the unlikely designation the *mont de Vénus*, a curiously literary use of language in the context of so technical a manual. In the text which accompanies the diagrams, Witkowski described this area as follows: 'The *mont de Vénus* is a hill which dominates the vulva and which is covered with hair from the time of puberty onwards. It is formed by the projection of the pubic bone covered by a more or less thick layer of fat depending on the size of the individual.'[10] The metamorphosis of the pubic area into a mountain associated with the classical goddess of love transforms it from body part to literary and visual trope whose function far exceeds its use as a descriptive term and alerts us to the figurative uses to which the female body was put. The horrifying hole which characterized women's sex in the masculine psyche could be overcome by over-investing the area which surmounted it with mythic significance.

When the centrally placed, bald-headed man in the forefront, the ideal viewer in the picture in *The Eternal Feminine*, is positioned to confront woman's sex from the front, he is protected in two ways, one, by the displacement of her wound from her genitals to her bleeding eyes, so that the space between her legs seems innocent, even insignificant in the whole scheme of the picture; and two, by the substitution by his surrogate in front of the canvas, of the Arcadian fantasy of a hill of love, a mountain of Venus, a Mont Sainte-Victoire, as the object of his desiring gaze. The mountain is the token of his victory, the displaced object of his 'voracious vision' (to use Merleau-Ponty's telling phrase). The image of his fantasy obliterates the physical evidence before his eyes. Desire produces its own oneiric universe, built on a necessary blindness which is at once a refusal to see and an impulse to allegorize. The final representation of the 'eternal feminine' occurs in the symbolization of her as pure sexual matter, mastered and managed in representation.

But how can we be sure of the relationship between the obstinate triangular shape on Paul's canvas and the central image of Woman that is Cézanne's focus? What if we have over-invested this shape with significance? What if Paul paints nothing in the face of Woman? What if the recalcitrant meaning of the marks on the small canvas propped on the easel remains always and only a question of paint? Should we search for 'the woman underneath the paint' or is paint all that we get in this curiously self-reflective exercise? Like Frenhoffer, the hero of Balzac's *The Unknown Masterpiece*, to which Cézanne may have paid a kind of homage here (notice the vague letters BA and perhaps L on the black box in *The Eternal Feminine*), Paul reveals his painting only to demonstrate the lack of fit between the painted work and the model it is meant to resemble. When Frenhoffer, the deluded ageing genius, had revealed *his* cherished nude to his admirers Porbus and Poussin, they searched in vain for a recognizable image of a woman on the canvas. At the moment of revealing his picture to his admirers, Frenhoffer declared:

> 'Ah! You did not anticipate such perfection! You are in presence of a woman and you are looking for a picture. There is such depth of colour upon that canvas, the air is so true, that you cannot distinguish it from the air about us. Where is art? lost, vanished! Those are the outlines of a real young woman.... Does it not seem to you as if you could pass your hand over that back? ... The flesh quivers. Wait she is about to rise!'[11]

Frenhoffer, as we saw at the beginning of this chapter, mistakes the painting itself for a woman. His fatal error is to misconceive the caress-

ing gesture of the act of painting for an act of representation. Relating to his canvas as a woman, he has come to believe that it depicts a woman who is clear for everyone to behold. Puzzled, Poussin turns to Porbus and asks:

> 'Can you see anything?'
> 'No. – And you?'
> 'Nothing.'

They examine the painting from all sides, after which Frenhoffer cries out:

> 'Yes, oh! yes, that is a canvas, ... See, there are the frame and the easel, and here are my paints, and brushes.'

Poussin returns to look at the picture and declares:

> 'I can see nothing there but colours piled upon one another in confusion, and held in restraint by a multitude of curious lines which form a wall of painting.'

At this point Porbus notices 'in one corner of the canvas the end of a bare foot standing forth from that chaos of colours, of tones, of uncertain shades.' This prompts him to cry:

> 'There is a woman underneath.'

Frenhoffer remains trapped in his own delusions. 'He was smiling at that imaginary woman', Balzac writes. But Poussin concludes that:

> 'sooner or later he will discover that there is nothing on his canvas'

In naturalist terms, Frenhoffer has indeed painted nothing. In erasing the image of Woman he has undermined the aim of art. Colour, shape and line without a referent amount, for a naturalist aesthetic system, to nothing. A signifier without a signified, it is empty of meaning. If Paul has, in the presence of Woman, painted nothing but a shape, one which stands for the Woman but does not resemble her, then he, like Frenhoffer, has defied the basic principle of the aesthetic system of his time. Either he is a deluded fool who persists in seeing Woman where she is not, or a knowing visionary who interrogates in paint painting's capacity to picture the world. The tactile density of his canvas, its painterly profusion and opaque materiality, alerts us to the dense tangibility of the rest of the canvas, with its agitated brushstrokes, painterly hatching and vivid brushwork. For *The Eternal Feminine* is no transpar-

ent illusionistic work. In the fraught facticity of the paint application and the intense interplay of grandiose colour contrasts – red, gold, black and white – it trumpets forth its identity as a painting. This is a painting which emerges knowingly from the blank canvas still evident on the bottom left-hand edge. The images to which it gives form remain always and explicitly a matter of paint, their iconic significance open to question rather than a fixed and secure solution.

Perhaps the teasing incomprehensibility of painting and its capacity to picture the world and the bodies that inhabit it is most tellingly encapsulated in this picture by a visual aside, a throwaway detail which is of no central significance and yet is deeply suggestive. Curiously, enigmatically, Cézanne places a hovering hat at the margins of his picture. Ancillary to the main action of the painting, this sartorial signifier is not securely attributable to any of the actors in the strangely theatrical bedchamber of *The Eternal Feminine*. Balanced at the edge of the picture, it threatens to float off into the space beyond the picture's limits. Iconically, it reinforces the naked vulnerability of the bald-headed men and of masculinity laid bare – deprived, as in Caillebotte's *Man at his Bath*, of all its defensive armour. The hat hovers above the head of the gesturing, cadaverous fellow on the right, and arguably belongs to him, but it could provide a potential covering for any number of the naked heads in the picture. Its shape and character teasingly invoke the pomp and ceremony of bourgeois masculinity without securing it firmly in social or pictorial space. Its identity as painted sign, as jaunty pictorial joke, exposes both the artifices of painting and the nakedness of desire. Peripherally placed like the proverbial blind spot, it is both marginal to the meaning of the picture and at its core. For while its shape and character make certain interpretations possible, it can no more easily be secured in space and significance than the mountain can be made to stand for Woman or the Woman be made to stand for the 'feminine'. The allegorical mode invites speculation on the relationship between image and meaning, but it simultaneously stages that relationship as fraught and fractured, a matter of representation. Enthroned and brutalized, displaced or erased, Woman provides the vehicle and vector for such speculation in this difficult and disturbing painting. The viewer, like Frenhoffer, confronts what is only 'an imaginary woman', whether the traced lines of her body are legible in the dense opacity of the surface or not.

The figure paintings of the late 1860s and 1870s had provided Cézanne with the opportunity to interrogate traditional subject pictures as well as realist reinterpretations of them. Engaging with the works of Courbet, Manet and Monet, Cézanne, as we saw in Chapter Six, reformulated these, sometimes satirizing them, sometimes deploying their pictorial structures to his own dramatic ends. Rarely did he engage in the kind of modern-life painting that Caillebotte and Degas explored, preferring to situate his figures in the mythic landscape of art rather than in the sordid bedchambers of contemporary Paris. As Cézanne's painting technique became more immediate, more tied to his engagement with visual sensations and their translation into paint, so his encounter with the nude became more and more hermetically pictorial, serving as a self-referential arena for the exploration of painting's effects rather than as a realist 'mirror' held up (figuratively) to the world. This supremely modernist enterprise becomes therefore divorced from the modern world, and 'modern flesh', in the case of Cézanne's late bathers, finds itself articulated in a fictive painterly universe rather than in an elaboration of an image of the modern world. But this painterly universe remained, nevertheless, haunted by sexual and psychic impulses, fostered by an early identification with Romanticism and an anxiety whose origins can be linked to the relentless policing of sexual difference which characterized nineteenth-century French society. So while Cézanne's painting practice became paradigmatically modernist, ostensibly framed by the autonomous concerns of art itself, its very fabric was equally dependent on the unconscious displacements and repressions which modern society had heralded.

Cézanne's late bathers bring together different (almost opposing) modes of working: the visceral encounter with the landscape (if not actually recorded in these specific instances then at least here suggested and implied through the painterly facture and the placing of the brushstrokes) together with the synthetic distillation of figures drawn from well-known pictorial precedents, standard academic life poses and the artist's own early figure drawings.[1] Neat distinctions between the

'outside' world and the 'inner' self are split apart here. The 'bodily' encounter with painting involves a complex interaction between the world of physical sensation, that of psychic projection, and conventionalized modes of representation. The viewer is faced with a picture of a world apparently seen, a staging of the scene of sensation, and yet one which is patently the product of imaginative fabrication and recycled codes. Painting here is a matter both of experience and translation (sight into touch, touch into sight), of invention and imitation.[2] Boundaries between *plein air* painting and studio stage sets, between the motif and its memory, between observation and imagination are impossible to sustain here. Painting is the place where these ostensibly opposing procedures and processes meet, producing an oeuvre which is evocative of previous models, but at the same time is unlike anything else made before it.

The radical disruption of pictorial conventions which Cézanne's late bathers represent has traditionally been established through comparison with the work of his contemporaries. Most often in this conjunction, the name of Renoir comes up. In 1959 the American art historian Theodore Reff made claims for the particularity of Cézanne's bathers by invoking what had come to be accepted as their opposite. He wrote: 'Cézanne's Bathers are frequently misunderstood: their apparent coarseness and ambiguity put off spectators accustomed to the Gallic verve and grace exemplified by Renoir'.[3] Meyer Schapiro had equally invoked Renoir's vision of 'a dream of happiness in nature' as a foil for Cézanne's bathers which he described as being 'without grace or erotic charm', retaining 'in their unidealized nakedness the awkward forms of everyday, burdened humanity'.[4] Where Renoir has signified Frenchness, grace and certainty, Cézanne has signified primitiveness, awkwardness and uncertainty. Where Renoir's bodies have been seen to offer comfort and reassurance, Cézanne's bodies have unsettled, provoked and disturbed generations of viewers. Renoir provides, therefore, a convenient foil against which to look at Cézanne.

Cézanne's *Large Bathers* (1906) is hung in the Philadelphia Museum of Art in a room next to Renoir's *Large Bathers* (1887; pl. XI), painted some twenty years before it. Looking at these two pictures together allows us to see the distinctive character of each more fully. Not that everything about these images is different. Indeed, they have some very strong similarities. Both are images showing female nudes in the landscape. Both present the familiar combination of female flesh, foliage and water. Both represent a mythic world which evokes the standard Arcadian fantasies of much *fin-de-siècle* French painting and which is indebted to a tradition which traced its lineage back to the High Renaissance. Both

140 PAUL CEZANNE The Large Bathers, 1906 (plate X)

could be seen to endorse the conventional gendering of the relationship
between nature and culture, a relationship which is so aptly set up by
two contemporary photographs of the artists and their works (figs 141
and 142). In both these images we see a juxtaposition of ageing clothed
masculinity with naked female flesh. Emile Bernard's 1904 photograph
of Cézanne shows him seated in front of an early version of his large
bather painting, now in the Barnes Collection in Philadelphia. The pho-
tograph shows the painting still propped on the easel, the palette resting
on the stand, the bare floorboards covered with scraps. The space of the
studio provides a setting for the elaborate fantasy which is played out
on the canvas. This is the workplace, the site of professional practice
and messy production, a world which could not be further removed
from the world represented in the painting. It asserts the cultural con-
text from which the fantasy of nature encoded in the painting draws
its meaning, that is those circuits of production and consumption con-
stituting the institutional fabric of art of which Cézanne, for all his
legendary isolation, was very much a part. Nature here has meaning
only in relation to the culture which produces it and Cézanne, for all the

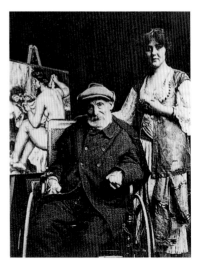

141 Paul Cézanne in his studio, photographed by EMILE BERNARD, March 1904

142 Pierre-Auguste Renoir and Dédée in his studio, photographer unknown, 1915

attempts to turn him into a mighty precursor or solitary saint, is as deeply rooted in that cultural context as are any of his contemporaries. The photograph of Cézanne with his large painting of nudes in the landscape can be read in terms of the naturalized assumptions around culture and nature: a productive, professional and pondering masculinity juxtaposed with a fantastic, elusive and natural femininity.

These issues, although present, are inflected slightly differently in the poignant image of the crippled Renoir, encircled and supported by his model-cum-maid in the space of the studio and sustained in the world of art by that fantasy of female fecundity which had become the hallmark of his late work. Masculinity and femininity, age and youth, beauty and wisdom, health and decrepitude are all encoded in this image of a masculinity under duress.[5] Here it is the youthful body of Woman, whether actual or pictured, clothed or stripped, which offers a vision of rejuvenation, of plenitude, of hope in relation to the disabled but powerful figure of the artist, whose intense and penetrating stare seems to compensate for the impotence of his strapped hands.

Both these photographs, therefore, invoke standard *fin-de-siècle* polarities, ones which were peddled in the Salons of Paris and recycled in the publicity that they engendered. When Armand Silvestre, the well-known critic and chronicler, published one of his annual surveys of

Le Nu au Salon in 1889, he used a sample of nudes for the cover. All of these are female nudes, the vast majority showing women in natural surroundings and presenting the standard conjunction of women with water, women with foliage, women at one with the natural world. When Silvestre's image itself appeared on the walls of the Salon in a painting by the modern-life painter Jean Béraud in 1894, he, like Cézanne in the famous photograph, was represented in front of a painting of naked women. But here the world of the real site of production, in this instance the study, and the fantasy world of art are seen to merge as the women descend from their lofty paradise to inspire and soothe the weary sensibility of the busy writer fixed firmly in the present by his clothing, his pipe and his poised pen. The smoke from his pipe becomes the ethereal cloud of his fantasy. The busy journalist is carried off in a transcendent reverie by his naked muses. Woman is the site of rest for the weary masculine imagination. She is the youth to his age, she is the beauty to his

143 Cover of Le Nu au Salon de 1889 by ARMAND SILVESTRE

144 JEAN BERAUD Portrait of Armand Silvestre, 1894

wisdom, she is the nature to his culture. Images of naked women disporting themselves in the landscape were the stock in trade of a culture which accepted such polarities as natural.

But for all the similarities in culture and context between Cézanne and Renoir's large bather paintings, the fact is that they could not look more different. Where the Renoir conforms much more closely to traditional standards of illusionistic representation, idealized femininity and conventional compositional strategies, the Cézanne refuses all of these.[6] Where the Renoir offers a cloying compromise between the demands of, on the one hand, a statuesque and timeless traditionalism and, on the other, a suitably unthreatening and assertively contemporary coquettish femininity, signified by make-up, jewellery and poised painted lips, the modernity of Cézanne's painting lies not in any inscription of contemporaneity on the bodies represented but in the search for a system of mark-making capable of signifying the immediacy of visual sensation.[7] While Renoir's composition is designed to focus attention on breasts, erect nipples, subtly occluded genital areas and open mouths, Cézanne's makes minimal reference to secondary sexual characteristics, reducing the signs of sexuality to a schematic and cursory form of notation. Where the Renoir surface is highly finished and polished, texture and touch being carefully contrived to give the effect of smooth alabaster-like flesh or soft, feathery foliage, the Cézanne reveals an overall painterliness which makes no distinction between body and landscape, figure and ground. Where every bit of the Renoir is covered and accounted for, the Cézanne leaves areas untouched, bare expanses of canvas juxtaposed with fluid, transparent areas of paint. Where Renoir's figures are highly individualized in their theatrical gestures and suspended movement, Cézanne's generalized bodies are solid, rooted and static. Where every limb, toe and finger is finely delineated in the Renoir, the figures in Cézanne's painting have hands and feet that are cursorily sketched in, with no concessions made to gracious gesturing or a titillating teasing of the spectator. Where Renoir's faces offer standard expressions of coquettish abandon, Cézanne's faces are mask-like, their features a series of schematic notations with no attempt to capture character or conform to conventional notions of prettiness. Where there is no ambiguity in Renoir's figures, with each body contained and distinct, and the standard three views of femininity offered in the front triangular group, Cézanne's bodies merge inexplicably into one another. The shoulder of one figure can operate simultaneously as the buttocks of another (as in the two figures to the far right), creating an eerie doubling of forms which turns a boundary into a crevice, a border into an

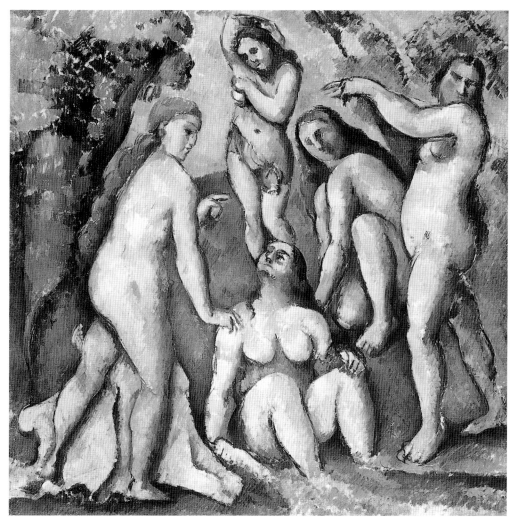

145 PAUL CEZANNE Five Bathers, 1885-7

opening. The emphatic edge of the bony shoulder of the crouching
right-hand figure of *The Large Bathers* can equally stand for the dark-
ened crack of the standing figure's buttocks. The presence provided by a
border and the absence indicated by a space are signified by the same
set of shadowy brushstrokes. The capacity of the doubled forms of the
shoulders to read as buttocks was already present in an earlier Cézanne
bather painting: in the *Five Bathers* (1885-7) in the Kunstmuseum in
Basle, for example, the crouching right-hand figure has emphatically

rounded shoulders and developed muscular arms which resemble the clenched cheeks of buttocks and strong thighs much more closely than a pair of shoulders and arms. The space between the shoulders where the chest should be is contracted and collapsed (as it is in the Philadelphia *Large Bathers*), creating the effect of a crevice rather than an expanse of flesh generous and wide enough to support breasts. But here, the double semicircles of the shoulders/buttocks echo the forms of the breasts (for which they leave no space), particularly those of the oddly schematic round forms of the standing figure on the right whose breasts are pulled around beneath the armpit. In *The Large Bathers*, neither figure in the fused couple has completed limbs; the crouching figure is without hands, the standing figure without feet. The over-investment in the charged duplicity of the shoulder/buttocks has deprived the figures of their extremities. This riveting pictorial pun seems to rob them of their capacity to touch or feel the earth and flesh that surrounds them. The vagueness and incoherence of the area of feet/hands is repeated in other parts of the picture: in the central figure whose orientation echoes the crouching bather to the far right that we have been discussing, the elongated left hand seems to be stroking or drying the leg, but the hand and foot remain undrawn, imagined but never stated. In the striding left-hand figure, the hand fuses with the shrunken head of the crouch-ing figure while the *passage* of the shoulder connects with the faceting brushwork of the sky behind. Neither the body's boundaries nor the spe-cific anatomical character of its parts are sacred here. Buttocks rhyme with breasts or knees, creating analogies of shape and structure. Hands fuse with feet, heads and foliage, destroying the specificity of each while subsuming all into the stringent demands of picture making.[8]

Where Renoir's bathing figures can be viewed according to standard modes of pictorial and corporeal consumption, therefore, Cézanne's resist both. There is no satisfaction here for the rapacious eye, no reso-lution for the fetishistic gaze which seeks reassurance in the polished surfaces and sealed orifices of the idealized body.[9] These are bodies without boundaries, bodies dangerously fluid in their delineation and equally ambiguous in their sexual identity. Where are the reassuring signs of femininity here? The bulky figures with their disproportionate limbs, broad shoulders and anonymous faces offer scant evidence that these are female figures. Difference is inscribed on these bodies by only the barest signs, hinted at in the arrangement of the hair and the cursory indication of the breasts without nipples. Where Renoir's female bodies seem to display that very excess of difference which is normative masculinity's defence, Cézanne's female bodies parade their difference

hardly at all. In Cézanne's bather paintings, the bodies alone are not an adequate guarantor of difference. If sexual difference is to be secured in his pictures, then it needs to be established elsewhere than in its inscription on the body.

In order to establish other signs of difference in Cézanne's late bather paintings, another comparison needs to be set up. Unlike Renoir, whose repertoire of nudes was confined to female figures, Cézanne executed a large number of paintings showing naked male figures disporting themselves in nature. These are never as large and monumental in conception as the female bathers but, like the female bathers, they seem to turn conventionalized modes of representation on their heads. A comparison of the small Philadelphia *Group of Bathers* of 1890–4 (fig. 147) with, for example, Jean-Frédéric Bazille's *Summer Scene* of 1869 (fig. 146) serves to illustrate this point.[10] While by no means a consummate celebration of a virile masculinity, Bazille's bathing scene nevertheless depicts bodies which are unambiguously male. Their bulging crotches revealed by striped bathing trunks, their sinewy bodies, accentuated musculature and general demeanour leave us in no doubt that these are men, even if they appear slightly ridiculous, even feminized, in the open surroundings which are not their 'natural' domain. Their bodies are individualized, their shapes vary, their features are distinct. The landscape too is particularized and localized. These are not generic trees subsumed into a painterly screen. Rather, what we are invited to look at is, apparently, an actual setting captured in highly specific light conditions. The contemporaneity of the scene is stressed by the particularity of the site and the activities of the figures, either leaning, swimming, fighting or reclining on the grassy bank. Nor are all of them undressed. One reveals only his torso, amply displaying his muscular arms as he strains to help another bather from the water. Another is still fully clothed and alludes to a world beyond this scene of male camaraderie. Two are engaged in the vigorous sport of wrestling, an increasingly popular modern-life subject deemed suited, as we have seen, to the elaboration of a virile masculinity.[11] A strange tension is set up between the signs of modernity as encoded in figure types, bathing trunks and contemporary setting, and the tradition of the male nude, which required a more heroic and distant context to sustain its lofty associations. The demands of naturalism necessitated a contemporary setting for the depiction of the nude and whereas this was no problem for the elaboration of a new naturalist iconography of femininity, it was not so easily pulled off within the genre of the male nude. The ideological construction of Woman as embedded in nature, fecund, and fulfilled in her

natural paradise lent a certain authenticity to the countless images of women frolicking about in the countryside that crowded the Salons of the early Third Republic. Women's femininity was, as we have seen, affirmed by their natural surroundings. By contrast, images of unclothed contemporary men, stripped of the uniform of masculinity which inscribed them within the realm of culture, made them seem rather vulnerable and decidedly unheroic. While the nakedness of modern women could appear natural, subsuming them into the mythic category of femininity for which they became a sign, that of men seemed odd, embarrassing, strangely anachronistic.

Cézanne's later male bathers display few of the signs of contemporaneity of Bazille's bathers. The site of their bathing is a generic rather than a specific one and the delineation of their bodies is often generalized and abstracted. Even the odd white shorts which some of the figures wear, or the drapery which hangs down and echoes their body forms, seem vague and generalized, drawn from the language of art rather than alluding to a contemporary world. Where the modernity of Bazille's bathers can be located in the scene represented and the bodies depicted, the modernity of Cézanne's bathers can be found only in

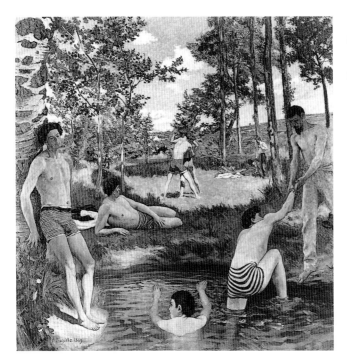

146 JEAN-FREDERIC BAZILLE
Summer Scene, 1869

147 PAUL CEZANNE Group of
Bathers, 1890–4

the manner of its depiction. Where light and colour construct a clear distinction between the figures and the surrounding landscape in the Bazille, for Cézanne the colour is continuous throughout the canvas, the ochres and flesh tones of the figures repeated in the clay, the sky and the trees, the blues and greens of the landscape vividly present on the bodies of the bathers. As with the female bathers, the bodies of the male figures have been subjected to a field of sensation which obliterates, obscures and smudges their bodily presence, at times collapsing the difference between figure and ground and subsuming the body into a profusion of paint which creates an equivalence between flesh and foliage, solid structure and surrounding space.[12] In the course of this process the description of the body as particular, as differentiated, is sacrificed. The body, here, like the trees, becomes the matter of sensation, eminently translatable into paint and eminently manipulable to conform to the demands of pictorial harmony. As the particularity of the body is dispensed with, so are the obvious signs of sexual difference. Male genitals are occluded, reduced now to a dab of darkened paint, or so far back and minutely indicated as to offer a vague and generalized reference rather than a detailed view, as in the larger *Bathers* (1892–4) at the Musée

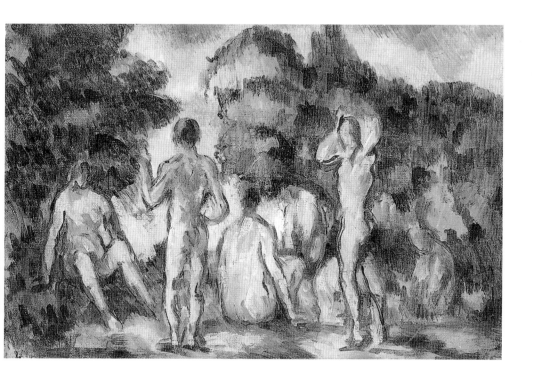

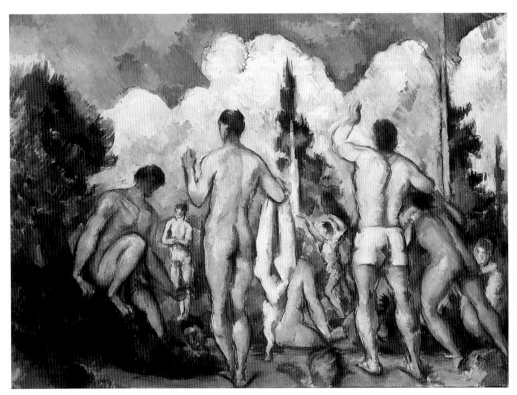

148 PAUL CEZANNE Bathers, 1892-4

d'Orsay. Musculature and flesh dissolve into a screen of paint, chests seems to sprout breasts, and many of the poses are drawn from the same art-historical repertoire as those on which the female figures are based. Poses are interchangeable between men and women. The *Bathers in Front of a Tent* (1883-5) shows the central standing figure adopting the pose of the Venus Anadyomene, associated with the feminine figure of the temptress in Cézanne's early work. This pose (arguably also suggesting Michelangelo's *Dying Slave*) occurs in a number of images of male bathers, where it is twisted around to show a three-quarter rather than a frontal view.[13] Male figures exist in a state of primeval innocence in the mythic landscape of art; they neither parade their sexual difference nor assume conventionally masculine postures. Feminized by their insertion into the realm of nature and by their curiously androgynous bodies, they offer a powerful visual analogue to the masculinized bodies and sexual ambiguity of the female bathers.

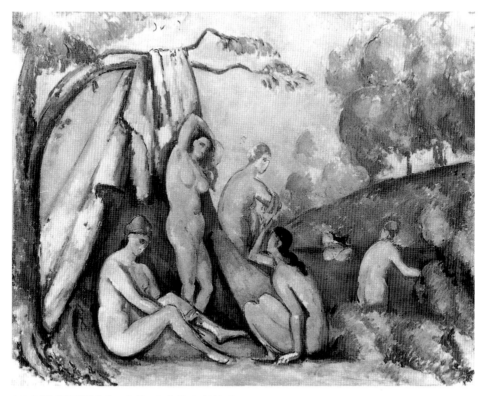

149 PAUL CEZANNE Bathers in Front of a Tent, 1883–5

The pictorial demands of a modernist practice, with its assault on conventional modes of representation (their rationalist scaffolding, traditional perspective and rigid separation between figure and ground), have brought a disruption at the level of the sexual. Sexual difference is not securely established in the figures of the bathers themselves. As the figure and the landscape are subsumed into a new mode of looking – one which stems from a psychic and bodily encounter with the world of physical sensations, a visceral witnessing of a world in which time, space and matter can be represented in paint and translated into colour – the body and the landscape are irreparably altered.[14] The fluidity of the paint constructs a fluid sexuality, the imaginative projection of a screen of sensations destroys difference and the assault on definition produces, inadvertently, a sexuality which seeps outside of its conventional margins, its narrow normative structures.

But for all their subversion of the conventional means of inscribing bodily difference, Cézanne's male and female bather paintings still look remarkably different from one another. They are by no means interchangeable. Indeed, the segregation of male and female figures which characterizes almost all the bather oil paintings from the early 1870s onwards is in itself remarkable.[15] As we saw in Chapter Six, Cézanne had rehearsed conventional modes of representing masculinity and femininity in some of his early pastiches of modern-life painting, such as his two versions of *A Modern Olympia* (1873–5). Here the voyeurism of conventionalized modes of looking was both staged and enacted, celebrated and ridiculed.[16] During the early years, Cézanne had also made a very small number of generic mixed bathing scenes. But he was not to linger with this potentially dangerous subject matter for long. Nor was he ever to develop it on a large scale or in an ambitious work. For the most part, it is in the context of the rigid separation of the sexes that the figural transgressions of the bathers is contained.

Much has been written to try to account for the difference between the male and female bather paintings. Explanations usually refer to the different kinds of fantasy invoked in these images. Where the male bathers are meant to be understood in terms of a nostalgic fantasy for a homosocial space, that of Cézanne's boyhood excursions with his friends Baille and Zola in the mountains and rivers of Aix-en-Provence, the female bathers are more often thought to represent Cézanne's continuing anxiety about women, his fear of female sexuality and his commitment to tradition and grand-scale figure painting. The anxiety which writers see in the female bathers is linked to Cézanne's own psychic drama, his inability to use naked female models and his personal psychic formation.[17]

Such interpretations are coupled with various observations on what makes these pictures look so different from one another. A number of writers have noticed, for example, that the compositions of the male and female bathers are consistently different. The female bathers are most often pyramidally arranged.[18] In the case of the Philadelphia *Large Bathers*, and others like it, the composition is made up of two triangular groupings which, together with the surrounding trees, form an enclosing pyramidal structure.[19] By contrast the male bathers are usually spread out across the front of the picture plane, forming an alternating rhythm of shapes from left to right.[20] The accent here is vertical rather than triangular.

In addition we could add that where some penetration into the picture space is facilitated in the female bathers by the gap in between the

two triangular groups, the assertive horizontality of the front bank in the male bathers disallows any such entry. Where the effect created by the triangular composition of the late multi-figured female bathers is of a gap in the centre of the picture space, a passage to enter, that of the male bathers is frieze-like, the figures arranged across the frontal plane of the canvas in the manner of an ancient bas-relief. The assertive horizontality of the bands which constitute the front river bank, water and opposite bank provide the anchoring for the thrusting verticals of the figures. In the Musée d'Orsay *Bathers* (fig. 148), this verticality is emphasized by two emphatic columnar structures in the landscape which echo the striding frontal figures, providing an anchor for the foliage and offsetting the organic ebullience of the cloud formations. In other male bather compositions, the verticality can be reinforced by tree trunks, hatched vertical brushstrokes or drapery. Where the female bather compositions allow some penetration into the picture space, therefore, the male bather compositions are phallic and resistant. Entry beyond the front river bank is rarely possible. While many of the female bathers are frontally placed, their bodies forming a containing semi-circle that anticipates rather than wards off the viewer, the focus in the male figures is away from the viewing position, fixed in the distance, far away. The male bodies, rather than inviting entry into the picture space, provide an impenetrable screen, a resistant boundary to ocular penetration. The backs and buttocks in the frontal plane form a clenched barrier, a defensive buttress against the viewer, who is invited to look at the painting but not to wander into its shallow pictorial recesses. Where the female bathers seem heavy, earthbound, dwarfed by their natural surroundings and static in their bodily presence, the male figures seem poised in frozen movement, tense, active and anticipating. In the words of art historian Eldon van Liere: 'Cézanne's male bathers spring from the earth like trees to dominate it while the woman bathers ... cling to the earth as if to be one with it.'[21]

The accumulated effect of these pictorial differences is to produce very different kinds of pictures, ones which are simultaneously transgressive and deeply conservative. Verticality, horizontality, triangularity: none of these is innocent of gender, all are implicated in the inscription of sexual difference in the visual field. Even as the sexual ambiguity of the bathers is being produced, it is at the same time being assimilated into a system of pictorial conventions which is highly gendered and which provides a containing psychic and physical structure for the transgressions that it frames. The association of verticality with masculinity and triangularity with femininity is so fundamentally a

displaced inscription of sexual difference that it hardly needs to be traced to Cézanne's own private psychic history. Indeed, his own affection for men and fear of women, though possibly represented here, could not possibly be an adequate explanation for the pictorial conventions that he deployed. These are, of course, always shared, and Cézanne, in rehearsing them, operated within the logic of the tradition and culture of which he was a part.

As we have seen, Cézanne had used conventional means to represent sexual difference, in terms both of dress and undress, and coded signs, when still overtly dealing with dominant narrative structures in his early work. The fishing rod thrusting over the water to the naked women on the opposite bank in *Fisherman and Bathers* (1870–1) deployed the most obvious metonymic and metaphoric associations. The verticality of the male figure and his directed apparatus are clear for all to see. The picturing of the female sex is not as easily displaced on to objects as its male counterpart. The sword, dagger, cane, cigarette, trumpet and paintbrush all provided standard phallic substitutes in nineteenth-century figure painting. The difficulty with representing a displaced female sexuality is that it is conceived of as a lack, a gap, a hole, a wound. What needs to be pictured is an absence. Most often this absence is papered over and sealed in order to offer an unthreatening image of femininity, and the fetishized female body acts as a substitute for the lost penis.[22] Another strategy of containment could be to displace that sign of femininity onto the pictorial structure itself so that the apparently innocent arrangement of shapes on the surface of the picture becomes charged with meaning.

In his analysis of dreams, Freud discovered a psychic mechanism that is crucial to the way in which the process of representation functions in the dream. He wrote of a 'psychical force' which 'strips the elements which have a high psychical value of their intensity', and 'by means of overdetermination, creates from elements of low psychical values new values'.[23] An internal censor suppresses danger by disguising its source and finds alternative routes for its representation. Interpretation involves a shift of attention away from the centre of interest to the periphery, the marginal, the ancillary. Through substitution and association, meaning is displaced and anxiety is diffused. The origin of anxiety is sexual and its resolution is found in a displacement in the field of representation, that is, in the realm of the visual. Sexuality and visuality, it seems, are intimately connected, and a disruption on the level of the one leads, inevitably, to a disruption on the level of the other.

Cézanne's two versions of *The Eternal Feminine* with which we dealt

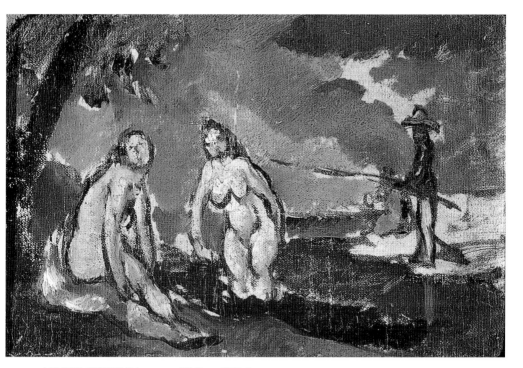

150 PAUL CEZANNE Fisherman and Bathers, 1870–1

so extensively in Chapter Six provide a telling instance of displacement in the visual field. In the oil painting of this theme, a naked woman is framed by a shadowy, cavernous, triangular canopy which functions as a sign of the sex that is hinted at but cannot be represented on the body itself. The canopy both contains and symbolizes Woman. Its assertive triangularity substitutes for the inverted genital triangle which is indicated but not described in the space between the woman's thighs. Simultaneously, the dark space flanked by the whites of the canopy (itself like massive, striding, splayed thighs) stands for that place between the thighs which cannot be represented. As an enclosing shape, the canopy provides the open space, the gap, which is the condition of femininity but does not inscribe it on the body of the woman. It is this space which is penetrated by the attributes of the surrounding male figures, their sticks, trumpets, jars and thrusting hands, and it is this space which becomes materialized, Mont Sainte-Victoire-like, in the small canvas on which Cézanne pictures himself working in the upper right-hand corner of the canvas.[24]

How curious that the represented witness to what is ostensibly a scene of homage to Woman should render himself painting the triangular mountain-like structure to which he would so obsessively return in his later years. Like a recurrent dream image, the painted pyramid of Mont Sainte-Victoire, that mute but resonant structure, would become for Cézanne the object of relentless fascination, of compulsive and compelling reinterpretation and repetition. The elemental triangularity of the shape that Cézanne is seen to construct in this picture seems like a premonition of that obsessive engagement.[25] It is tempting to view his repeated encounter with this pyramidal peak as an unconscious playing out of painting's libidinal character, allegorized in *The Eternal Feminine* in that crucial transformation of Woman into mountain but in the many images of Mont Sainte-Victoire finding its ultimate resolution in the eclipse of Woman's body altogether. If the body of Woman provided the perfect vehicle for an exploration of painting's physical and phantasmatic investments, its irrational, unconscious aspects, then the image of

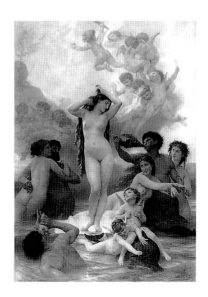

the mountain alone, rising corporeally from the well-worked earth beneath it, still suggests its psychic residue, etched like an almost forgotten memory into the painting's form and facture.

Cézanne had, of course, created an analogy between the curves of a woman's body and the contours of the mountain in his painting of *Bathsheba* (fig. 137), in which the reclining, faceless female figure is echoed both by the curves of her maidservant and the hilly outcrop behind them. Indeed, Cézanne himself is supposed to have said: 'I want to marry the curves of women to the shoulders of the hills. But the focal point? I can't find the focal point.... Tell me, what shall I group them round?'[26] The gap at the heart of the female bather compositions created by the flanking triangular groups which Cézanne began habitually to use needed both to be represented and resisted. He could not, like so many of his nineteenth-century contemporaries, rely on the figure of Venus to occupy the central point in a composition, often at the summit of a triangular group of female figures. Sometimes paint alone fulfilled this function, standing for air, sky, foliage, clouds; at other times the triangular shape of the mountain rises between the groups of women, filling the space which their pyramidal groupings create. Occasionally, trees and leaves are clumped together to form the mythic triangular shape which occupies the central gap between the flanking groups of female figures.

Cézanne, it seems, had a special relationship with the triangular, one which makes sense both within his own psychic history and within the

153 PAUL CEZANNE Bathers in Front of a Mountain, 1902–6

broader culture of which he was a part. It is by no means necessary to trace the insistent triangularity of the female bather compositions to Cézanne's own private history, to some individualized and personal obsession, even though it comes to have specific meaning for him. The use of the triangle for the representation of female figural groups had become standard practice in late nineteenth-century France.[27] Renoir himself had deployed this device in his *Large Bathers*, as did accomplished figure painters such as Bouguereau and Cabanel, who frequently arranged their female bodies and attendants to form triangular groupings. Such formal arrangements made a certain cultural and political sense in the highly sexually differentiated context of late nineteenth-century France.

The emphatically triangular arrangement of Cézanne's female bathers is remarkable in its consistency. It can be traced in three-figure groups such as the *Three Bathers* of 1879–82 (fig. 155) – originally owned by Matisse and now in the Musée du Petit Palais, Paris – in which an extraordinary painterly pyramid in the landscape seems to echo the arrangement of the figures. It becomes more pyramidal and three-dimensional in numerous four- and five-figure groups from the late 1870s to '80s, as

in the Basle *Five Bathers* of 1885–7 (fig. 145). This strategy is still at the heart of the design in late watercolours like the *Bathers in Front of a Mountain* of 1902–6, where the overarching framing of the trees and the two triangular groupings of bathers on each bank of the river (themselves creating an inverted triangular shape reminiscent of the pubic triangle) are offset by the simplified triangular shape of the mountain which fills the gap and forecloses on the penetration which the river invites. Woman, mountain, triangles: all are present. The enigmatic slippage of *The Eternal Feminine*, painted three decades earlier, finds its resolution in the triumphant transposition of the *mont de Vénus* on to the Mont Sainte-Victoire, screen of countless projections, imaginings and yearnings, the object of infinitely deferred desire. It was the *mont de Vénus* that covered up the hole that it surmounts, figuratively turning an opening into a solid, a cavity into a hill, a physiological organ into a figure of speech.

As we have seen, echoes of *The Eternal Feminine* and standard figural groupings are still found in the late bathers like *The Large Bathers*. Gone is the steamy interaction between the sexes, the melodramatic cacophony of references and marks. Gone, too, are the overt bodily

154 PAUL CEZANNE Bathers, 1895–8

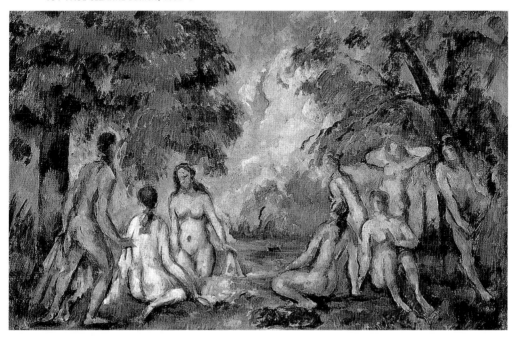

inscriptions of difference. But the pictorial composition still echoes the basic triangularity of the earlier work, a triangularity which was a standard substitution for the forbidden representation of the female genitals and which inscribed on the surface of the picture that sign of femininity which had to be sacrificed on the bodies themselves.

Cézanne's art was tied to a new mode of looking, one which was embedded in the late nineteenth-century obsession with an art of sensation, an art adequate to the processes of vision, an art which could subsume the integrity of the objects it represented into the screen of sensation that was constructed as the modern mode of vision. Whether imagined or observed, the bathers in the landscape, no less than the landscapes themselves, had to signify that transformation of sight into touch, of vision into matter which was the hallmark of a modernist practice. In the process of the obsessive tracking of sensation, bodily difference was sacrificed. The distortions, grotesqueries and ambiguities pictured in the late bather paintings are the by-product of this process. They are not necessarily intentional or deliberate. It was the intensity of engagement at the level of the visual which produced the ambiguities at the level of the sexual. Or, alternatively, it was the strategies of containment at the level of the sexual which produced a disruption at the level of the visual. Visuality and sexuality are here inextricably intertwined. But the resultant transgressive androgyny of the bodies depicted, with their potential for disrupting those identities which modernity holds in such fragile balance, is produced within the conventional framework of difference, a framework which is encoded as much in the compositional structures and pictorial rhythms of the images as in the bodies represented. It is in the tension set up between these that the interest of these works lies. For it is in the interaction of figure and ground, of body and surface, that the very modernity of these images can be found. But that modernity is located as much in the anxiety that they parade as in the formal transgressions that they represent.

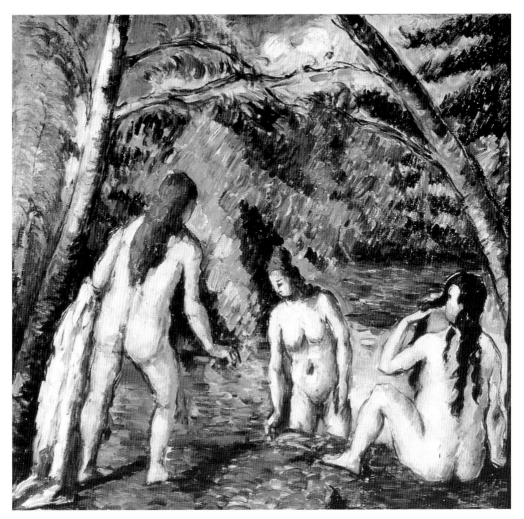

155 PAUL CEZANNE Three Bathers, 1879–82

Notes and Sources

Author, title, and date and place of publication are given in full when a source is first cited for a chapter; subsequent references give author's surname and short title only.

Preface and Acknowledgments

Notes to pages 7–9

1. A different version of Chapter One was published as 'Masculinity, Muscularity and Modernity in Caillebotte's Male Figures', in Terry Smith (ed.) *In Visible Touch, Modernism and Masculinity* (Sydney, 1997), pp. 53–74.

2. An earlier version of Chapter Seven was published as 'Visuality and Sexuality in Cézanne's Late Bathers', *Oxford Art Journal*, vol. 19, no. 2, 1996, pp. 46–60.

Introduction

Notes to pages 10–15

1. For a discussion of the scientific justification of the incommensurable difference between men and women, see T. Laqueur, *Making Sex: Body and Gender from the Greeks to Freud* (Cambridge, Mass., 1990).

Chapter One

Notes to pages 24–53

1. The feminist bibliography on the female nude is, by now, lengthy. Important general accounts on which my own analysis draws include Linda Nochlin, *Women, Art and Power* (London, 1989); Lynda Nead, *The Female Nude: Art, Obscenity and Sexuality* (London and New York, 1992); Susan R. Suleiman (ed.), *The Female Body in Western Culture* (Cambridge, Mass., and London, 1986); and Kathleen Adler and Marcia Pointon (eds), *The Body Imaged: The Human Form and Visual Culture since the Renaissance* (Cambridge, England, 1993), which contains essays on male and female nudes. The literature on the male nude is not so extensive but important contributions have been made by M. Walters, *The Nude Male: A New Perspective* (New York and London, 1978); A. Potts, *Flesh and the Ideal: Winckelmann and the Origins of Art History* (New Haven and London, 1994); and Abigail Solomon-Godeau, *Male Trouble: A Crisis in Representation* (London and New York, 1997).

2. For an interesting account of this painting in the context of debates about wrestling in the nineteenth century, see K. Herding, 'Les Lutteurs Détestables' in *Courbet: To Venture Independence* (New Haven and London, 1991), pp. 11–43.

3. For a detailed history of washing and bathing practices in modern France, see G. Vigarello, *Concepts of Cleanliness: Changing Attitudes in France since the Middle Ages* (Cambridge, England, 1988; tr. from French edition, Paris, 1985).

4. For an interesting account of the representation of the feminized male body in post-Revolutionary French culture, see Solomon-Godeau *Male Trouble*.

5. By 'subjectivity' I mean the position that a human being occupies in a given social situation. His or her 'subjectivity' is seen as the product of forces beyond conscious control. The 'subject' is the result of complex social and psychic influences which constitute his or her apparent individuality in a given social situation. Subjectivity is an historical construction, contingent upon economic, psychological and social factors. It forms character and personality in accordance with internal and external forces which are historically produced.

6. See comment by P. Georgel at the end of K. Herding, 'Les Lutteurs Détestables' in *Courbet: To Venture Independence*.

7. For a discussion of classical precedents in boxing, see Léon Ville, *La Lutte et les lutteurs* (Paris, 1891).

8. Ibid., p. 19. Ville, like a number of his contemporaries, firmly believed that it was in

'la lutte' that one needed to look for a means of regenerating the anaemic French nation. For a widely quoted nineteenth-century defence of wrestling and fighting, see Guillaume Depping, *Les Merveilles de la force et de l'adresse* (Paris, 1869).

9. See R. Nye, *Masculinity and Male Codes of Honor in Modern France* (Oxford, 1993).

10. See C. Blanc, *Art in Ornament and Dress* (London, 1877), p. 81.

11. J.J. Virey, the author of these words, continues: 'The one [the male] must give and the other is constituted to receive, the first for that reason must embody the principle of overabundance, which aspires to pour out its forces, its generosity, its liberality; the second, on the contrary, being inversely disposed, must, through its timidity, be ready to welcome, to absorb, out of need and a feeling of deficit, the overflow of the other in order to establish equality and reach fullness.' See *De la femme* (1825) quoted in Nye, *Masculinity and Male Codes of Honor*, p. 58.

12. Nye, *Masculinity and Male Codes of Honor*, pp. 58–61.

13. For a history of the bachelor in France, see J. Borie, *Le Célibataire français* (Paris, 1976). See also Nye, *Masculinity and Male Codes of Honor*, pp. 8–10.

14. For a discussion of the effects of the defeat on the French army and on French society, see A. Ehrenberg, *Le Corps militaire* (Paris, 1983), pp. 89–118.

15. See Blanc, *Art in Ornament and Dress*, p. 136.

16. For a discussion of masculine dress in the eighteenth century, see D. Roche, *The Culture of Clothing: Dress and Fashion in the Ancien Régime* (Cambridge, England, 1994). For its transformation in the early nineteenth century, see Philippe Perrot, *Les Dessus et les dessous de la bourgeoisie: une histoire du vêtement au XIXᵉ siècle* (Paris, 1981) and A. Ribero, *The Art of Dress: Fashion in England and France, 1750–1820* (New Haven, 1995).

17. Blanc, *Art in Ornament and Dress*, p. 265.

18. See J.C. Flügel, *The Psychology of Clothes* (London, 1930), p. 105.

19. For a Lacanian theorization of masculinity, see K. Silverman, *Male Subjectivity at the Margins* (New York, 1992).

20. See G. Groom, 'Interiors and Portraits' in *Gustave Caillebotte: Urban Impressionist*, exhib. cat., The Art Institute of Chicago (New York, 1995), p. 204.

21. Illustrated ibid., p.180.

22. For a brief account of his relationship with the Impressionists and their responses to his early death, see A. Distel, 'Introduction: Caillebotte as Painter, Benefactor and Collector', ibid., pp. 19–26.

23. For a discussion of the identification of house painting with fine art painting, see J. Sagraves, 'The Street', ibid., pp. 93–4.

24. Photography was used as a way of documenting physical characteristics and deformities and was regarded as a useful tool for identifying professions and thereby helping to identify criminals: 'Il est reconnu que dans le travail manuel certaines déformations des mains, certaines callosités ou rugosités, certaines déchirures sont produites chez l'ouvrier par la pratique de tel ou tel métier. C'est là un puissant moyen d'investigation et qui, dans la pratique, facilite beaucoup l'identification, car il permet de déterminer avec certitude la profession exercée par le sujet examiné.' A. Londe, *La Photographie médicale* (Paris, 1893), p. 214.

25. 'In his *Floor-Scrapers*, Caillebotte declares himself to be a Realist as crude and intelligent, in his own way, as Courbet, as violent and precise, again in his own way, as Manet.' M. Chaumelin, quoted in *Gustave Caillebotte: Urban Impressionist*, p. 37.

26. Louis Enault quoted in *Gustave Caillebotte: A Retrospective Exhibition*, exhib. cat., Houston Museum of Fine Arts and The Brooklyn Museum (Houston, 1976), Appendix A, pp. 207–8.

27. As for example in Louis Enault's statement: 'Je regrette ... que l'artiste n'ait pas mieux choisi ses types, ou que, du moment où il acceptait ce que la réalité lui offrait, il ne se soit pas attribué le droit ... de les interpréter plus largement. Les bras de ses raboteurs sont trop maigres, et leurs poitrines trop étroites. Faites du nu, messieurs, si le nu vous convient; je ne suis pas bégueule, et je n'aurai point l'esprit assez mal fait pour le trouver mauvais. Mais que votre nu soit beau ou ne vous en mêlez pas!' Cited ibid., p. 207.

28. See S.L. Gilman, 'The Jewish Nose' in *The Jew's Body* (New York and London, 1991).

29. In the wake of France's military defeat, educationalists and social commentators focused on a newly invigorated male body in the hope of reversing defeat and safeguarding the physical and ethical future of the Nation. To this effect school sports and gymnastics were introduced, sports and gymnastic societies multiplied, and impassioned

enthusiasts for active leisure pursuits and organized physical training were to be heard in all the major newspapers. The newly disciplined and powerful body of physical exercise was deemed to be suited to military life (which was desperately in need of improvement) as well as primed for the cooperation and camaraderie that the new and still-fragile democracy required. See 'Gymnastique', *Le Drapeau*, no. 1, 29 Dec 1881, p. 6 for a representative account which puts physical training at the service of patriotism, duty and democracy. For general accounts of developments in physical training in the period, see P. Arnaud, *Les Athlètes de la République: gymnastique, sport et idéologie républicaine 1870–1914* (Paris, 1987); E. Weber, 'Gymnastics and Sports in Fin-de-Siècle France: Opium of the Classes?', *American Historical Review*, vol. 76, Feb–April 1971, pp. 70–98.

30. See entry on 'canotage' in Larousse, *Grand dictionnaire universel du XIXᵉ siècle*, vol. 3, p. 284.

31. G. Hocquenghem, *Homosexual Desire* (London, 1993; tr. from French edition, 1972), p. 101. For a brilliant analysis of the devaluation of the anus in bourgeois culture, see L. Edelman, 'Seeing Things' in *Homographesis: Essays in Gay Literary and Cultural Theory* (New York and London, 1994), pp. 173–91. See also L. Bersdani, 'Is the Rectum a Grave?', *October* 43, winter 1987.

32. See for example the *Prix de Rome*-winning painting by Nicolas Hesse, *Philémon et Baucis* (1818), reproduced in P. Grunchec, *Les Concours des Prix de Rome* (Paris, 1986), p. 111. For a discussion of the feminized male in early nineteenth-century French painting, see Solomon-Godeau, *Male Trouble*.

Chapter Two

Notes to pages 54–79

1. G. Strehly, 'Causerie sur la Gymnastique', *La Revue athlétique*, 1, 25 Jan 1890, p. 26.

2. G. Strehly, 'Du rôle de l'émulation dans la culture physique', *La Culture physique*, 6, Aug 1904, p. 123.

3. For typical contemporary lamentations of the sorry state of French masculinity see the many articles published in *La Culture physique* during this period. A good example is Dr G. Rouhet's 'De la nécessité de la culture physique', issue 2, March 1904, pp. 28–9. Much of the mainstream press was preoccupied with this issue. See for example L. Hugonnet in *La France*, reprinted in *Bulletin de la Ligue nationale*

de l'éducation physique, 1, 1888, p. 6. For discussions of degeneration in the context of the reform of the military, see A. Ehrenberg, *Le Corps militaire* (Paris, 1983).

4. For a discussion of conservative aesthetic theory in the period, see M. Marlais, *Conservative Echoes in Fin-de-Siècle Parisian Art Criticism* (Pennsylvania, 1992).

5. See Dr G. Rouhet, 'De la nécessité de la culture physique', *La Culture physique*, 8, Oct 1904, p. 173.

6. For a description of how Eugen Sandow succeeded as an artist's model in Paris, see David L. Chapman, *Sandow the Magnificent: Eugen Sandow and the Beginnings of Bodybuilding* (Urbana and Chicago, 1994), pp. 14–15. For a discussion of the idealizing rhetoric surrounding the life class, the use of the male model and the implications for women artists, see Tamar Garb, 'The Forbidden Gaze: Women Artists and the Male Nude in Late Nineteenth-Century France' in Kathleen Adler and Marcia Pointon (eds), *The Body Imaged: The Human Form and Visual Culture since the Renaissance* (Cambridge, England, 1993), pp. 33–42. For the implications of these ideas for women aspiring to enter the Ecole des Beaux-Arts, see 'Reason and Resistance: The Entry of Women into the Ecole des Beaux-Arts' in Tamar Garb, *Sisters of the Brush: Women's Artistic Culture in Late Nineteenth-Century Paris* (New Haven and London, 1994), pp. 70–104.

7. See 'Qu'est-ce que la culture physique?', *La Culture physique*, 2, March 1904, p. 18.

8. See L. Chéroux, 'Les Hommes beaux', *La Culture physique*, 1, Feb 1904, p. 4.

9. For a defence of physical culture in these terms, see A. Surier, 'Pas d'anormaux', *La Culture physique*, 13, March 1905, pp. 1–2.

10. *La Culture physique*, 13, March 1905, p. 12.

11. See Paul Richer, *Physiologie artistique de l'homme en mouvement* (Paris, 1895), p. 71.

12. Physical sculpture enthusiasts could purchase moulds of the arms of famous athletes such as Sandow, Hackenschmidt, Batta, etc. See advertisement published in *La Culture physique*, 24, 15 Dec 1905.

13. Paul Richer commented on the way that antique sculptors 'schematized and regularized' the abdominal area in their sculptures. See Richer, *Physiologie artistique*, p. 111.

14. For a contemporary discussion of photographic retouching, its merits and disadvantages, see A. Londe, *La Photographie moderne* (Paris, 1896), pp. 385–6. For a discussion of the use of make-up in the preparation of Eugen Sandow's body for performance and photography, see Chapman, *Sandow the Magnificent*, p. 79.

15. See Allen Ellenzweig, *The Homoerotic Photograph: Male Images from Durieu/Delacroix to Mapplethorpe* (New York and Oxford, 1992), pp. 92–4.

16. See L.D., 'Le Nu n'est pas immoral: nos photographies artistiques', *La Culture physique*, 14, April 1905, p. 40.

17. See L. Chéroux, 'Les Hommes beaux', *La Culture physique*, 1, Feb 1904, p. 4. Chéroux even went so far as to publish Sandow's measurements, which were described as 'ideal'.

18. For a description of how the photographic competitions worked, see *La Culture physique*, 16, June 1905, pp. 84–6.

19. See *La Culture physique*, 16, June 1905, p. 85.

20. See '2ᵉ Concours de beauté plastique', *La Culture physique*, 19, Sept 1905, p. 167.

Chapter Three

Notes to pages 80–113

1. Nestor Roqueplan, *Parisine* (Paris, 1869), p. 43. Quoted in and translated by D. Roche, *The Culture of Clothing, Dress and Fashion in the Ancien Régime* (Cambridge, England, 1994; tr. from French edition, 1989), p. 61.

2. On the use of dressing gowns as a 'petrified trace of the Ancien Régime', see Philippe Perrot, *Les Dessus et les dessous de la bourgeoisie: une histoire du vêtement au XIXᵉ siècle* (Paris, 1981), p. 201. Perrot also discusses the use of the 'gilet' as a hidden decorative garment, and the beautiful slippers that men wore at home. In public, however, these all had to be relinquished for 'le drap noir' (p. 203).

3. Octave Uzanne, *The Modern Parisienne* (London, 1912), p. 22.

4. Ibid., p. 27.

5. On the pathologizing of cross-dressing as 'perverse' in late nineteenth-century psychiatry, see J. Matlock, 'Masquerading Women, Pathologized Men: Cross-Dressing, Fetishism, and the Theory of Perversion, 1882–1935' in E. Apter and W. Peitz (eds), *Fetishism as Cultural Discourse* (Ithaca and London, 1993), pp. 31–61.

6. The literature on woman as 'object of the gaze' is now extensive. Crucial for this formulation was Laura Mulvey's essay 'Visual Pleasure and Narrative Cinema' in L. Mulvey, *Visual and Other Pleasures* (Basingstoke, 1989).

7. See Meurville, 'La Femme à Paris', *La Gazette de France*, 22 April 1885, p. 2.

8. For an interesting psychoanalytic analysis of this phenomeon, see E. Lemoine-Luccioni, *La Robe: essai psychanalytique sur le vêtement* (Paris, 1983), p. 86.

9. For biographies of Tissot, see W.E. Misfeldt, *J.J. Tissot: A Bio-Critical Study* (Ann Arbor, 1991) and M.J. Wentworth, *James Tissot* (Oxford, 1984). Most reviewers commented on the English filter through which Tissot observed Parisian life. In the words of one critic: 'C'est à travers le brouillard de Londres qu'il s'est mis à regarder de côté de Paris avec cet attendrissement que donnent les souvenirs et les regrets. Et maintenant il s'est fait l'historiographe au pinceau de cette vie parisienne dont il fut si longtemps privé.' 'Courrier de Paris', *Le Monde illustré*, 25 April 1885, p. 266.

10. For a detailed discussion of the project, see M.J. Wentworth, *James Tissot: Catalogue Raisonné of his Prints* (Minneapolis, 1978), pp. 300–25.

11. I am grateful to Juliet Hacking for her help in tracking down some of the reviews of the London exhibition.

12. 'La Femme à Paris', *La Vie parisienne*, 2 May 1885, p. 255.

13. See A. Georget, 'Deux expositions', *L'Echo de Paris*, 2 April 1885, p. 2.

14. See, for example, F. Javel, 'M. James Tissot', *L'Evénement*, 19 April 1885, p. 2; G. Dargenty, 'Exposition de J.J. Tissot', *Courrier de l'art*, 24 April 1885, p. 200; R. dos Santos, 'Chronique', *Moniteur des arts*, 24 April 1885, p. 1.

15. See Henry Becque, *Parisienne* (Paris, 1885). I am grateful to Ann Sedelmeyer for bringing this play to my attention.

16. For a discussion of the relationship between commodity fetishism and the development of an eroticized, spectacular femininity, see Abigail

Solomon-Godeau, 'The Other Side of Venus: The Visual Economy of Feminine Display' in V. de Grazia and E. Furlough (eds) *The Sex of Things: Gender and Consumption in Historical Perspective* (Berkeley and London, 1996), pp. 113–50.

17. Etienne de Neufville writes of the effect of perfume when women are out walking: 'c'est un délice; on aime qu'une femme laisse derrière elle une trainée odorante, dont l'impression vous pénètre longtemps encore après qu'elle a disparu.' *Physiologie de la femme* (Paris, 1842), p. 2.

18. For a detailed discussion and illustration of these types, see B. Farwell, *French Popular Lithographic Imagery, 1815–1878*, vol. 2, 'Portraits and Types', pp. 12–17.

19. For a discussion of classificatory practices in the early to mid-nineteenth century, see J. Wechsler, *A Human Comedy: Physiognomy and Caricature in 19th Century Paris* (London, 1982), pp. 22–39.

20. The classic example of the 'physiologie' is the eight-volume work *Les Français peints par eux-mêmes*, published in the early 1840s. For a discussion of this and the genre as a whole, see Wechsler, *A Human Comedy*, pp. 16 and 36–8.

21. The enigmatic character of the 'Parisienne' permeates much of the literature and the critical reception of Tissot's paintings. By painting this figure in all her guises he claimed the capacity to represent her. As she was so mysterious and elusive a figure, though, his efforts were bound to be read as a failure. See, for example, 'Courrier de Paris', *Le Monde illustré*, 25 April 1885, p. 266.

22. For an elaboration of such a claim, see Uzanne, *The Modern Parisienne*, p. 2.

23. Octave Uzanne, *La Femme à Paris: les Parisiennes de ce temps dans leur divers milieux, états et conditions* (Paris, 1894), pp. 38–9.

24. See P. Perret, *La Parisienne* (Paris, 1868), pp. 20–1.

25. See Arsène Houssaye's *Les Parisiennes* (Paris, 1869) for an elaboration of the 'Parisienne's' obsession with personal appearance.

26. In a very revealing paragraph from *Au bonheur des dames*, Emile Zola describes the activities of Mouret, the department store owner: 'He raised a temple to her [Woman], had her covered with incense by a legion of shopmen; he created the rite of a new religion thinking of nothing but her, continually seeking to imagine more powerful seductions; and behind her back, when he had emptied her purse and

shattered her nerves, he was full of the secret scorn of a man to whom a woman had just been stupid enough to yield herself.' Tr. by Frank Belmont as *The Ladies' Paradise* (London, 1883), p. 128.

27. See the review by H. Havard in *Le Siècle*, 21 April 1885, p. 2.

28. See G. Dargenty, 'Exposition de J.J. Tissot', *Courrier de l'art*, no. 17, 24 April 1885, p. 200.

29. For the clearest expression of this view, see Colombine, 'Chronique', *Gil Blas*, 20 April 1885, p. 1.

30. L. Halévy, 'The Most Beautiful Woman in Paris' in *Parisian Points of View* (New York and London, 1894), p. 108.

31. For an interesting reading of the exchange of looks in this picture, see Hollis Clayson, *Painted Love: Prostitution in French Art of the Impressionist Era* (New Haven and London, 1991), p. 124.

32. The ratio of men to women in the audience seems roughly to duplicate that which prevailed at masked balls during the period. According to *The Parisian* (an Anglo-American journal that provided a chronicle of the week's events in Paris, covering items from fashion to finance) the number of persons attending one masked ball at the Opera was 3,968, comprised of 2,239 'gentlemen in evening dress', 688 men in costume, and 1,041 women in costume or domino. The ratio was almost 1:4. See *The Parisian*, 24 Jan 1882, p. 1.

33. See 'La Femme à Paris', *La Vie parisienne*, 2 May 1885, p. 255.

34. See, for example, Meurville, 'La Femme à Paris', *La Gazette de France*, 22 April 1885, p. 2.

35. See, for example, Colombine, 'Chronique', *Gil Blas*, 20 April 1885, p. 1, and *Moniteur des arts*, 24 April 1885, p. 1.

36. Such anecdotal preoccupations were identified as English, the English being associated with an altogether too literary approach to painting. Tissot was described as having returned to Paris *résolument anglicisé* and incapable either of understanding the niceties of Parisian society or of representing these in an appropriately French way. See G. Dargenty, 'Exposition de J.J. Tissot', *Courrier de l'art*, no. 17, 24 April 1885, p. 200. Another critic wrote: 'Anglais par le style, par le facteur, et dans le choix même tant soit prétentieux de titres...', *Moniteur des arts*, 24 April 1885, p. 1. Yet another compared him to Hogarth and accused him of

becoming a 'caricaturist'. Colombine, 'Chronique' *Gil Blas*, 20 April 1885, p. 1.

37. There is no evidence that this is the case, but Michael Wentworth, the expert on Tissot's prints, thinks it likely. See Wentworth, *James Tissot: Catalogue Raisonné of his Prints*, pp. 340–3.

38. For a nineteenth-century account of these male accessories, see C. Debelle and A. Delbès, *Physiologie de la toilette* (Paris, 1840s), vol. 13, pp. 61–3 and 68–76.

39. Some critics of the show used it as an opportunity to lament what they saw as the dull uniformity of modernity and to indulge in nostalgic reminiscences for pre-Revolutionary elegance and splendour. They focused on masculine costume as symbolizing the demise of the colourful extravagances of the *ancien régime*: 'Il n'y a pas à s'y tromper, nos habits noirs portent le deuil d'une société disparue et d'une gaieté morte; le noir et le gris nous enveloppent de tous côtés et jettent sur nos rêves envolés leurs crêpes de brouillard et de fumée. Ça et là, quelques points blancs et lumineux, panaches ou aigrettes, linceuls ou voiles de mariée, diamants ou lampes de sanctuaire, phares ou étoiles. Quelques points rouges aussi, tache de sang ou lampion qui fume aux pieds du saltimbanques, ruban de vanité ou fleur qui brille a un corsage de femme; c'est tout ce qui perce la brume où nous vivons et soulève la monotonie de notre deuil.' Meurville, 'La Femme à Paris', *La Gazette de France*, 22 April 1885, p. 2.

40. See *La Gazette de France*, 22 April 1885, p. 2.

41. See *Pleasures of Paris: Daumier to Picasso*, exhib. cat., Boston Museum of Fine Arts (Boston, 1991), pp. 43–4 and 167–71.

42. For a late nineteenth-century discussion on decorum and the *lorgnette*, see Octave Uzanne, *Les Ornements de la femme* (Paris, 1892), p. 79. For an earlier account of modesty and female spectatorship, see L. d'Amboise, 'Physiologie de la spectatrice' in *Physiologie du parterre*, 1841, vol. 10, pp. 103–5.

43. 'Voici le *Cirque Molier* avec son public de femmes du monde ... ou de demi-monde, la nuance n'est pas très bien marquée, – avec ses clubman [sic] perchés sur des trapèzes, le monocle dans l'oeil, montrant leurs formes un peu vieillottes et ... l'embarras d'une fausse position.' Meurville, 'La Femme à Paris', *La Gazette de France*, 22 April 1885, p. 2.

44. I am grateful to Chrisopher Wilson and Tom Gretton for discussions about the identity of the soldiers.

45. Such figures featured in Jules Claretie's *Le Train 17* (1877) and Gustave Kahn's *Le Cirque soalire* (1898). For a discussion of this phenomenon see M. Verhagen, 'The Poster in Fin-de Siècle Paris: "That Mobile and Degenerate Art"' in L. Charney and V. Schwartz (eds) *Cinema and the Invention of Modern Life* (Berkeley and London, 1995), p. 122.

46. See Meurville, 'La Femme à Paris', *La Gazette de France*, 22 April 1885, p. 2.

47. For a brief discussion of the Hippodrome, see *Pleasures of Paris*, Boston Museum of Fine Arts, pp. 39–40 and 168.

48. The idea that Tissot had created 'dolls' not 'women' appears in a number of critical accounts of the show. See for example, Colombine, 'Chronique', *Gil Blas*, 20 April 1885, p. 1.

49. I am indebted to Hollis Clayson's reading of this painting in Clayson, *Painted Love*, pp. 124–5.

50. As Alexandre Gourget described it: 'le boulevard joyeux et animé vu au travers des glaces de l'etroite boutique, et le vieux beau qui lorgne le petit modillon...', *L'Echo de Paris*, 21 April 1885, p. 2.

51. I am grateful to Caroline Arscott for discussions with her on the symbolic role of chairs in Tissot's paintings. It was her observations in relation to a number of other Tissots that led me to see the relationship between these two chairs as anything but innocent.

52. Critics like Meurville noticed the link between this painting and Zola in their reviews. See 'La Femme à Paris', *La Gazette de France*, 22 April 1885, p. 2.

53. Emile Zola, *The Ladies' Paradise* (London, 1883), p. 24.

54. See Meurville, 'La Femme à Paris', *La Gazette de France*, 22 April 1885, p. 2.

55. G. Dargenty, 'Exposition de J.J. Tissot', *Courrier de l'art*, 24 April 1885, p. 200.

56. A number of critics describe this as the location. See: Meurville, 'La Femme à Paris', *La Gazette de France*, 22 April 1885, p. 2; Alexandre Georget, 'Deux expositions', *L'Echo de Paris*, 21 April 1885, p. 2; and G. Dargenty, 'Exposition de J.J. Tissot', *Courrier de l'art*, 24 April 1885, p. 200.

57. See A. Daudet, *Les Femmes d'artistes* (Paris, 1876), tr. by Laura Ensor as *Artists' Wives* (London, 1890).

58. Ibid., p. 13.

59. Ibid., p. 24.

60. Alexandre Georget describes the artists as 'nerveux et maussades', 'Deux expositions', *L'Echo de Paris*, 21 April 1885, p. 2.

61. See Caliban, 'La Femme d'Artiste', *Le Figaro*, 26 April 1885, p. 1.

62. He is identified as such by Alexander Georget, 'Deux Expositions', *L'Echo de Paris*, 21 April 1885, p. 2.

63. Described as such by Meurville, 'La Femme à Paris', *La Gazette de France*, 22 April 1885, p. 2.

64. See, for example, A. Houssaye, *Les Parisiennes* (Paris 1869).

Chapter Four

Notes to pages 114–43

1. For a contemporary discussion of the 'femme à sa toilette' as a credible naturalist setting for the nude, see Maxime Dastique, 'Femme à sa Toilette' in A. Silvestre, *Le Nu au Salon de 1894* (Paris, 1894), pp. 13–14. Silvestre had already made this point in a discussion of H. Gervex's *The Tub* exhibited at the Salon of 1888, at which numerous 'toilette' scenes were on display. See A. Silvestre, *Le Nu au Salon de 1888* (Paris, 1888), n.p. Equally popular in this period were paintings of the model at rest in the artist's studio, which provided a parallel setting for modern-life nude paintings.

2. See Paul Smith, *Seurat and the Language of the Avant-Garde* (London and New Haven, 1997) for such a reading of Seurat's *Young Woman Powdering Herself*, pp. 119–21.

3. See G.J. Witkowski, *Tetoniana: anecdotes historiques et religieuses sur les seins et l'allaitement comprenant l'histoire du décolletage et du corset* (Paris, 1898), p. 29.

4. See Witkowski, *Tetoniana*, p. 34.

5. See for example 'Les Femmes d'Aujourd'hui – 1 Série: Avant et Après le corset', from the collection Bibliothèque Nationale, Moeurs, 0 à 22, fol. Moeurs 013, tome 1 (illustré).

6. For a discussion of the privacy which surrounded women's dressing rooms, see Baroness Staffe, *Le Cabinet de Toilette*, tr. by Lady Colin Campbell as *The Lady's Dressing Room* (London, 1892), p. 14.

7. See *L'Art français*, no. 449, 30 Nov 1895, p. 10.

8. See A. Silvestre, *Le Nu au Salon de 1892 (Champs de Mars)* (Paris, 1892), pp. 1–4, for a lengthy account of this painting.

9. A. Silvestre, *Le Nu au Salon de 1891* (Paris, 1891), p. 61.

10. See C. Baudelaire, *The Painting of Modern Life* (London, 1964; tr. from French edition, 1863).

11. See Freud, 'On Narcissism' (1914). Reprinted together with a series of critical essays in J. Sandler et al. (eds), *Freud's 'On Narcissism': An Introduction* (London, 1991), p. 88.

12. For a lengthy discussion of the position of the woman artist in this period, see Tamar Garb, *Sisters of the Brush: Women's Artistic Culture in Late Nineteenth-Century Paris* (New Haven and London, 1994).

13. Octave Uzanne, *La Femme à Paris: les Parisiennes de ce temps dans leur divers milieux, états et conditions* (Paris, 1894), p. 38.

14. Ibid., p. 40.

15. Baroness Staffe, *The Lady's Dressing Room*, p. 15.

16. See Jacqueline Lichtenstein, 'Making up Representation: The Risks of Femininity', *Representations*, 20, Fall 1987, pp. 77–87.

17. For alternative readings of Morisot's images of women at the toilette, see C. Armstrong, 'Facturing Femininity: Manet's *Before the Mirror*', *October* 74, Fall 1995, pp. 75–104; and A. Higonnet, *Berthe Morisot's Images of Women* (Cambridge, Mass., and London, 1992), pp. 159–94.

18. For a brief discussion of this idea in relation to the *Young Woman Powdering Herself*, see R. Thomson, *Seurat* (Oxford, 1985), pp. 196–7.

19. For the revival of interest in Baroque painting and decorative arts in the nineteenth century, see Carol Duncan, *The Pursuit of Pleasure: The Rococo Revival in French Romantic Art* (New York and London, 1976). I am grateful to Helen Weston for discussions with her on Boucher's *Madame de Pompadour at her Toilette*.

20. See Robert Herbert et al., *Georges Seurat, 1859–1891*, Metropolitan Museum of Art (New York, 1991), p. 333, for a discussion of the costume of the model in *Young Woman Powdering Herself*.

21. For a reading of the 'joke' around smell suggested by the perfume bottles on the table and the flowers in the picture, see Smith, *Seurat and the Language of the Avant-Garde*, p. 119.

22. See Thomson, *Seurat*, p. 196.

23. See J. Rewald, *Georges Seurat* (New York, 1946), p. 70.

24. I am grateful to T.J. Clark for discussions with him about this painting and especially for his suggestion that the hairdo echoes the breasts. It was this observation that led me to look for instances of doubling and multiple representations of the breast elsewhere in the picture.

25. For a discussion of the changing meaning of the breast over time, see M. Yalom, *A History of the Breast* (London, 1997).

26. See, for example, Thomson, *Seurat*, p. 197.

27. See Robert Herbert et al., *Georges Seurat, 1859–1891*, p. 335. See also *Impressionist and Post-Impressionist Masterpieces: The Courtauld Collection* (New Haven and London, 1987), cat. entry 36.

28. For a discussion of this painting in the context of contemporary criticism, see Hollis Clayson, *Painted Love: Prostitution in French Art of the Impressionist Era* (New Haven and London, 1991), pp. 67–75. See also C. Armstrong, 'Facturing Femininity: Manet's *Before the Mirror*', *October*, 74, Fall 1995, pp. 75–104.

29. I am grateful to Briony Fer's suggestive discussion of the 'exoskeleton' in her work on Bruce Nauman for my reading of the frame.

30. See Witkowski, *Tetoniana*, pp. 90–1.

31. For a discussion of Seurat and Idealism, see Smith, *Seurat and the Language of the Avant-Garde*.

Chapter Five

Notes to pages 144–77

1. For a discussion of Renoir's escapist aesthetic, see John House, 'Renoir and the Earthly Paradise' in *Renoir*, exhib. cat., Hayward Gallery, London (London, 1985).

2. For feminist critiques of Renoir's representation of women, see Tamar Garb, 'Renoir and the Natural Woman', *Oxford Art Journal*, vol. 8, no. 2, pp. 3–15; Kathleen Adler, 'Reappraising Renoir', *Art History*, vol. 8, no. 3, 1985, pp. 374–80; and Lynda Nead, 'Pleasing, Pretty and Cheerful: Sexual and Cultural Politics at the Hayward Gallery', *Oxford Art Journal*, vol. 8, no. 1, pp. 72–4.

3. For a discussion and theorization of the history of the female nude see Lynda Nead, *The Female Nude: Art, Obscenity and Sexuality* (London and New York, 1992).

4. For a discussion of the history of images of bathing and the contemporary transformation of bathing habits, see Linda Nochlin, 'Bathtime: Renoir, Cézanne, Daumier and the Practices of Bathing in Nineteenth-Century France', The Gerson Lectures Foundation (Groningen, the Netherlands, 1991). For a revival of interest in eighteenth-century precedents, see Carol Duncan, *The Pursuit of Pleasure: The Rococo Revival in French Romantic Art* (New York and London, 1976), and Debora Silverman, *Art Nouveau in Fin-de-Siècle France: Politics, Psychology and Style* (Berkeley and London, 1989).

5. See, for example, the responses of Albert Wolff and Louis Enault, *The New Painting: Impressionism 1874–1886*, The Fine Arts Museum of San Francisco (1986), p. 184.

6. The literature on the representation of the prostitute in late nineteenth-century France is vast. Indispensable texts include: T.J. Clark, *The Painting of Modern Life: Paris in the Art of Manet and his Followers* (London, 1985); Charles Bernheimer, *Figures of Ill Repute: Representing Prostitution in Nineteenth-Century France* (Cambridge, Mass., and London, 1989).

7. For a detailed analysis of this painting, see Tamar Garb, 'Gender and Representation' in F. Frascina et al., *Modernity and Modernism: French Painting in the Nineteenth Century* (New Haven and London, 1993).

8. See *A Passion for Renoir: Sterling and Francine Clark Collect, 1916–1951*, Sterling and Francine Clark Art Institute (Williamstown, Mass., 1997), p. 88.

9. See Jean Renoir, *Renoir my Father* (London, 1962), p. 183.

10. For a discussion of the construction of Renoir's biography and analysis of photographs of the aging artist, see Marcia Pointon, 'Biography and the body in late Renoir', *Naked Authority: The Body in Western Painting 1830–1908* (Cambridge, England, 1990), pp. 83–97.

11. Renoir did paint a number of male portraits but never undertook paintings of the male nude, which held no interest for him. For a discussion of Renoir's portraits see Colin B. Bailey, *Renoir's*

Portraits: Impressions of an Age (New Haven and London, 1997).

12. Nineteenth-century commentators liked to compare the shape of women's breasts to fruits, commonly invoking pears and apples to describe them. One newspaper, *Le Courrier français*, even petitioned its male readers in 1891 to establish which of them preferred 'pears' to 'apples' and to establish the advantages and disadvantages of each. See G.J. Witkowski, *Tetoniana* (Paris, 1898), p. 26.

13. For a discussion of Renoir's construction of a 'natural femininity' in the context of the new demands of feminists and social reformers, see Tamar Garb, 'Renoir and the Natural Woman', *Oxford Art Journal*, vol. 8, no. 2, pp. 3–15.

14. See A. Callen, *Renoir* (London, 1978), p. 97.

Chapter Six

Notes to pages 178–95

1. Joachim Gasquet gives a very suggestive interpretation to the encounter with the flesh that figure painting involved for Cézanne. He puts it thus: 'Nude flesh made him giddy, he wanted to leap at his models; as soon as they came in he wanted to throw them, half-undressed, onto a mattress... He had found another way to adore those nudes whom he chased from his studio, he bedded them in his paintings, tussled with them, lashed them with great coloured caresses, despairing to the point of tears at being able to put them to sleep in scarlet enough rags, to stroke them with subtle enough glazes.' The conflation of surface and female flesh that we saw with Renoir is evident here, but the gesture of painting is now imagined as a violent quest for control, a subduing of the motif as it is captured in paint. *Joachim Gasquet's Cézanne: A Memoir with Conversations* (London, 1991), p. 78.

2. Honoré de Balzac, *Le Chef-d'oeuvre inconnu*, (Paris, 1832), tr. as *The Unknown Masterpiece* (1899), pp. 34–5.

3. Gasquet gives an account of other versions, subsequently destroyed.

4. I am grateful to Richard Shiff for conversations with him about the picture's transformation.

5. I am grateful to John House for drawing out the significance of the bishop.

6. For an interesting account of Cézanne's reworking of the Olympia theme, see Hollis Clayson, *Painted*

Love: Prostitution in French Art of the Impressionist Era (New Haven and London, 1991), pp. 16–26.

7. *Cézanne*, exhib. cat., Galeries Nationales du Grand Palais, Paris, Tate Gallery, London, and Philadelphia Museum of Art (London, 1996), p. 161.

8. For Freud's use of this phrase, see the case of Miss Lucy R. in *Studies on Hysteria*, vol. 2 (London, 1955), p. 117.

9. For a feminist reading of this painting as a modern allegory, see Sarah Faunce and Linda Nochlin in *Courbet Reconsidered* (New Haven and London, 1988).

10. G.J. Witkowski, *Anatomie et physiologie de l'appareil génital de la femme* (1874) in *Anatomie iconoclastique* (Paris, 1877), p. 3.

11. Balzac, *The Unknown Masterpiece*, p.41.

Chapter Seven

Notes to pages 196–219

1. For Cézanne's dependence on pictorial precedents in his figure paintings, see T. Reff, 'Cézanne and Poussin' in *Journal of the Warburg and Courtauld Institutes*, vol. 23, 1960, pp. 150–74; T. Reff, 'Cézanne and Hercules', *Art Bulletin*, vol. 48, 1966, pp. 35–44; G. Berthold, *Cézanne und die alten Meister* (Stuttgart, 1958).

2. The 'tactility' of Cézanne's work has been stressed by a number of critics. For a discussion of this, see R. Shiff, 'Cézanne and Poussin: How the Modern Claims the Classic' in R. Kendall (ed.), *Cézanne and Poussin: A Symposium* (Sheffield, 1993), pp. 55–6. See also R. Shiff, 'Cézanne's physicality: the politics of touch' in S. Kemal and I. Gaskell (eds), *The Languages of Art History* (Cambridge, 1991), pp. 129–80. Merleau-Ponty's reading of Cézanne depends rhetorically on an actual encounter between the artist and nature in order for the separation between self and world to be enacted and dissolved. While this may work beautifully with the landscapes and still lifes, it is difficult to sustain in relation to the imaginative compositions like the bathers.

3. T. Reff, 'Cézanne: the enigma of the nude', *Art News*, vol. 18, 1959, p. 26. Meyer Schapiro also contrasted these two artists, seeing Renoir's bathers as expressing 'a dream of happiness in nature' while Cézanne's were 'without grace or erotic charm and

retain in their unidealized nakedness the awkward forms of everyday, burdened humanity.' Schapiro (1952) in Judith Wechsler (ed.), *Cézanne in Perspective* (Englewood Cliffs, NJ, 1975), p. 137.

4. Meyer Schapiro, *Cézanne* (London, 1952; reprinted 1988), pp. 132 and 137.

5. For an interesting reading of this photograph, see Marcia Pointon, 'Biography and the Body in Late Renoir' in *Naked Authority: the Body in Western Painting 1830–1908* (Cambridge, England, 1990), pp. 83–5.

6. For a discussion of Renoir's bathers in the context of nineteenth-century bathing in general, see Linda Nochlin, 'Bathtime: Renoir, Cézanne, Daumier and the Practices of Bathing in Nineteenth-Century France', The Gerson Lectures Foundation (Groningen, the Netherlands, 1991). For an early feminist discussion of the gendering of the relationship of nature to culture, see S.B. Ortner, 'Is Female to Male as Nature is to Culture?' in M.Z. Rosaldo and L. Lamphere (eds), *Woman, Culture, Society* (Stanford, California, 1974).

7. For the best account of Cézanne's quest for an art of 'sensation', see Richard Shiff, *Cézanne and the End of Impressionism* (Chicago and London, 1984).

8. T.J. Clark has recently published a fascinating account of this painting in 'Freud's Cézanne', *Representations*, 52, Fall 1995, pp. 94–122.

9. For a discussion of fetishism in relation to the image of the female nude, see L. Mulvey, 'Fears, Fantasies and the Male Unconscious *or* "You don't know what's happening, do you Mr Jones?"' in *Visual and Other Pleasures* (Basingstoke, 1989), pp. 6–13. See also the discussion of boundaries and framing in L. Nead, *The Female Nude* (London, 1992).

10. A drawing for this painting is thought to have influenced Cézanne in his decision to paint male bathers: see Dorival (1949) referenced in *Frédéric Bazille: Prophet of Impressionism*, The Brooklyn Museum, (Brooklyn, 1993), p. 116.

11. For a discussion of the iconography of wrestling in the nineteenth century, see K. Herding, 'Les Lutteurs Détestables' in *Courbet: To Venture Independence* (New Haven and London, 1991), pp. 11–43. For a discussion of wrestling and sport in images of modern masculinity see Tamar Garb, 'Masculinity, Muscularity and Modernity in Caillebotte's Male Figures' in T. Smith (ed.), *In Visible Touch: Modernism and Masculinity* (Sydney, 1997), pp. 53–74.

12. For an account of the modernity of this vision and the pictorial tensions it sets up, see C. Greenberg (1951) in Wechsler, *Cézanne in Perspective*, p. 132.

13. For the feminine appearance of this figure type, see the glossary of figure types provided by M.L. Krumrine, *Paul Cézanne: The Bathers* (London, 1990), pp. 243–53.

14. Describing Cézanne's project, Emile Bernard wrote that for him each brushstroke had to 'contain the air, the light, the object, the composition, the character, the outline, and the style.' Quoted by M. Merleau-Ponty in 'Cézanne's Doubt', G.A. Johnson, *The Merleau-Ponty Aesthetics Reader: Philosophy and Painting* (Evanston, Illinois, 1993), pp. 65–6.

15. A careful trawl through the watercolours reveals a small number of anomalies where the sex of the figures is hardly decipherable, and where the labelling of the bathers as male or female by subsequent historians seems hard to justify, or where there is some question as to whether the bathers are of mixed sexes. The system of segregation which works in the oils is, therefore, not always as carefully controlled in the small, private studies executed in the sketchbook; see J. Rewald, *Paul Cézanne: The Watercolours. Catalogue Raisonné* (London, 1983), nos 129, 605, 609.

16. For humour and parody in early Cézanne see N. Athanassoglou-Kallmyer, 'An Artistic and Political Manifesto for Cézanne', *Art Bulletin*, vol. 72, no. 3, Sept 1990, pp. 482–92.

17. See, for example, Schapiro, *Cézanne*, p. 44.

18. Roger Fry laments the recurrence of the pyramid in Cézanne's 'large "poésies"' and attributes this to the invented or imaginary status of these compositions. For him, Cézanne is at his 'greatest' when 'the stimulus was external vision'. When working 'from an internal stimulus Cézanne shows ... only a curiously restricted power. He has at his command only this one elementary framework.' R. Fry, *Cézanne: A Study of his Development* (London, 1927), p. 85. Fry's dislike of the imaginative compositions made him unwilling to make fine distinctions between them and to notice that the pyramidal compositional structure primarily characterized the female rather than the male bather paintings.

19. Similar compositions include *Baigneuses* (V.359); *Baigneuses* (V.540); *Baigneuses* (V.722); *Baigneuses* (V.723); *Ebauche des Grandes Baigneuses* (V.725); *Les Grandes Baigneuses* (V.720).

20. See Schapiro, *Cézanne*, p. 44; E. van Liere, *Le Bain: The Theme of the Bather in Nineteenth-Century French Painting* (1974), pp. 125–7. For other typical male bather compositions, see *Le Bain* (V.588); *Baigneurs* (V.589); *Baigneurs* (V.390); *Les Baigneurs* (V.389); *Les Cinq Baigneuses* (V.268); *Baigneurs* (V.585); *Baigneurs* (V.581).

21. Van Liere, *Le Bain*, p. 125.

22. See Mulvey, *Visual and Other Pleasures*.

23. S. Freud, 'The Dream-Work' in *The Interpretation of Dreams* (1900), reprinted in *The Standard Edition of the Complete Psychological Works of Sigmund Freud*, vol. 4 (London, 1986), p. 417.

24. Mary Krumrine argues that the painting on the easel represents not the woman but the canopy and landscape that frame her. Such an explanation does not account for the filling in of the triangular space, and although Krumrine notices the similarity of the shape to the Mont Sainte-Victoire, she can do nothing with this observation, which she links to a naturalistic claim that Cézanne has set the scene in Provence. Her description of the female type of which this woman is an exemplar as 'grotesque', 'formidable' and 'emasculating' betrays an extraordinary lack of critical distance from the phantasmatic constructions of nineteenth-century men and produces a discourse which seems to collude with nineteenth-century attitudes rather than explain them. See Krumrine, *Paul Cézanne: The Bathers*, pp. 93–4.

25. Hugh Silverman writes compellingly of Cézanne's bodily engagement with the mountain: 'Again and again he brought his body to a site from which he could see the mountain... He regularly lent his body to the mountain in the act of painting it... By lending his body to it, standing before it with his easel and palette, Cézanne would lean forward towards his canvas and render visible what the profane eye would not see. Through both vision and movement, Cézanne would transpose the visibility of his own body in its relation to the mountain into the secret visibility of his canvas.' 'Cézanne's Mirror Stage' in G.A. Johnson, *The Merleau-Ponty Aesthetics Reader*, p. 269. But Silverman's account of the profound physicality of painting and the consequent transposition of the artist's body into the body of the work does not question the nature of the obsession with this shape, this thing, nor relate it to the representational languages of its time. The painter and the mountain function in glorious isolation from the symbolic systems that give them meaning.

26. This statement from Henri Perruchot's *Cézanne* (1963) is quoted in van Liere, *Le Bain*, p. 125.

27. 'A woman elevated to the apex of a triangular composition with adoring supporting figures is a standard arrangement used in paintings dealing with the theme of the birth of Venus....' See van Liere, *Le Bain*, p. 125.

List of Illustrations

Index